A VISION OF CANADA

The McMichael Canadian Collection □ With an introduction by Paul Duval

Clarke, Irwin & Company Limited TORONTO, VANCOUVER 1973

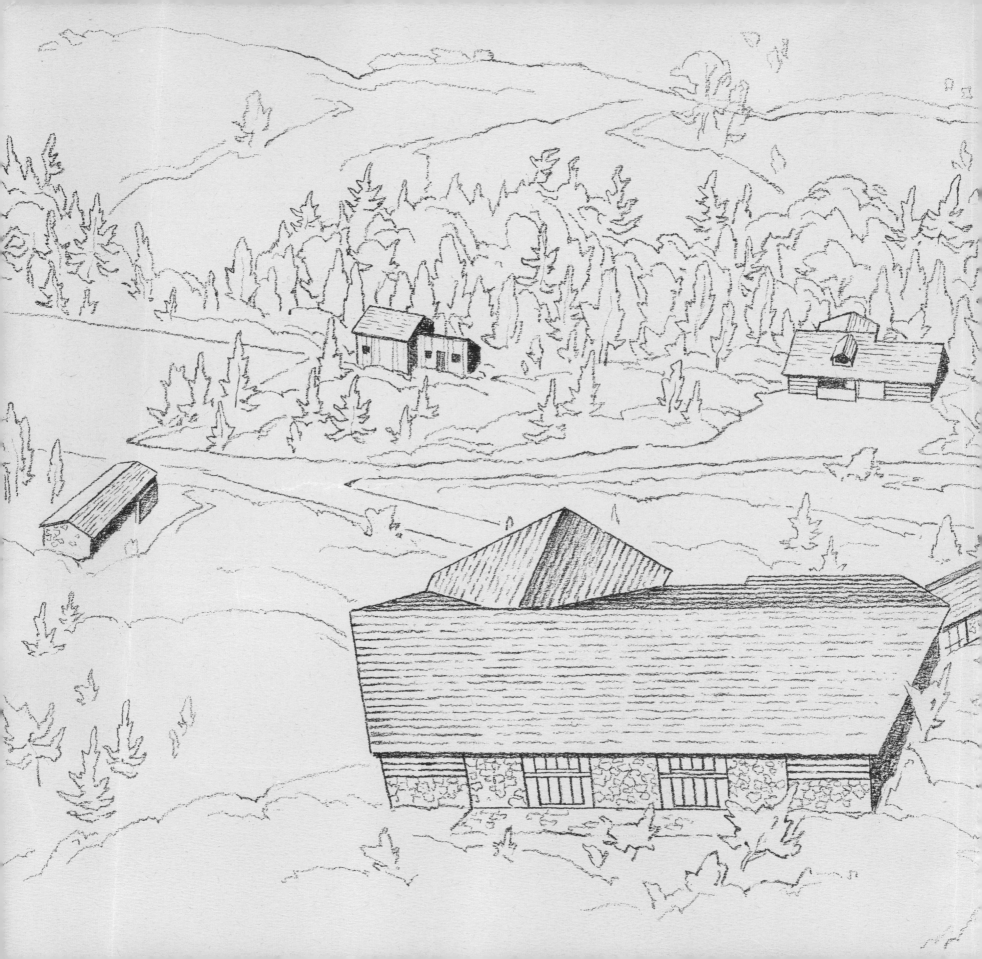

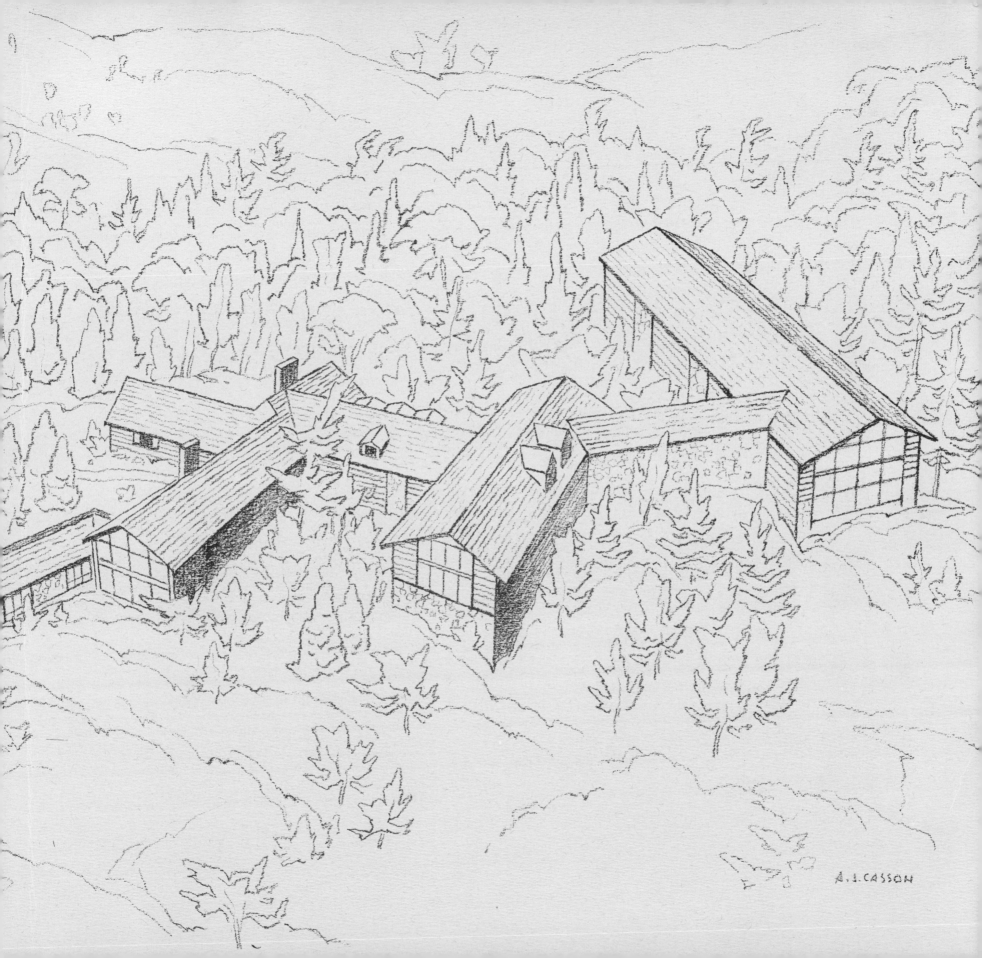

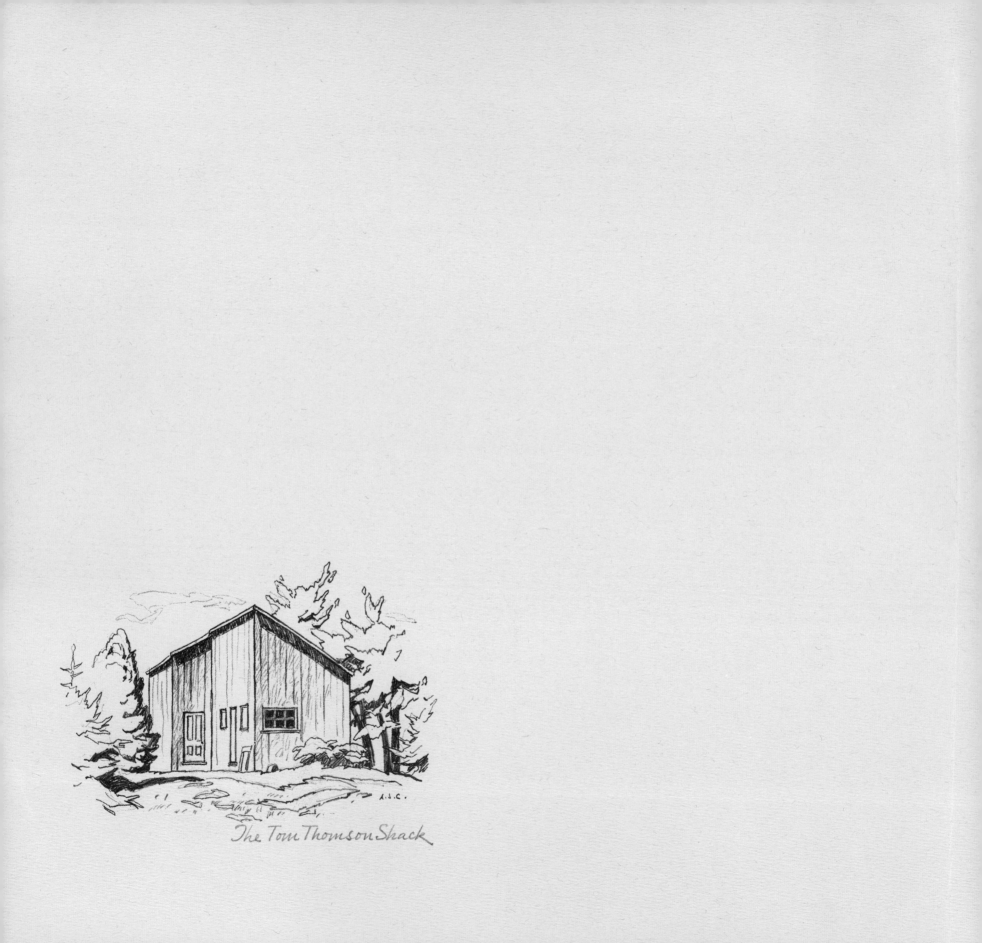

The Tom Thomson Shack

The McMichael Canadian Collection

KLEINBURG · ONTARIO

PAUL DUVAL

The most interesting personal art collections in the world have been born of a compelling enthusiasm for a particular period or kind of art. Material for such collections may be the work of one painter, one nation or one school of artists.

The enthusiasm that founded the McMichael Conservation Collection was triggered by the art of a legendary Canadian, Tom Thomson and those Group of Seven painters who shared his devotion to our native landscape.

Robert and Signe McMichael were attuned since childhood to the grandeur and scale of the Canadian earth. Long before they were married, they separately came to know the tundra, forests and streams of the wilderness. Signe McMichael arrived from Europe with her Danish parents when she was six years old, and spent her formative years on the family's farm in the Peace River district of the far northwest. Bob, though born in Toronto, had vivid recollections of many summer trips which included Algonquin Park and the Timagami area of Northern Ontario. For both of the McMichaels, love of art has long run in tandem with their affection for the land which first nurtured their visual experience.

Born to a generation that inherited the works of Tom Thomson and the Group of Seven almost wet from the easel, the McMichaels first came to enjoy art from the reproductions of Thomson's West Wind and Jack Pine in their school textbooks. For both of them, Thomson has remained a special favourite among artists.

Although a Thomson painting was not their first purchase (they had earlier bought a Montreal River sketch by Lawren Harris), the McMichaels' acquisition of Thomson's Pine Island sketch in 1953 started them earnestly on the road to the magnificent public collection of today. Only a year later, in 1954, they moved into the unfinished first stage of what is today the McMichael Canadian Collection. It was erected on ten acres of land purchased in the winter of 1952 on the outskirts of Kleinburg, then a village of about two hundred persons.

5

When they first bought the site of their country home only twenty miles from Toronto, Bob and Signe could hardly imagine where their love of the outdoors and art would eventually lead them. Certainly, a large collection of Canadian treasures had not yet been envisioned. There were enough problems paying for and completing their new home. They had decided to build it from pioneer Ontario materials, stone and square-hewn logs. Two patient years had been spent searching out old barns from whose century-old timbers their first six room home was constructed. Bob and Signe were fortunate to locate expert local craftsmen, under the supervision of A.W. Bayliss, to fit the nine inch thick logs and local rock to shape. The same craftsmen have since continued to fashion each addition to the gallery-home and the building is thus as much an harmonious unit as the collection of art it houses.

When the first stage of the McMichael house was completed, it was an L-shaped structure of six rooms, one of them a vast living room 42 x 22 feet, centred by a huge fireplace. The young couple called their new home Tapawingo, the Indian word for Place of Joy, and in November, 1954, they settled in to enjoy the isolation and beauty of their ten acre country estate, with its magnificent views of first growth forest, sloping hills and a constantly changing parade of animal and bird life.

The natural beauty that surrounded Tapawingo was soon to be balanced within its walls by beauty created by man. When, in 1953, the McMichaels bought their first Harris and Thomson sketches on the installment plan they became, as Bob stated it, "hooked on Canadian art". They visualized the walls of Tapawingo decorated with paintings by Thomson, the Group of Seven and their great contemporaries, Emily Carr and David Milne. Every dollar that could be spared from the expanding McMichael business interests went toward buying paintings and by 1960 almost fifty canvases and sketches had been acquired.

It was at this point that friends and acquaintances began to bring visitors to see the growing collection in its unique natural setting. They would sit enjoying the McMichaels' hospitality, a Group of Seven canvas sharing their line of sight with the view through a panoramic window. During these visits, the subjects of painting and collecting were often foremost.

Frequent visitors to Tapawingo were many of the famed Group of Seven members themselves. A.Y. Jackson, A.J. Casson, F.H. Varley and J.E.H. MacDonald's artist-son, Thoreau, became firm friends and assisted the McMichaels in many ways, as did the painter Yvonne Housser. As these meetings and talks continued, Bob and Signe began to visualize Tapawingo as a continuing "Place of Joy" for anyone who wished to share it. They started to draw up plans for a gallery which would be given to the people of Canada, a gallery where paintings by Tom Thomson, the Group of Seven and their contemporaries would be on permanent view.

The functions of a home were gradually superseded at Tapawingo by the needs of a gallery. The next two stages in its construction, completed in 1963 and 1966, were designed primarily as exhibition areas for the effective display of paintings.

In 1962, a unique annex was added to Tapawingo, with the acquisition of the shack in which Tom Thomson had lived and painted in downtown Toronto's Rosedale Valley. Thomson had

painted the West Wind and other famous masterpieces in this small wooden structure located behind the Group of Seven's Studio Building. Its removal, plank by plank, and re-erection on the McMichael property has made it possible to preserve the historic building and convert it into an exhibition area for objects and material relating to Thomson's life and times.

Its walls are decorated with paintings done originally for the walls of the shack by the Group and others, along with a series of witty contemporary impressions of the Group members by Arthur Lismer. Among other items on display are Thomson's own easel and palette.

Tapawingo, which had begun as a cherished and very private retreat for two people, was rapidly becoming a public shrine for lovers of Canadian art.

As early as 1962, thousands of visitors were coming to see the McMichael Collection. Individuals and groups would appear at the door unannounced to see the collection about which they had read or heard. Signe and Bob would accommodate the unexpected callers as much as possible. They considered any inconvenience to themselves compensated by the eagerness of their visitors for Canadian art. Soon, school classes, community clubs, convention groups and other organizations were making appointments to see Tapawingo. By 1964, the annual number of visitors had increased to more than eleven thousand.

One of those 1964 visitors was the Honourable John Robarts, Prime Minister of Ontario. A keen conservationist and enthusiast for Canadian art, Mr. Robarts was deeply impressed by what the McMichaels had achieved. Subsequent visits between the Prime Minister, members of his staff and the McMichaels brought about the realization of Bob's and Signe's most cherished ambition. Tapawingo and a surrounding 600 acres was to become a public institution administered by the Government of Ontario.

The home and collection which had given the young couple so much pleasure was now to be given to as many people as wished to come and enjoy it, for as long as man can foresee. It was only one short decade since Bob and Signe had first moved into their unfinished home.

On November 18th, 1965, an agreement was signed between Prime Minister John Robarts, for the Government of Ontario, and the McMichaels, creating the McMichael Conservation Collection of Art, and the McMichael Conservation Area as a gift to Canada, in Right of the Province of Ontario. By this time, the McMichael Collection had grown to over two hundred important works. The terms of this document stipulate that the Province of Ontario guarantees to maintain the grounds, buildings and collection in perpetuity and add such facilities as would be deemed necessary for ever increasing attendance. The 600 acres of the McMichael Conservation Area and the 30 acres that embrace the Collection would be tended and protected by Government staffs. Bob and Signe McMichael would remain at Tapawingo as unpaid curators and would supervise the growing size and quality of the now-public collection.

Premier Robarts' interest in the McMichael Collection was shared by his successor, Premier William Davis. In the fall of 1972, an Act was passed by the Ontario Legislature formalizing the status of the Collection as a major cultural institution. Under the terms of this Act, the name of the gallery was changed from The McMichael Conservation Collection of Art to The McMichael Canadian Collection.

During its first six months as a public institution, between May and November, more than forty thousand people came to see the collection. They arrived, not only from surrounding towns and cities, but from as far away as the Pacific Coast and deep into the United States. Articles about the collection in national and international publications brought it to the notice of millions of potential visitors.

By 1967, the Collection numbered two hundred and eighty-seven canvases, sketches and drawings. The great majority of these were amassed personally by the McMichaels, but they

proudly made it known that many of the paintings and sketches were gifts of other Canadian collectors who admired what was evolving in Kleinburg.

These early donors are many and are separately noted elsewhere in this book, but special mention should be made of a few, such as the late Dr. Arnold Mason. A friend to several members of the Group of Seven, Dr. Mason paved the way for the acquisition of such masterpieces as J.E.H. MacDonald's *Leaves In The Brook* and F.H. Varley's *Mountain Portage*. Robert A. Laidlaw, a distinguished collector and close friend of many Group members, presented twenty-six paintings to the McMichaels, including nine brilliant Tom Thomson sketches. Norah de Pencier of Owen Sound, an early supporter of the Group, gave among other works, a major A.Y. Jackson canvas, *Grey Day, Laurentians* and Emily Carr's dramatic *Shoreline*. Yvonne Housser added other notable items.

"These gifts have been one of the biggest joys of our entire art experience", Bob McMichael stated. "It is not the paintings themselves, wonderful and welcome though they are, but even more, the reassurance to Signe and me that our ideas and aims are shared and supported by distinguished Canadians who have been experiencing and collecting art much longer than we have."

If there could be said to be a cornerstone of the Collection it would almost certainly be the nearly seventy paintings and drawings by Tom Thomson.

Born in Claremont, Ontario in 1877, Tom Thomson spent his boyhood in Leith, near Owen Sound. He wandered briefly to Seattle, settled in Toronto as a commercial artist, but found his spiritual and creative home in Algonquin Park. Today, in the McMichael Collection and its natural surroundings with his shack close by, Tom Thomson has found a different sort of home, where millions in the future will be able to see our land through his eyes.

In 1913, Lawren Harris built, in partnership with art patron Dr. James MacCallum, the famed Studio Building in Toronto. It was here that most of those destined to form the Group of Seven were to work at one time or another. Tom Thomson occasionally shared a studio with A.Y. Jackson, but mostly worked in the shack on the Studio Building property. Franklin Carmichael, J.E.H. MacDonald, Arthur Lismer, and Harris himself, all had studios there and created most of their major works within its walls.

Many of the artists with whom Thomson painted were later to band together as the Group of Seven, a body which changed membership occasionally, but kept substantially the same core of adherents.

The seven artists decided at a meeting in the Studio Building, to bring attention to their common creative aims by holding a show at the Art Gallery of Toronto. That maiden exhibition was opened in May, 1920. The number 7 proved magical for the Group's members. Their exhibit focussed keen public attention upon them and their painting. The concentration of the Seven's powerful expression brought forth a mixture of public and critical applause and abuse. Certainly, their first exhibition did more to arouse general interest in Canadian art

than any single event that had happened before. Further shows cemented their claim to public attention and the label "Group of Seven" became a familiar nationwide cultural symbol, even where its members' pictures were never seen.

The 1920 founding members of the Group were Franklin Carmichael, Lawren Harris, A.Y. Jackson, Frank Johnston, Arthur Lismer, J.E.H. MacDonald and Frederick H. Varley. Frank Johnston resigned shortly afterwards and was replaced by A.J. Casson in 1926. Edwin Holgate was elected a member — the "eighth" — in 1930 and LeMoine FitzGerald was given what can only be called an honorary membership in 1932, a year after the last Group show.

The Group of Seven's first exhibition of 1920 was followed by shows in 1921, 1922, 1925, 1926, 1930 and 1931. In the fifth exhibition of 1926, ten guest artists with sympathetic aims were invited to show with the Seven. During that brief decade of existence, the Seven did realize the goal stated by Arthur Lismer in 1920: "to get a show together that would represent the spirit of painting in Canada".

The creative saga of the Group had begun years before its formal organization as an exhibition society. Many of the familiar masterpieces by members of the Seven were painted well before their 1920 exhibition. MacDonald's *Tangled Garden* and *The Elements* were executed in 1916, *Logs On The Gatineau* in 1915 and *Leaves In The Brook* in 1919. A.Y. Jackson's famous *Red Maple* was painted in 1914 and the monumental *Terre Sauvage* in 1913. Many of the best of Lawren Harris' familiar house paintings were completed before 1915 and the best known of the town canvases, *Return From Church* is dated 1919. Arthur Lismer was well into his dramatic interpretations of Georgian Bay by 1916, having first visited there in 1913. F.H. Varley's eloquent portraits of women were already known by 1919. Frank Johnston realized some of his best tempera paintings of landscapes by 1917. During those early years, its members had been exposed to their favourite sketching grounds of

Georgian Bay and Algonquin Park. The latter has a special place in the careers of most of the later members of the Group of Seven. Some commentators sensed this special connection between these artists and the Park, and by 1913 the painters involved were labelled the "Algonquin School". This was a fitting name for the pioneer band which included A.Y. Jackson, Arthur Lismer, Lawren Harris, F.H. Varley, J.E.H. MacDonald and Tom Thomson, the solitary genius who did not live to see the formal creating of the Group of Seven.

Thomson's name is the one most intimately associated with Algonquin Park. He first went there in 1912, to Canoe Lake, where he was to drown a mere five years later. The legend of Thomson's time spent in the Park grows with the years. He came to know its wilderness foot by foot with the affection and observation of one who was at once artist, guide and woodsman. Thomson's enthusiasm for Algonquin was limitless. He extolled its beauty in all seasons in sketches and canvases which have now assumed the status of national icons. He enthused about it to his fellow artists and, in 1914, introduced Jackson, Lismer and Varley to its pictorial wonders. J.E.H. MacDonald came to know the Park the same year through J.W. Beatty who had been painting there since 1910. Lawren Harris certainly painted in Algonquin Park in 1916 and possibly earlier.

Together, these artists found a new creative release through the grandeur of the landscape and the infectious example of Tom Thomson. Certain pictorial touchstones in the development of Canadian landscape painting were created in the Park, including the 1914 *Red Maple* by A.Y. Jackson and its near companion piece, Thomson's *Red Leaves*. These works are, in their way, as trail-blazing as Jackson's *Terre Sauvage* painted the previous year in Georgian Bay.

The key importance of Algonquin Park and of Thomson in the early development of the future members of the Group of Seven is witnessed in many of their letters. In 1914, Varley wrote home from the Park: "The country is a revelation to me".

Lismer enthused: "The first night spent in the north and the thrilling days after were turning points in my life". In 1917, at war more than three thousand miles away from the peace of Algonquin, Jackson wrote to J.E.H. MacDonald upon the news of Thomson's death: "Without Tom the north country seems a desolation of brush and rock. He was the guide, the interpreter and we the guests partaking of his hospitality so generously given . . . my debt to him is almost that of a new world, the north country, and a truer artist's vision . . ." In another letter to MacDonald, late the same year, Jackson again spoke of Thomson: "He has blazed a trail where others may follow and we will never go back to the old days again".

By the "old days", Jackson meant a grey and brown interpretation of Canada as a pastorale land, cultivated, pruned and not too different from the Europe from which most Canadian families had emigrated. In its limited way, this picture was true of parts of Northern Ontairo and Quebec, not too different in either topography or vegetation from parts of the Old World. What Thomson and his fellow artists celebrated was a new wilderness, with brilliant colours and rugged forms almost peculiar to Canada. They brought that eloquent land to their fellow Canadians for the first time in canvas form and as rugged in execution as the topography they portrayed.

The formation of the Group of Seven in 1920 seemed like a seal on Jackson's 1917 pledge to Thomson's memory that "we will never go back to the old days again".

Another part of north central Ontario, the Algoma district, played as important a role for future Group of Seven members as did Algonquin. For at least one of them, J.E.H. MacDonald, it was the inspiration for his greatest achievements.

Algoma, in 1919, was a wilderness waste where virtually no one lived and travelling was almost impossible. The Algoma Central Railway line ran through the forests and it was this fact that enabled the future Group members to realize their ambition to paint that virgin area.

It was Lawren Harris who first inspired the two famous "boxcar" trips to Algoma, the result of a visit he had made in the spring of 1918 with Dr. MacCallum, the earliest supporter of Tom Thomson and his colleagues. Harris was eager to share that wilderness landscape he had discovered along the Algoma Central right of way with his painter friends. In September of 1918, a small group of four, Harris, Dr. MacCallum, J.E.H. MacDonald and Frank Johnston headed north. Varley, Jackson and Lismer were still engaged in war work. Ingenious arrangements had been made for the rental of a private caboose for the four, and they were able to get themselves shunted from one part of Algoma to another by passing freight trains. In this way, they visited the Agawa Canyon and the Montreal River, two themes immortalized by some of them in paint.

The almost boyish enthusiasm for the adventure and the quality of the sketches with which they returned to Toronto overflowed into a second Algoma "boxcar" trip early in the autumn of 1919. The four on this September trip were Harris, MacDonald, Johnston and Jackson, who was making his first visit to the area. The month-long journey took them to many parts of Algoma, and resulted in some of the greatest masterpieces in Canadian art. Some of these to be seen in the McMichael Canadian Collection are A.Y. Jackson's *First*

Snow, Algoma, J.E.H. MacDonald's *Leaves In The Brook*, *Algoma Waterfall* and *Forest Wilderness*, and Lawren Harris' brilliant sketches *Montreal River* and *Algoma Woodland*.

All of the sketches and canvases resulting from those two boxcar trips share a power and joy of expression that mark a high point in the work of the artists involved. With a caboose as their base and the wilderness as their studio, the four artists, weary from the four years of war, found a buoyant and contagious release in paint which still conveys itself to the gallery visitor of today.

In 1933, the disbanded Group of Seven members, with the exception of J.E.H. MacDonald who had died in 1932, spearheaded the creation of a more broadly-based society to be called *The Canadian Group of Painters*. The Canadian Group of Painters' 28 founding members held their initial exhibition in Atlantic City in the summer of 1933, followed by their first Canadian show at the Art Gallery of Toronto in November of the same year. Until it disbanded in 1969, the Canadian Group of Painters offered an exhibition base for the country's most creative artists. The McMichael Collection includes a small selection of paintings by members of the Canadian Group.

In its own way, the Canadian Group of Painters was to prove as important a platform for original Canadian art as had been the Group of Seven itself. In the years between its formation in 1933 and its dissolution in 1969, the Canadian Group

played host to virtually every significant painter of the period, regardless of style. Its 28 founding members included the members of the Group of Seven (excluding Frank Johnston and J.E.H. MacDonald) and such important figures as Emily Carr, LeMoine FitzGerald, Albert Robinson, Jock MacDonald Bertram Brooker, Will Ogilvie, Charles Comfort, George Pepper, Yvonne Housser, Isabel McLaughlin and Prudence Heward. In the decades that followed, the Canadian Group exhibited the works of Carl Schaefer, Pareskeva Clark, Pegi Nicol MacLeod, David Milne, L.A.C. Panton, Paul-Emile Borduas, Oscar Cahen, Alfred Pellan, Jack Humphrey, Alex Colville, Jack Shadbolt, York Wilson, Goodridge Roberts, Marian Scott and Graham Coughtry.

Many of Canada's finest talents of the past few decades first found a natural showcase with the Canadian Group. It searched out new talent from coast to coast and the "invited contributors" columns of its annual catalogue read like a Who's Who of the country's best painters.

Many visitors to the McMichael Canadian Collection are astonished by the large number of small oil paintings included in the collection. The explanation for this is to be found in the creative methods favoured by the Group of Seven and their immediate followers.

Their approach to the making of pictures essentially followed in the "open air" tradition of the great English landscape painter, John Constable. Like him, the Group initially painted many small oil sketches in front of nature and later enlarged the best of these into major canvases.

Almost every famous masterpiece by Tom Thomson and the Group of Seven first existed in the form of a small oil sketch on a wooden or hardboard panel. Thomson's *West Wind*, and *The Pointers*, J.E.H. MacDonald's *Tangled Garden* and *Solemn Land*, A.Y. Jackson's *Red Maple*, F.H. Varley's *Stormy Weather*, *Georgian Bay*, Arthur Lismer's *September Gale* and Lawren Harris' *Pic Island* all first saw creative life as little on-the-spot studies. Such small studies produced by Thomson and the Group number into the thousands. Because of the manner in which they were executed, they are delightfully spontaneous, truly autographic statements.

Small wooden or hardboard panels ideally suit the needs of the on-the-spot landscape painter. Such panels are easily carried in a specially designed, wooden sketch box not unlike an attaché case.

Within the lid of such boxes are a number of grooves to hold the edges of the sketch panels secure, plus compartments for palettes, brushes, paints and turpentine. The sizes of these sketch boxes and the panels they accommodate vary considerably. In the early years of the Algonquin School and the Group of Seven, most of the panels used were 8½″ x 10½″, and sometimes smaller. In their later years, many of the Group members used such larger sizes as 10½″ x 13½″ and 12″ x 15″.

Since they were painted out of doors and on-the-spot, the character and quality of these small panel paintings varies widely, from completely realized compositions to quick notes of skies or details done mainly for future reference.

These sketches were taken back to the artist's studio, where he enlarged his favourites into canvases. To simplify this procedure, the painter would sometimes mark a grid of chalk squares or stretch string across the face of the sketch. Despite this attempt at faithful enlargement, the rich spontaneity of the best of these sketches was sometimes lost in the larger studio canvases based on them.

Two masterpieces where the final canvas versions maintain the vitality of the sketches are to be found in the McMichael Collection. Hanging side by side for instant comparison are the on-the-spot sketches and the final studio versions of J.E.H. MacDonald's *Leaves In The Brook* and Lawren Harris' *Mount Lefroy*.

Between 1967 and 1970, the size of both the McMichael Canadian Collection and the gallery itself, showed a dramatic growth.

In 1967, there were 287 paintings and drawings at Kleinburg; by 1970 these had increased to more than six hundred. This growth reflected the vastly increased support of the endeavour by other deeply interested Canadians. More than half of the new items were donated by private collectors.

Many of the finest treasures added to the McMichael Collection in recent years were donated by the late R.S. McLaughlin, who, in 1968, offered his entire collection of Canadian paintings to the Kleinburg gallery. This included works by Clarence Gagnon, Maurice Cullen, J.W. Morrice and Emily

Carr, along with many more by members of the Group.

The collection's representation of works by A.Y. Jackson took a giant leap in the autumn of 1968 when the late S. Walter Stewart donated his unequalled private collection of more than thirty Jackson paintings and sketches. Mr. Stewart was a life-long friend of the artist and had been a student at university when he bought his first panel by Jackson.

Many further contributions have come forward from other noted Canadian collectors during recent years. R.A. Laidlaw, who earlier had presented his priceless group of Tom Thomson and J.E.H. MacDonald paintings, continued to add major works and sketches.

From Mr. and Mrs. C.A.G. Matthews came a collection which had been carefully put together over a period of many years.

Between 1967 and 1970, 29,000 square feet of floor space were added to the gallery, bringing the total up to more than one acre of exhibition area. This increased size includes two of the most magnificent gallery rooms to be found anywhere in Canada, their ceilings reaching to a height of twenty-two feet. The walls stretch forty feet wide and eighty feet long. Such dimensions are ideal for hanging major canvases of the country's landscape artists and the soaring roof line can easily accommo-date a totem pole. This gallery also houses other artifacts of the West Coast Indian culture and paintings of western themes.

In August of 1970, the McMichaels' interest in this culture took them into the wilderness of British Columbia on a quest for an original totem pole which might have survived the elements. Almost all such poles have long since been removed to museums and storage areas where they may be preserved against the damp ravages of coastal winters. Most of these large totems remaining in the open have deteriorated beyond rescue.

Despite the odds against them, Bob and Signe McMichael found what they were looking for at Blunden Harbour, an Indian locale made famous in paint by Emily Carr. In the forest near that almost inaccessible abandoned village, they located a white pole leaning forward and silhouetted against the dark green cedars surrounding it. After considerable negotiation, they purchased the pole from the Seaweed family. This pole, by the great Kwakiutl carver Willie Seaweed, proved to be in a remarkable state of preservation and required only a minimum of restoration. It now stands in the Western Canada room of the McMichael Canadian Collection, a testimony to the per-sistence with which Bob and Signe built the entire collection from its beginnings of one Lawren Harris sketch.

Indian and Eskimo art now has a significant place in the Collection. Important objects are continually added as they be-come available. The works on view now include totems in wood and argillite, masks, paddles and a number of dramatic contem-porary Eskimo sculptures and prints. Here also hang monu-mental works by Emily Carr and Lawren Harris, along with views of the Skeena River area and the Rockies by such masters as A.Y. Jackson, J.E.H. MacDonald and F.H. Varley.

Western Canada, with its magnetic combination of visual atmospheric effects, possessed a great attraction for several mem-bers of the Group of Seven and for the great native woman genius, Emily Carr. Nowhere else in Canada can one find the dramatic combinations and contrasts of hard edged rock against soft, ephemeral mist. This challenging interplay of atmosphere and form brought out the best in the romantic nature of Fred Varley. His *Moonlight At Lynn*, with its ethereal character, is one of the most poetic pictures in the McMichael Canadian Collection. From the same Rocky mountains, Lawren Harris fetched forth a very different pictorial answer, in resolute, luminous compositions wrought with a razor-edged clarity. J.E.H. MacDonald had less success in some of his mountain studies than with his Northern Ontario canvases, but when he did succeed, as in his *Goat Range* canvas, his efforts were as rewarding for us as any of the Group paintings of Western Canada.

The increase of attendance by both students and general public has demanded many practical changes. The staff has been increased on all levels from grounds keepers to educational lecturers and guides. Parking facilities have been expanded and the need for handling the constantly increasing visitor load has extended to enlarging the gallery itself. To help direct the press of human traffic, a new entrance complex was opened in the spring of 1973. This combines a giant lobby and a 125 seat restaurant plus a new bookstore and adequate cloak room facilities.

The pitched roof of the dramatic new lobby soars 27 feet above a floor that measures 60 by 80 feet. In the centre of the lobby a huge rough hewn granite column reaches to the ceiling. Down clefts of the column water constantly falls into a surrounding pool—a compelling architectural symbol of the rugged northern country explored and painted by Canada's greatest group of landscape painters. Not far from this unique waterfall stands an Inukshuk, ancient stone symbol of the Eskimo, used for centuries as a pointer along the dangerous routes of the Arctic wastelands. Thus nature and art combine in immemorial form to greet the visitor to the McMichael Canadian Collection.

From the gallery's very beginnings as their own small, private home, the McMichaels have insisted that all construction be of native materials and this rule has been continued into the latest additions. The timbers supporting the vaulted roof are of British Columbia Douglas fir. These are believed to be the largest solid pieces of wood ever used for rafters and almost certainly the largest to be shipped across Canada by rail. Each of the giant timbers measures 38 feet in length and 12 inches by 22 inches in thickness. To retain a unity with the rest of the gallery, each beam has been hand hewn by woodsmen using adzes and broad axes.

Within any building in which art treasures are housed, safety is of paramount importance. Concern for the priceless and irreplaceable heritage which the Collection represents has caused its curator and Provincial authorities to design a thorough safety program. During the 1969-70 building program, Ontario Government experts installed a municipal-type system of hydrants to protect the building and surrounding woodland. For safety and cleanliness, all the heat in the gallery buildings has been converted to electricity. During the day trained guides keep a polite, but watchful eye on all the gallery rooms. At night, the building is constantly patrolled by watchmen accompanied by dogs.

Preserving the unspoiled character of the lands surrounding the McMichael Collection has been a prime concern of the authorities involved. Fortunately, some private owners of land in the area have been generous in sharing this concern with gifts of their own properties to the Province of Ontario. The late J. Grant Glassco and his family presented some 400 acres immediately adjoining the McMichael area to the Province. This gift ensures a broad area of conservation land for future public enjoyment along that picturesque stretch of the Humber River.

Nature makes its presence felt even within the gallery through the large windows placed at intervals to allow a panoramic view of the surrounding country.

The McMichael Canadian Gallery, in fact, stands in the midst of a large nature preserve. Located in the flyways of many bird species, the area is frequented by hawks, jays, thrushes,

warblers, grosbeaks, kinglets and flocks of other varieties. The densely wooded areas that edge up to the very walls of the gallery building are a main attraction for the birds. A rare stand of first-growth white pine flourishes in the midst of cedars, hemlocks, tamaracks, beech, ash, birch, and other trees. Beneath their boughs, fox, lynx, racoons, chipmunks and rabbits leave imprints of their passage through the snow in winter. From time to time, deer are seen along the clearing leading down to the Humber River. As the seasons change, so do the forms surrounding the gallery, often echoing the shapes and colours of the landscape paintings hanging within.

The beauty of its valley surroundings has also affected the design of the McMichael Canadian gallery. Throughout the construction of its rooms, great care has been taken to preserve a balance between solid gallery walls, and windows which permit a view of the magnificent surrounding scenery. In this way, the visitor is offered a frequent change of focus for his eyes, allowing them to rest on tree tops and hills between periods of close-up concentration upon the paintings.

No gallery of art should be judged on the merits of its physical structure and the quality of its contents alone. An important measure of the worth of any institution is found in the efforts it makes to share its riches and in the success of those efforts.

Since its beginnings, the McMichael Collection has placed a strong emphasis upon reaching the widest possible public. This stress on the community and educational side of its existence, which originally was a very informal one, has now grown to a point where the Kleinburg gallery plays host to more than 1,200 school classes each year. As many as 3,000 people pass through its exhibition rooms in one day. On Mondays and the remaining weekday mornings, the galleries are reserved exclusively for the use of school children and cultural groups. Other afternoons are for the enjoyment of the general public. Even then, youth has shown a remarkable interest and gallery officials estimate that more than sixty percent of the general visitors are young people.

A full time Educational Director arranges for all school visits and for the training of guides who tour the collection with students and other groups.

The McMichael Canadian Collection by its very character lends itself to classroom extension studies. Thematically, it presents a panorama of the nation's geography. All parts of Canada are portrayed on its walls, from Newfoundland to Vancouver Island. There are characteristic views of the Maritimes, Quebec, Ontario and the Prairies. The Arctic tundra and the Polar seas are also well represented. The visiting student not only receives a vital introduction to Canadian painting but also gains a colourful lesson in the topography of his native land. For those interested in the legends and anthropology of Canada's original settlers, there are the striking totems, masks and figures carved by our West Coast Indians and contemporary Eskimos, as well as pioneer artifacts.

The educational aspect of the McMichael Canadian Collection reaches out much further than to school children. It includes the numerous convention and cultural groups who often make a mass trip to the Kleinburg gallery as part of their plans. The collection reaches into all segments of Canadian life, from students to the retired Provincial Park guide who just wanted to renew his acquaintance with Algonquin.

Many children who first visit the McMichael Collection as students, later return bringing their parents with them. Thus, the younger generation are introducing their elders to the Kleinburg treasury of Canadian art.

For most visitors, the McMichael Canadian Collection represents much more than a gallery of fine pictures. It is a place that makes tangible the creative spirit of a whole people. From its beginnings as a small, private effort, the Kleinburg collection has grown to become an eloquent symbol of nationhood.

Through the years, many will receive joy and knowledge because a few have given treasured possessions to the Collection.

C. S. Band
Lady Banting
Ruth E. Bond
Marjorie Lismer Bridges
Frank Erichsen Brown
Mrs. Hugh Cameron
Mr. and Mrs. H. J. Campbell
Mr. and Mrs. W. J. P. Cannon
A. J. Casson
Mr. and Mrs. H. Spencer Clarke
Mrs. R. Colerick
Rogers G. Colgrove
Mrs. J. E. Collins
Mr. and Mrs. C. W. Densmore
Norah de Pencier
Mr. and Mrs. R. E. Dowsett
Douglas M. Duncan
Mr. and Mrs. Arthur B. Gill
Dr. and Mrs. Walton Groves
Mrs. Chester Harris
Mrs. Lawren Harris
Donald S. Harvie
Percy R. Hilborn
Syd. Hoare
Mrs. J. D. Holbrook
Yvonne McKague Housser
Sophia Hungerford
A. Y. Jackson
Mr. and Mrs. John A. Jackson
Mr. and Mrs. Walter Klinkhoff
R. A. Laidlaw
A. J. Latner Family
A. H. Libby

Thoreau MacDonald
Mr. and Mrs. Keith MacIver
Mr. and Mrs. R. W. M. Manuge
Dr. Arnold Mason
Hart Massey
Mr. and Mrs. C.A.G. Matthews
R. S. McLaughlin
Hon. J. C. McRuer
Marjorie Meredith
Leo Mol
Mrs. J. R. Mooney
W. A. Norfolk
Mr. and Mrs. W. D. Patterson
Mrs. E. J. Pratt
Dr. Samuel Raxlen
Dr. Benjamin Raxlen
Mrs. F. E. Robson
Mrs. H. L. Rous
Mr. and Mrs. F. Schaeffer
School of Nursing, University of Toronto
L. Sessenwein
Dr. and Mrs. J. Murray Speirs
S. Walter Stewart
Mrs. D. Stone
Margaret Thomson Tweedale
Dr. and Mrs. R. W. I. Urquhart
Mrs. C. A. Wells
Mrs. N. D. Young

In 1933 the Group of Seven felt that changing times demanded an enlargement of the Group and the seven became twenty-eight, later adding others under the name of the Canadian Group of Painters. A representative group of forty-two paintings is in this Collection and each was presented by the artist or his estate.

Paul Duval, the author of the text for this volume is a noted authority on Canadian painting. His most recent publication is *Four Decades*, the story of the Canadian Group of Painters and their contemporaries from 1930 to 1970. He is also the author of the Painting Section of the *Encyclopedia Canadiana* and such books as *A. J. Casson 1950*, *Canadian Drawings and Prints 1952*, *Canadian Watercolour Painting 1954* and *Group of Seven Drawings 1965*.

ISBN 0 7720 0585 0

Designed by A. J. Casson, LL.D., R.C.A.
Photography Hugh W. Thompson
Portraits of Artists by Joachim Gauthier, A.R.C.A., O.S.A.
Produced by Sampson Matthews Limited, Toronto
© 1973 McMichael Canadian Collection
Printed in Canada

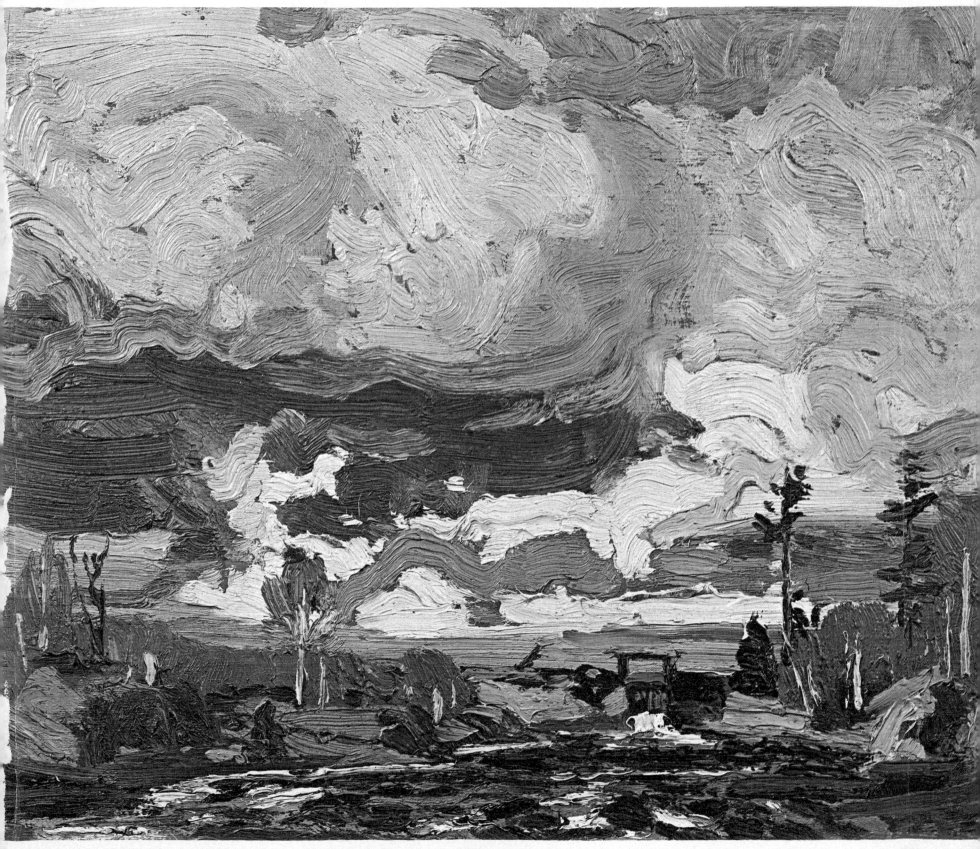

Wildflowers. 1917
8½ x 10½

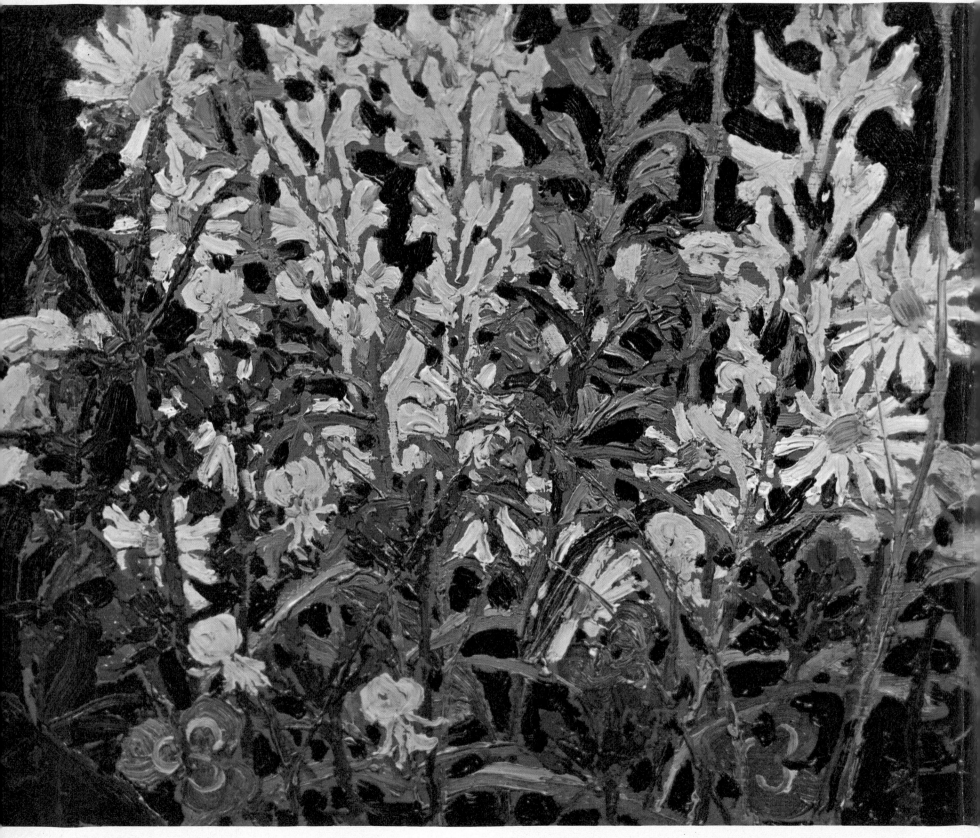

TOM THOMSON 1877-1917

The life of Tom Thomson was the pure stuff of legends. Most of his later years were lived alone in the forest. His early death, in mysterious circumstances, plus the meteor-like briefness of his dazzling career, combined to turn him into a national icon of art.

Tom Thomson's art has always had a special meaning for Bob and Signe McMichael, as it has for most Canadians. The magic of his style, his close identification with the wilderness and his legendary career have put him to the forefront of an art that is truly Canadian. The name of Tom Thomson is synonymous with the search for a native art expression. The magnificent selection from his production in the McMichael Canadian Collection allows one to see his search through its total evolution.

Although he was only forty when he drowned in Algonquin Park's Canoe Lake, Thomson achieved an astonishing body of work. His large canvases are few, but his small oil panels number into hundreds. He managed to produce these while spending much of his time as a guide and forest ranger.

Thomson's finest and most characteristic art was compressed into a brief period of three years, from 1914 until the summer of his death in 1917. Thomson started very slowly as an artist. He was doing dull, imitative, and not very accomplished drawings of figures and landscapes well into his thirties, an age when most artists have already achieved a personal authority of style. In the McMichael Collection examples of these early founderings are available to provide valuable comparisons with the achievements of his last years. It is difficult to believe that these earlier pieces were done only a few years before Thomson first visited Algonquin Park and became, virtually overnight, a totally equipped landscape painter.

In the little *Fairy Lake* sketch of 1910, Thomson gives some inkling of his ability to capture mood, but it is still a painting dictated by the subject: the artist is not in full command. In the canvas *Afternoon, Algonquin Park*, Thomson begins to find his true style—that combination of exact observation and spirited execution that was his own. Then in such 1915 sketches as *Burned Over Land* and *The Log Flume*, he breaks into the radiant colour and commanding brushwork that led to the climactic intensity of his last 1917 studies.

The McMichael Canadian Collection exhibits many of Thomson's most masterly late sketches. It would be difficult to imagine more spirited and compelling landscapes than these small masterpieces. From the pictorial resources of Algonquin Park, Thomson mined such glowing compositions as *Autumn Birches*, *Tea Lake Dam*, *Tamaracks*, *Ragged Pine* and *Autumn Colour*, all painted in 1915 and 1916. These on-the-spot sketches were the work of a few hours at most, but they will survive as long as a love for Canadian art survives.

Born in Claremont, Ontario, in 1877, Tom Thomson spent his boyhood in Leith, near Owen Sound. He wandered briefly to Seattle, Washington, then settled in Toronto as a commercial artist, but finally found his spiritual and creative home in Algonquin Park. Today, in the McMichael Canadian Collection and its natural surroundings, with his shack close by, Tom Thomson has found a different sort of home, where millions in the future will be able to see our land through his eyes.

In tribute to Thomson, it would be difficult to improve on J.E.H. MacDonald's description of him, written for a memorial cairn in Algonquin Park: "He lived humbly but passionately with the wild. It made him brother to all untamed things of nature. It drew him apart and revealed itself wonderfully to him. It sent him out from the woods only to show these revelations through his art. And it took him to itself at last."

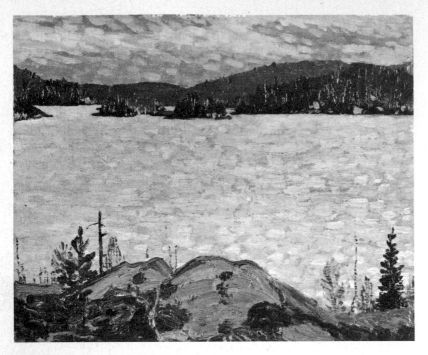

Islands, Canoe Lake. 1915
$8^1/_2$ x $10^1/_2$

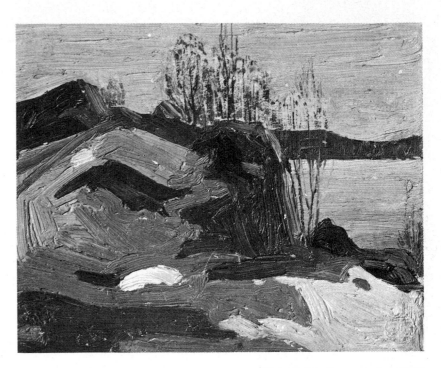

Moonlight, Canoe Lake. 1915
8½ x 10½

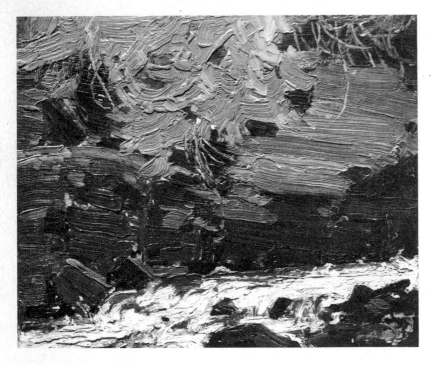

Rushing Stream. 1915
$8^1/_2$ x $10^1/_2$

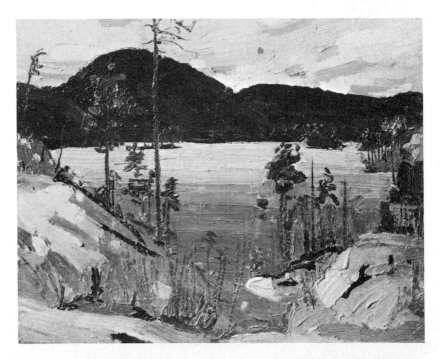

Aura Lee Lake. 1915
$8^1/_2$ x $10^1/_2$

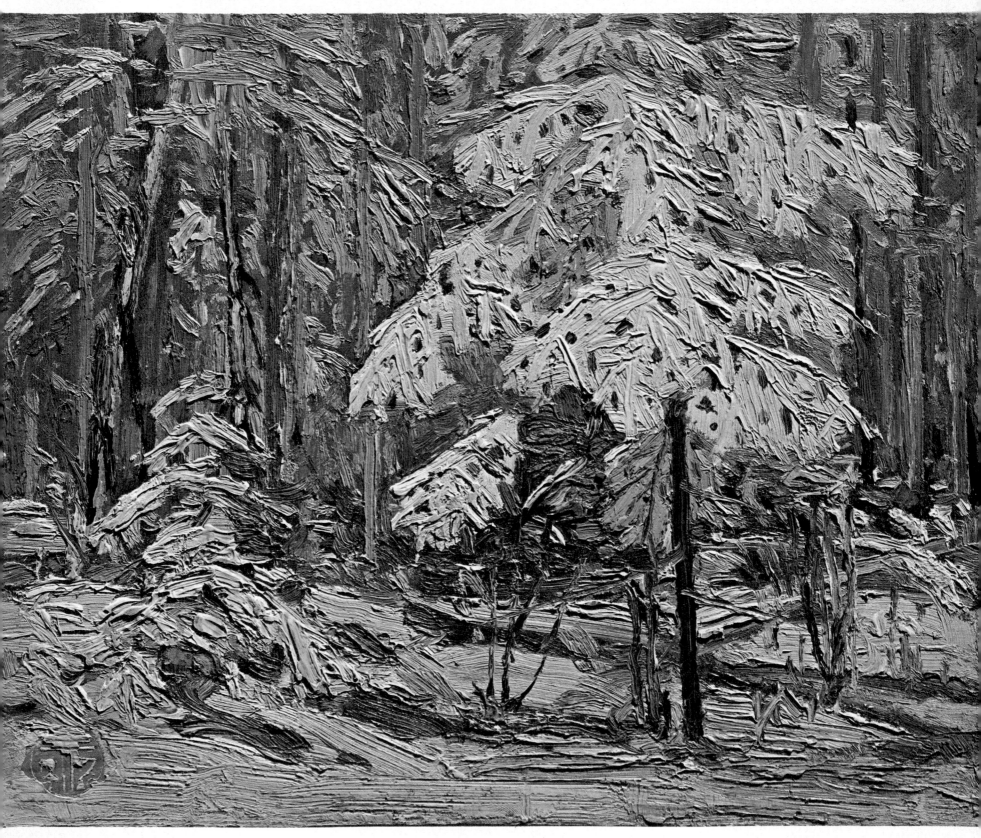

TOM THOMSON

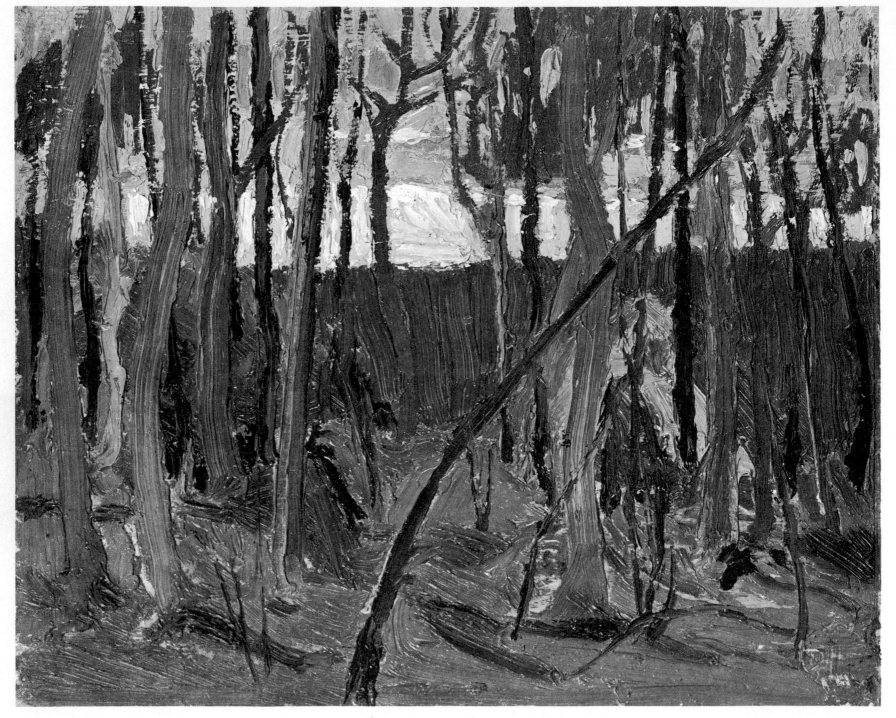

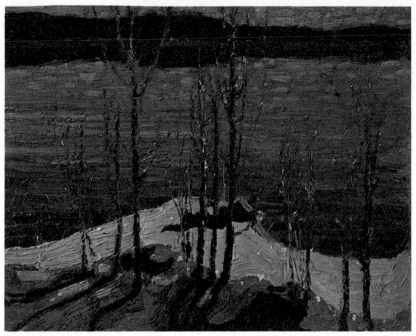

Moonlight and Birches. 1916-17
8¹/₂ x 10¹/₂

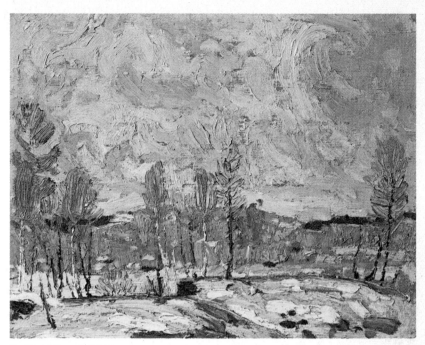

Spring Flood. 1915
8¹/₂ x 10¹/₂

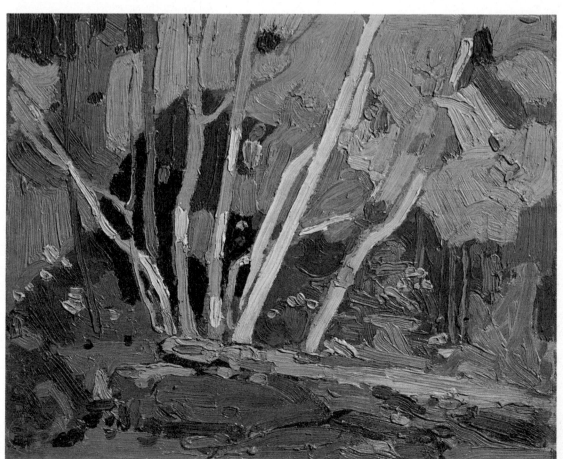

Autumn Birches. 1916
8¹/₂ x 10¹/₂

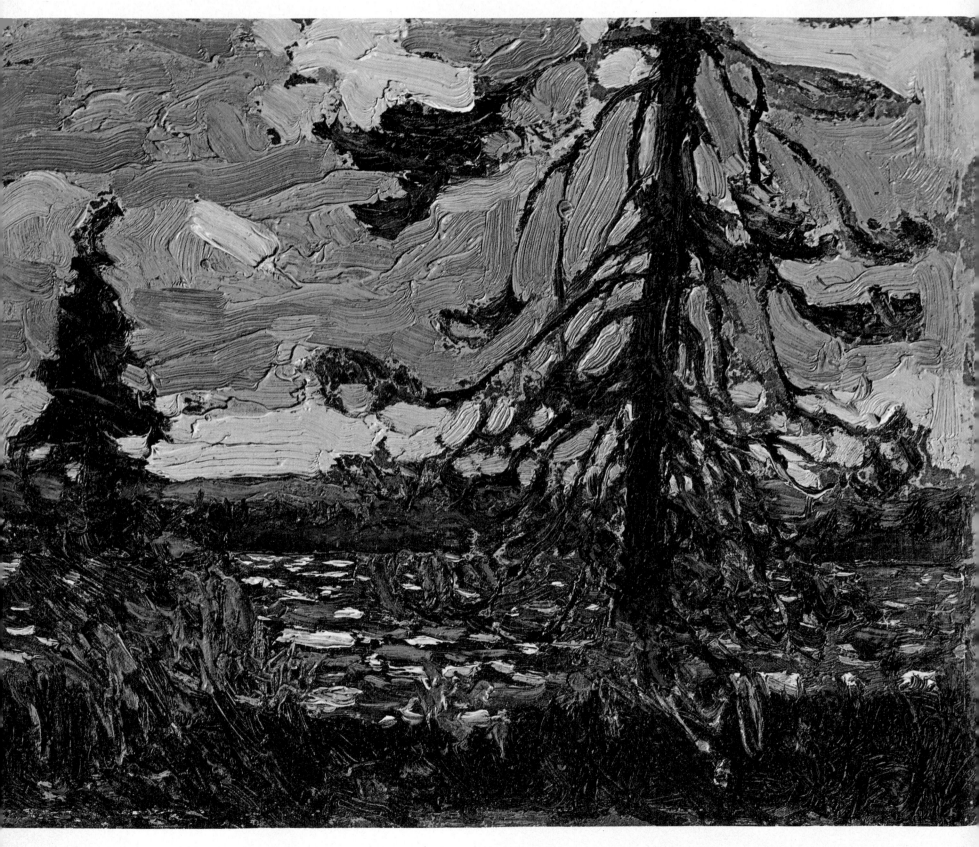

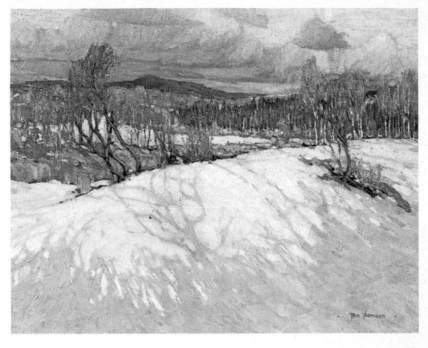

Afternoon Algonquin Park. 1914-15
25 x 32

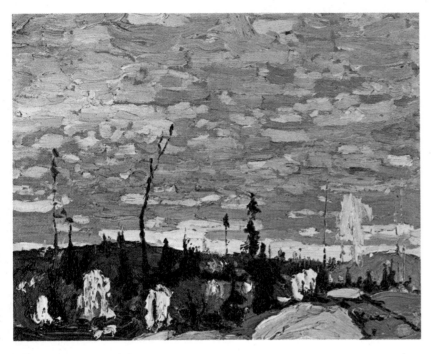

Sunrise. 1916-17
8¹/₂ x 10¹/₂

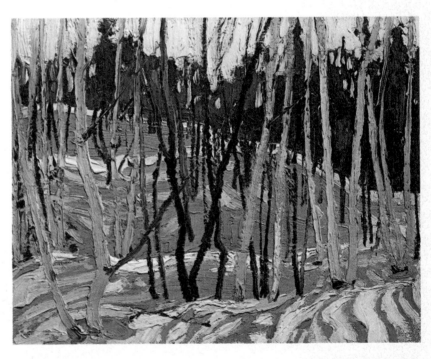

Snow Shadows. 1915
8¹/₂ x 10¹/₂

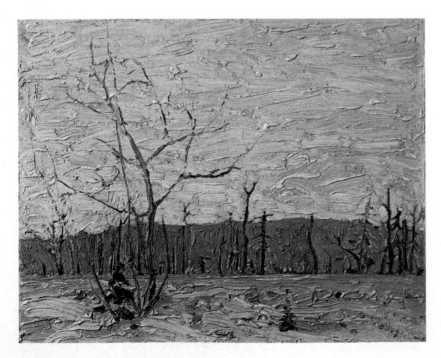

Sombre Day. 1916
8¹/₂ x 10¹/₂

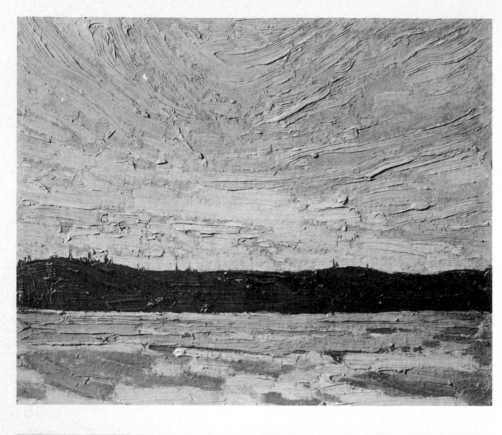

Sunset. 1915-16
$8^1/_2$ x $10^1/_2$

Log Jam. 1915
5 x $6^3/_4$

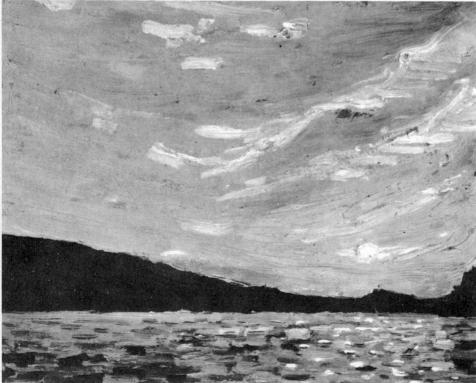

Smoke Lake. 1915
$8^1/_2$ x $10^1/_2$

Black Spruce in Autumn. 1916
8½ x 10½

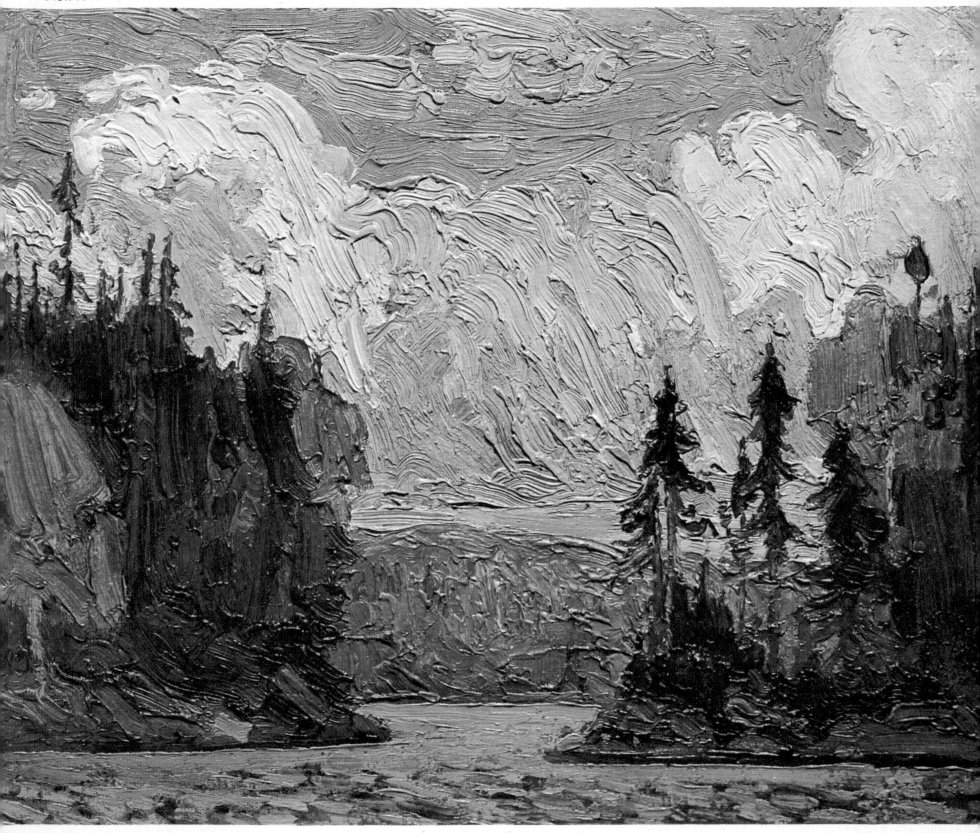

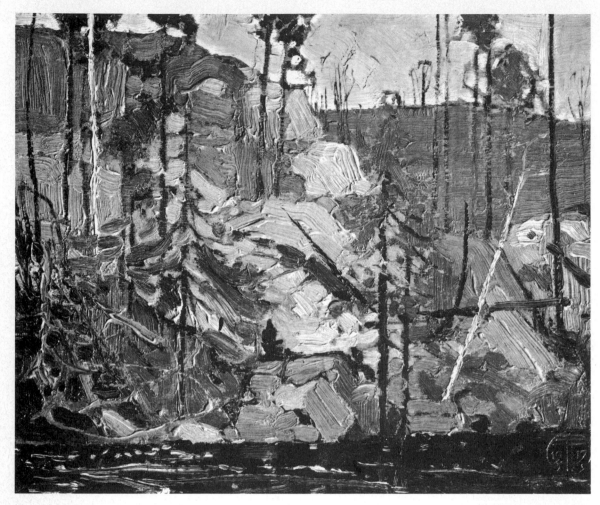

Rocks and Deep Water. 1916
8¹/₂ x 10¹/₂

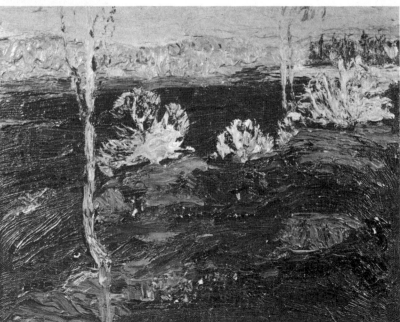

Hoar Frost. 1915
8¹/₂ x 10¹/₂

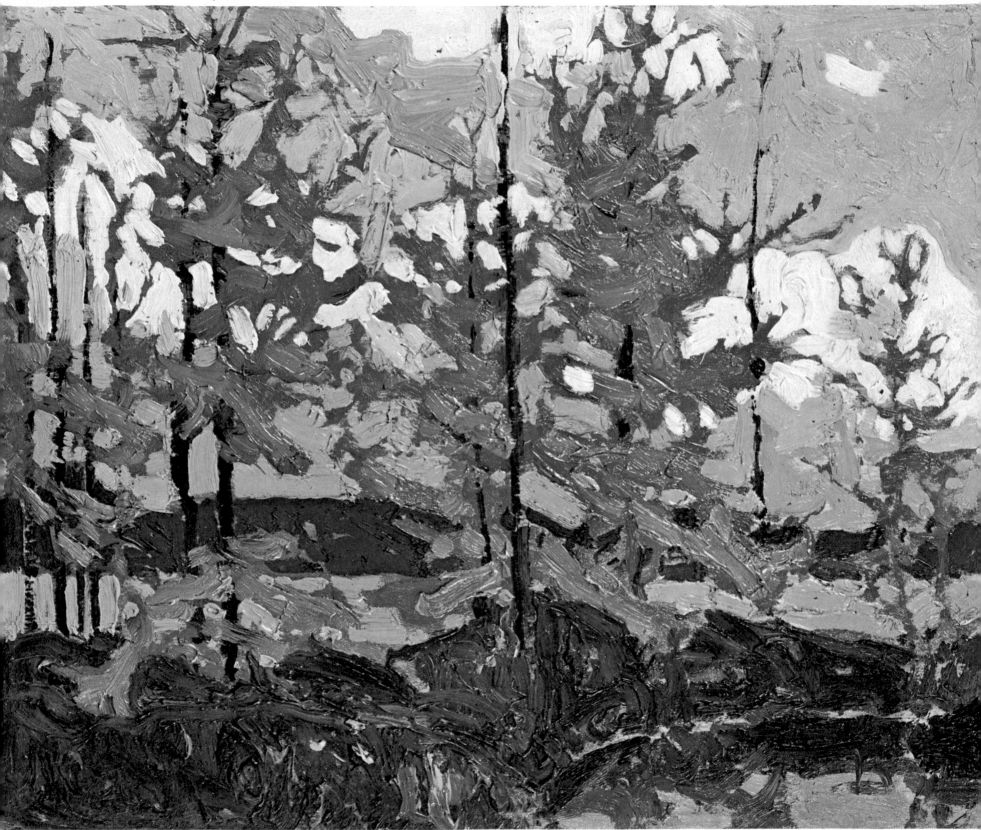

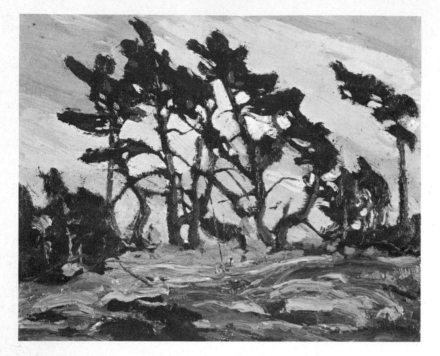

Pine Island. 1914
8¹/₂ x 10¹/₂

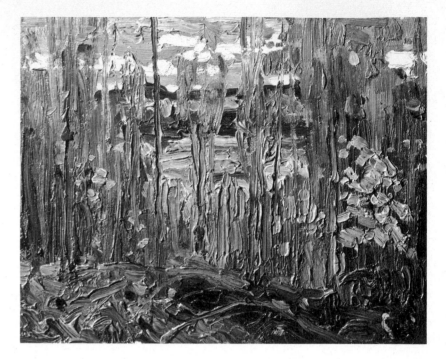

Autumn, Algonquin. 1915
8¹/₂ x 10¹/₂

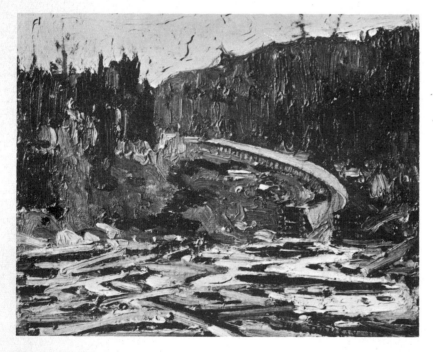

The Log Flume. 1915
8¹/₂ x 10¹/₂

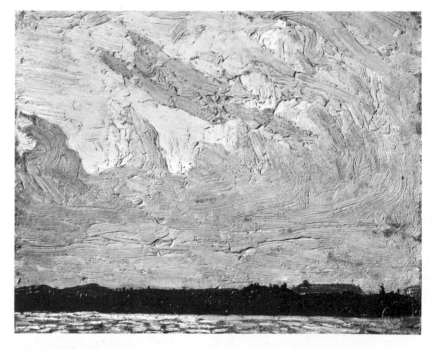

Evening Clouds. 1915
8¹/₂ x 10¹/₂

Purple Hill. 1916
8¹/₂ x 10¹/₂

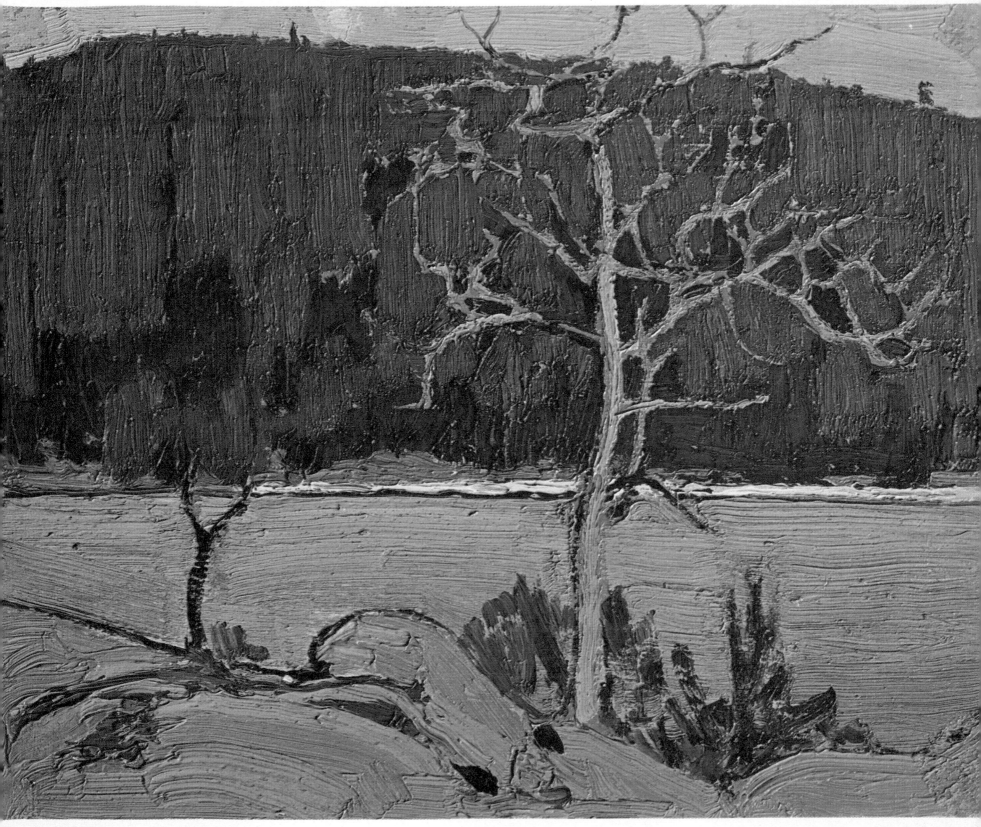

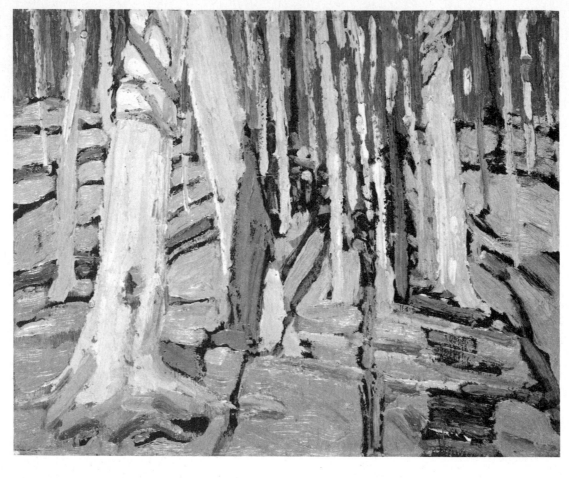

Beech Grove. 1915-16
8¹/₂ x 10¹/₂

Windy Day. 1916-17
8¹/₂ x 10¹/₂

New Life After Fire. 1914
8¹/₂ x 10¹/₂

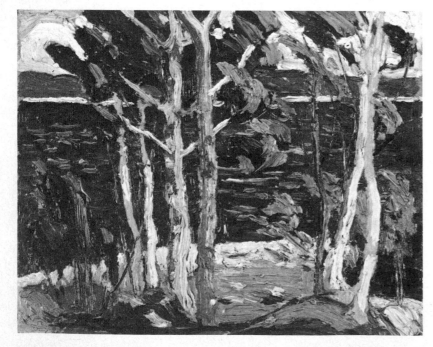

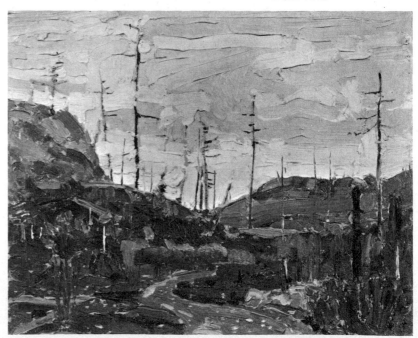

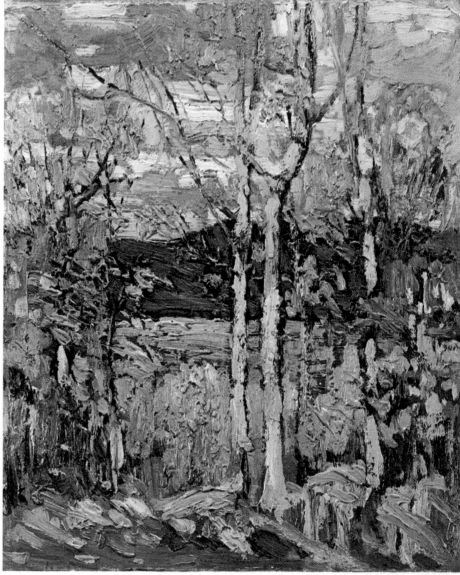

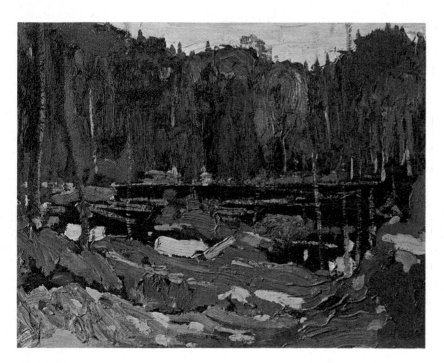

Backwater. 1915
8¹/₂ x 10¹/₂

Algonquin, October. 1915
10¹/₂ x 8¹/₂

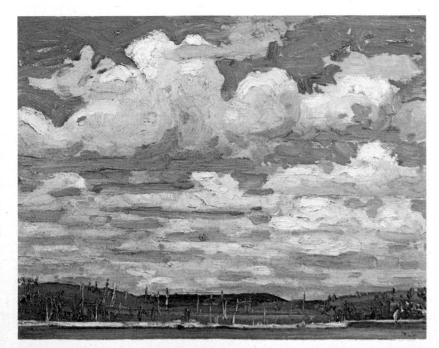

Summer Day. 1915-16
8¹/₂ x 10¹/₂

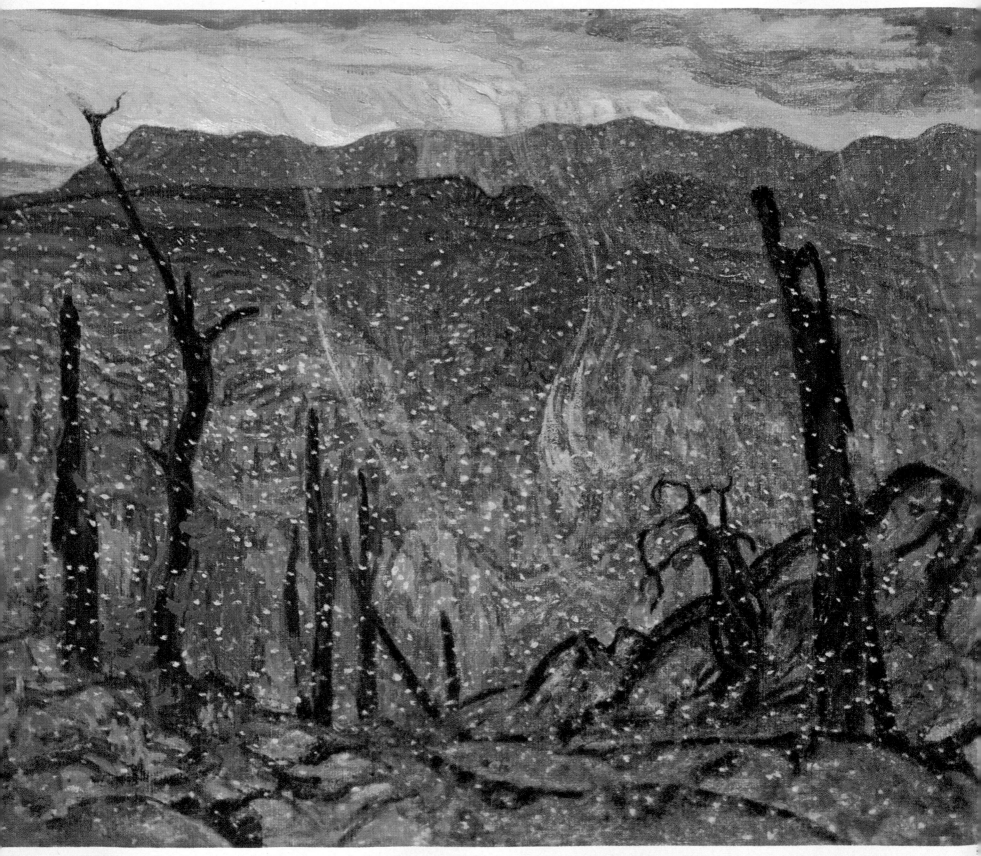

A.Y. JACKSON 1882-

The name of A.Y. Jackson has been more closely associated with the McMichael Canadian Collection than that of any other artist. Jackson encouraged and supported the creation of the Collection from its beginnings and helped formulate its early character. It was ideally fitting that, after a lifetime of travel he chose to spend his last years as an artist-in-residence at the Kleinburg gallery. There, he was available to meet and advise any of the interested public about the Group of Seven and their contemporaries. For thousands of visitors—especially schoolchildren— to the Collection, "A.Y." was a warm link with a heroic creative period of Canada's past.

The artistic Odyssey of A.Y. Jackson began in Montreal, where he studied as a young man under William Brymner, who also taught fellow Group member, Edwin Holgate. After studying and painting in Europe, he was encouraged by Lawren Harris and J.E.H. MacDonald to settle in Toronto in 1913. The next year, he took up residence with other future members of the Group of Seven in the famous Studio Building in Toronto's Rosedale Valley. Jackson remained at the Studio Building for most of his life, using it as a base from which he sojourned in his countless painting trips that covered the breadth of Canada.

Over a career of more than six decades, Jackson came to know the geographic features of this country better than any other man. He came to know it intimately from the vantage point of his sketch box, from Newfoundland to the Pacific and into the farthest recesses of the Arctic. During his wanderings, he did not forget the presence of man at the edge of the wilderness. He affectionately portrayed Quebec's pastel-hued rural villages, Ontario's northern mining towns, ice-bound Eskimo settlements and British Columbia's Indian enclaves.

Jackson's art forms a visual diary proclaiming pictorial paeans to the physical shape of his homeland. From its pages emerge the bleak Arctic tundras, the glories of Algoma autumns, the gently swelling forms of the Prairies, the rolling hills of the Laurentians, the ice-blue features of the Polar icecaps and the thrusting challenge of the Rockies. As an artist, Jackson was of necessity often a loner, but he took an infectious enjoyment in his fellow men. Wherever he went, he made new friends and admirers until, in the end, he became in the minds of most of his countrymen, the living symbol of Canadian art. In a more specific way, Jackson used his enormous energy and experience to teach and lecture between his painting journeys.

The more than 150 works in the McMichael Canadian Collection present an unrivalled survey of A.Y. Jackson's art from its beginnings. Here are to be seen all of the gradual stylistic progressions that marked his career from the delicate water-colour, *Elms and Wildflowers* of 1902, to drawings of Newfoundland executed half a century later. Among his oils done early in this century are the subtle impressionist panel of *Venice*, 1908 and the canvas *Sand Dunes, Etaples* of 1912. From this same formative period, the McMichael Canadian Collection includes some unexpected subjects by Jackson. *The Parlour* of 1910 is an interior study of Jackson's aunt's home in Berlin, Ontario, now Kitchener. In the background of this painting may be seen the Dutch masterpiece, *Incredulity of St. Thomas*, by the seventeenth-century artist, Hendrick Terbrugghen, which now hangs in the Rijksmuseum in Amsterdam. Two other unusual early compositions are a still life of *Dahlias* and *Figure Against the Sky*, both painted in 1913. From that period on, with the exception of the witty self-portrait *Père Raquette*, Jackson appears in the collection as the great painter of the Canadian landscape so familiar to every Canadian.

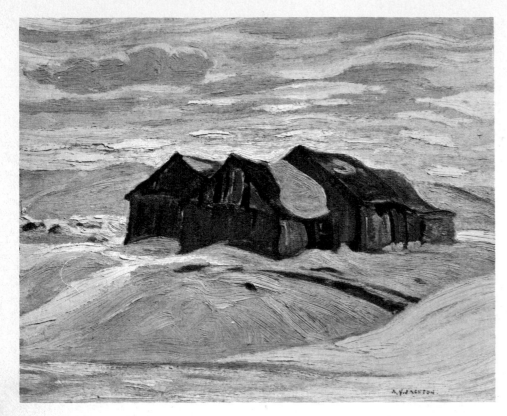

Barns. 1926
8½ x 10½

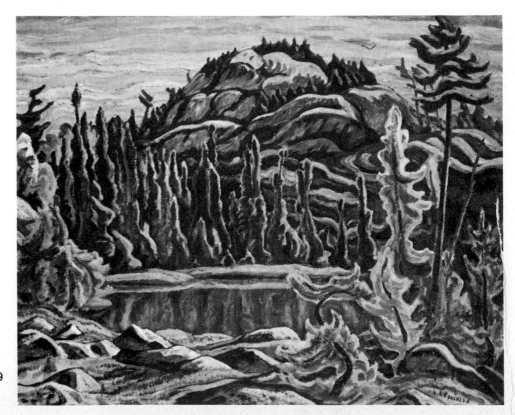

Sunlit Tapestry. 1939
28 x 36

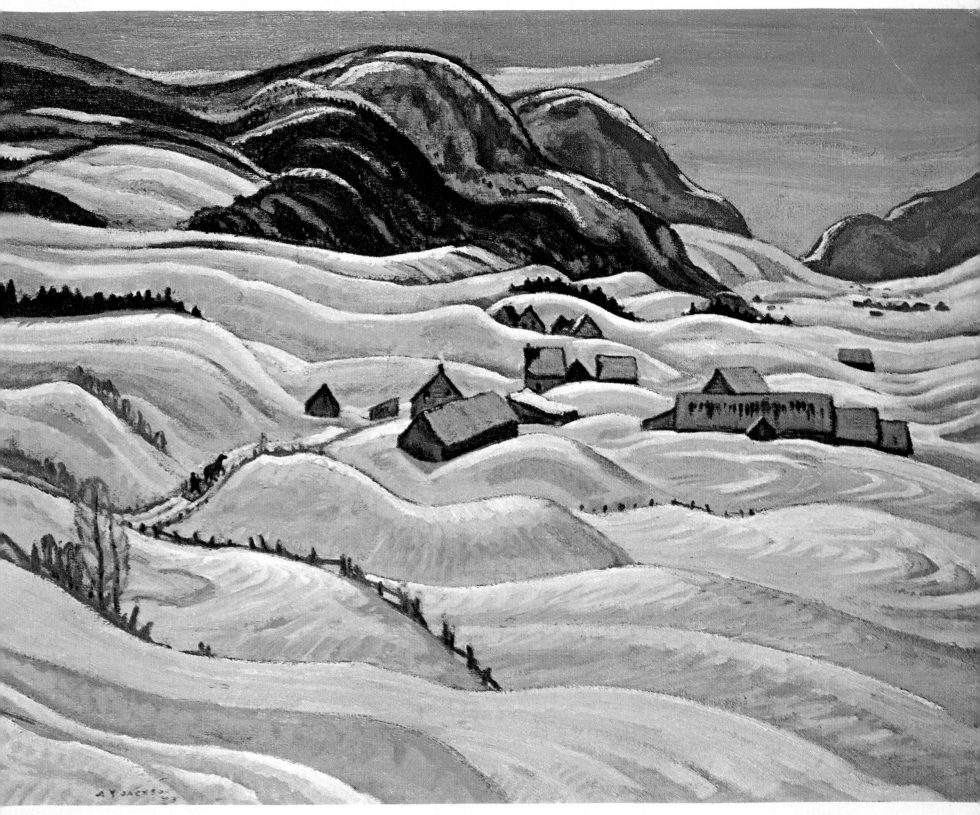

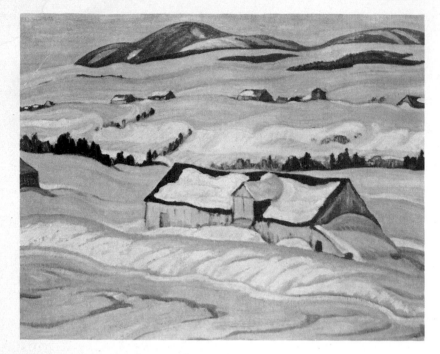

Winter Morning, St. Tite des Caps. 1934
21 x 26½

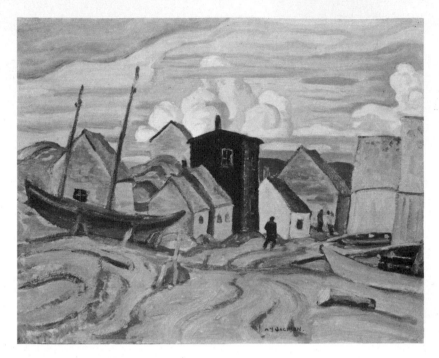

Village, Cape Breton. 1936
10½ x 13½

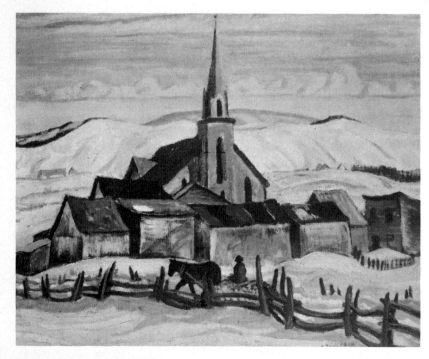

Church at St. Urbain. 1931
21 x 26

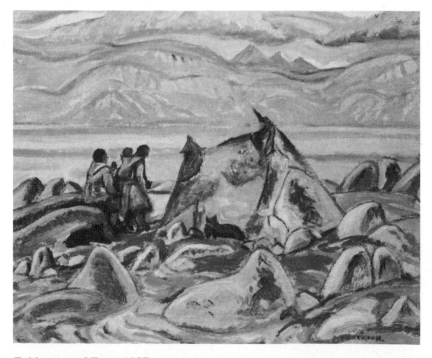

Eskimos and Tent. 1927
8½ x 10½

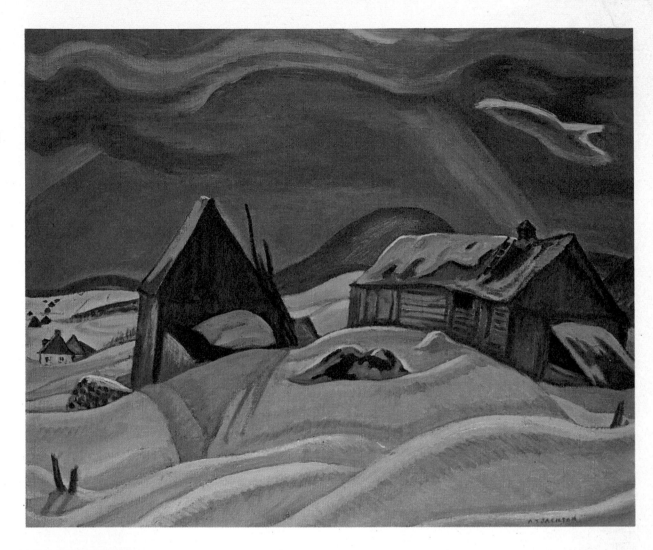

Grey Day, Laurentians. 1933
21 x 26

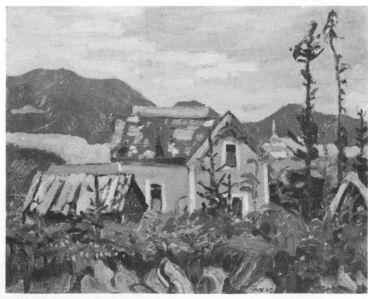

Indian Home. 1926
8¹/₂ x 10¹/₂

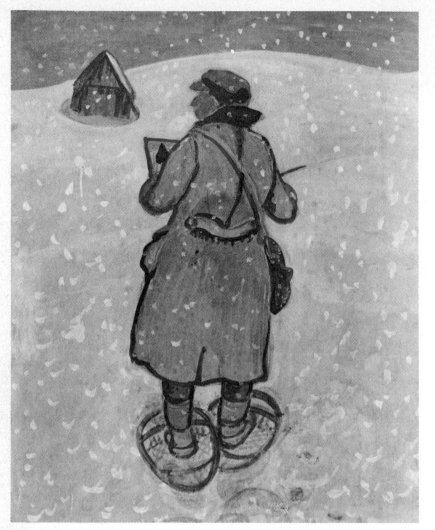

Père Raquette. 1921
31 x 25

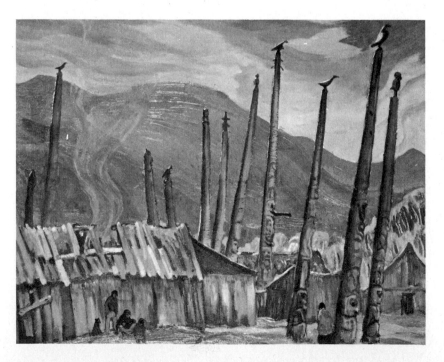

Skeena Crossing. 1926
21 x 26

The Red Maple. 1914
8¹/₂ x 10¹/₂

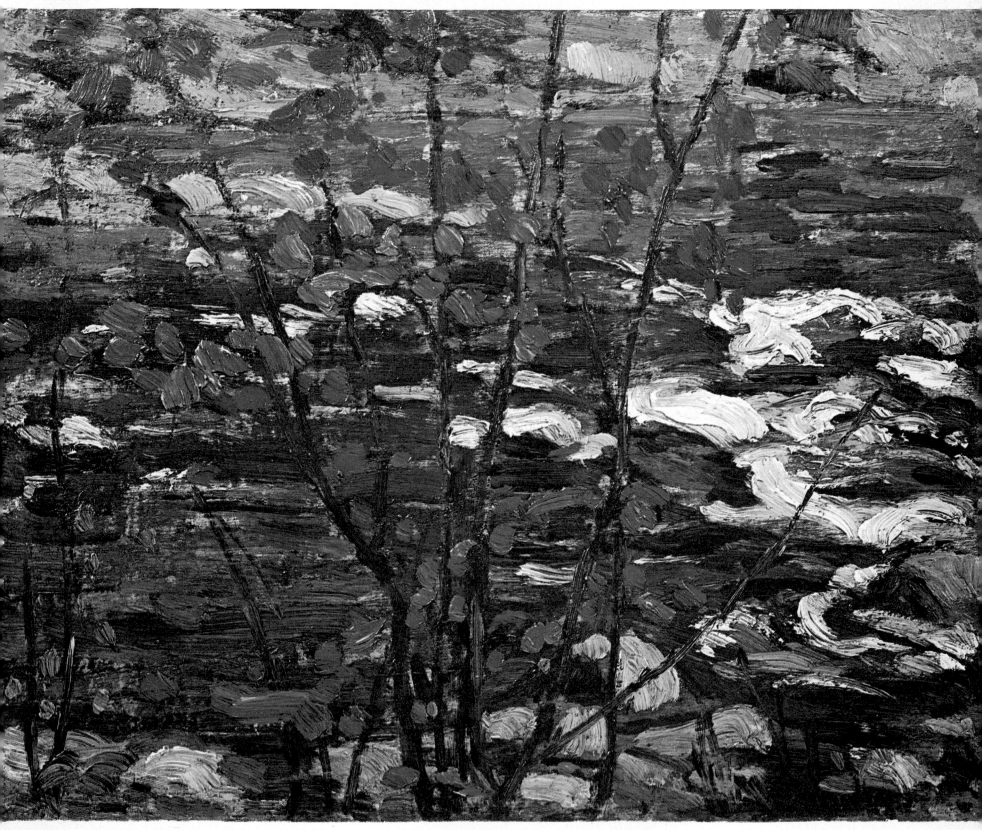

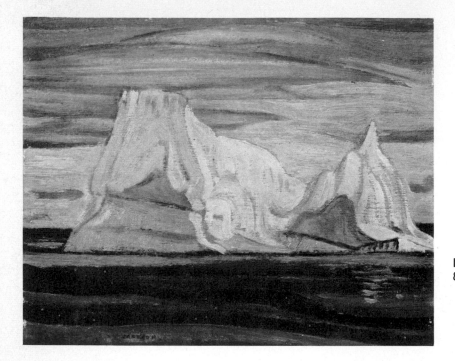

Iceberg, at Godhaven. 1930
$8^{1}/_{2}$ x $10^{1}/_{2}$

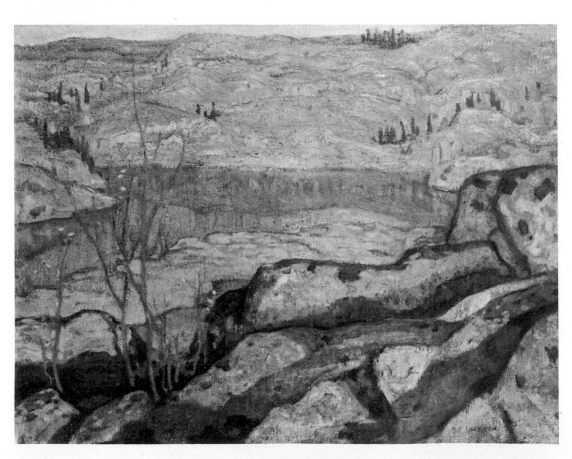

Lake in the Hills. 1922
$24^{1}/_{2}$ x 32

Nellie Lake. 1933
31½ x 29½

A. Y. JACKSON

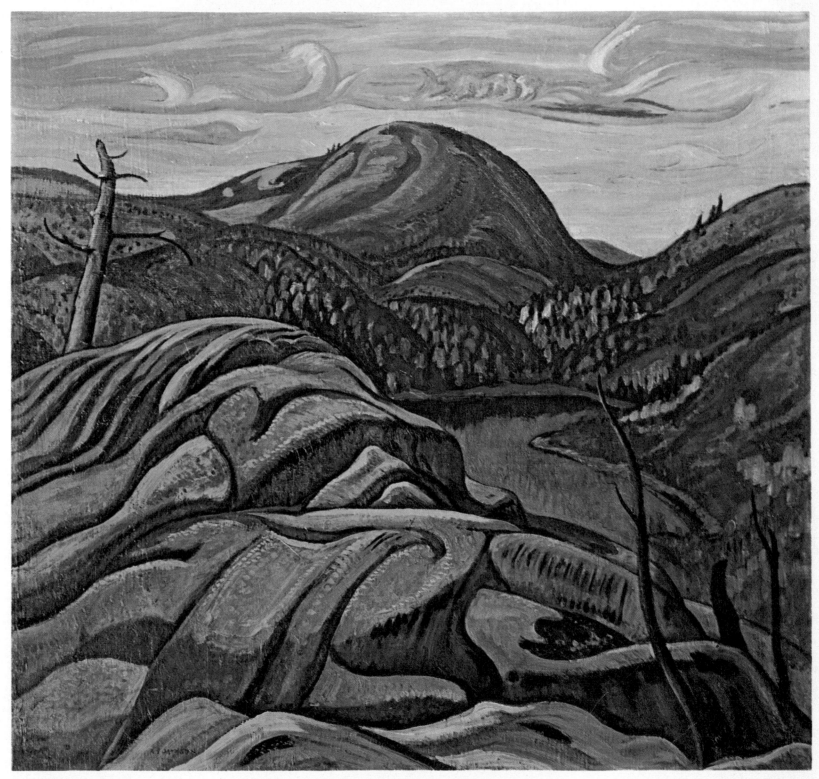

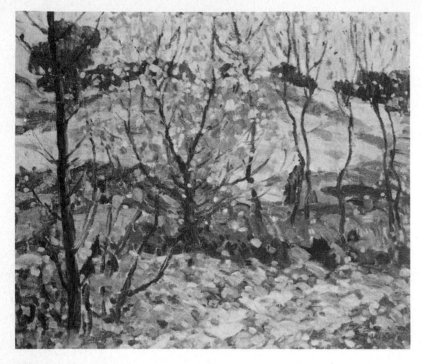

Sand Dunes, Etaples, France. 1912
$21^1/_2$ x $25^1/_2$

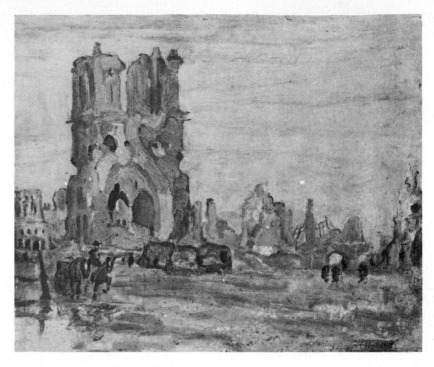

Cathedral at Ypres. 1917
$8^1/_2$ x $10^1/_2$

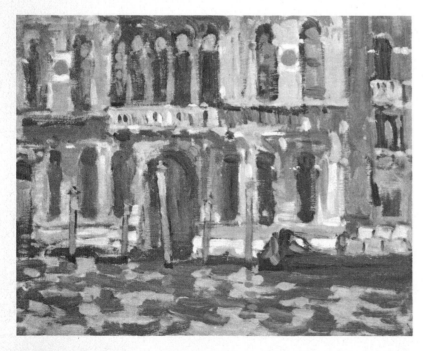

Venice. 1908
$8^1/_2$ x $10^1/_2$

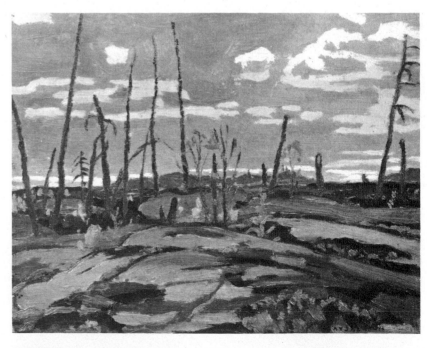

October, Lake Superior. 1923
$8^1/_2$ x $10^1/_2$

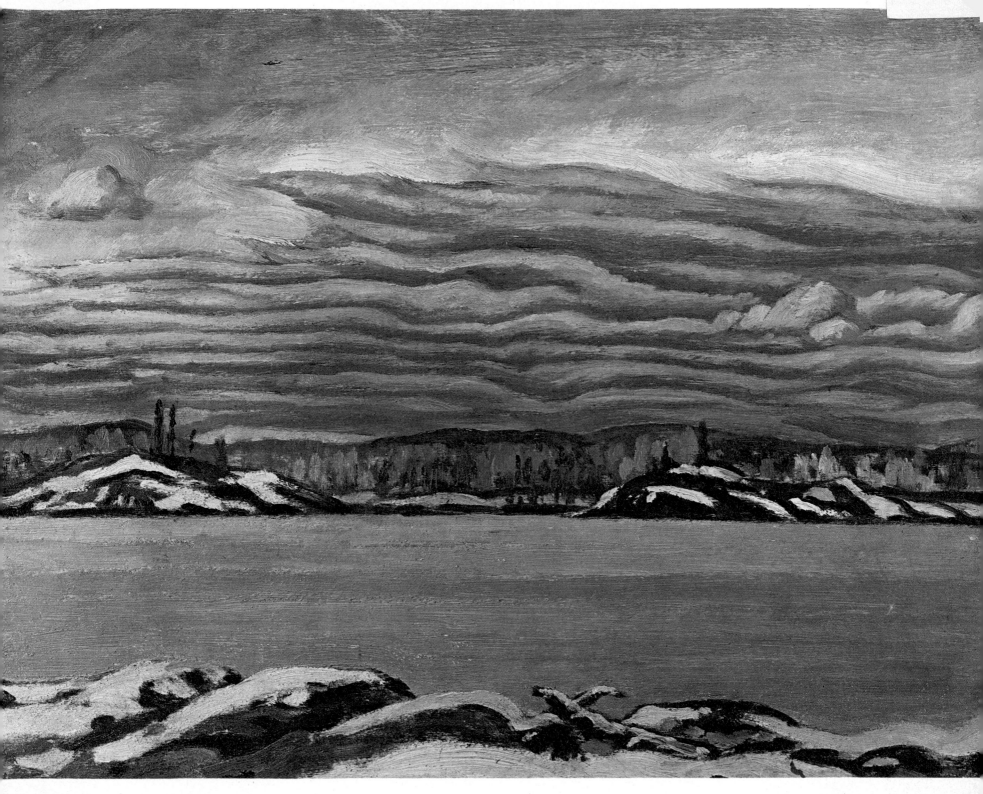

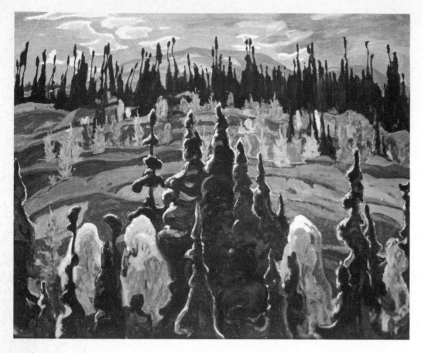

Above Lake Superior. 1924
46 x 58

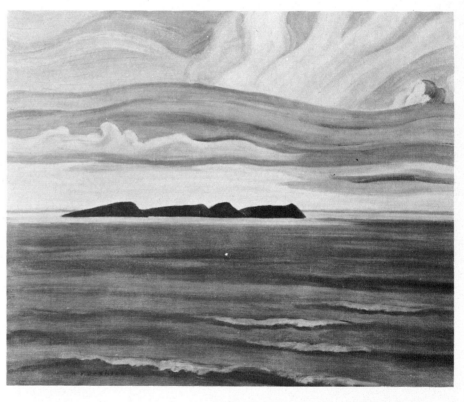

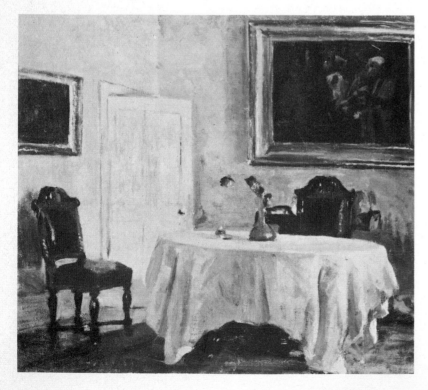

The Parlour. 1910
14 x 16

Superstition Island, Great Bear Lake. 1950
21 x 26

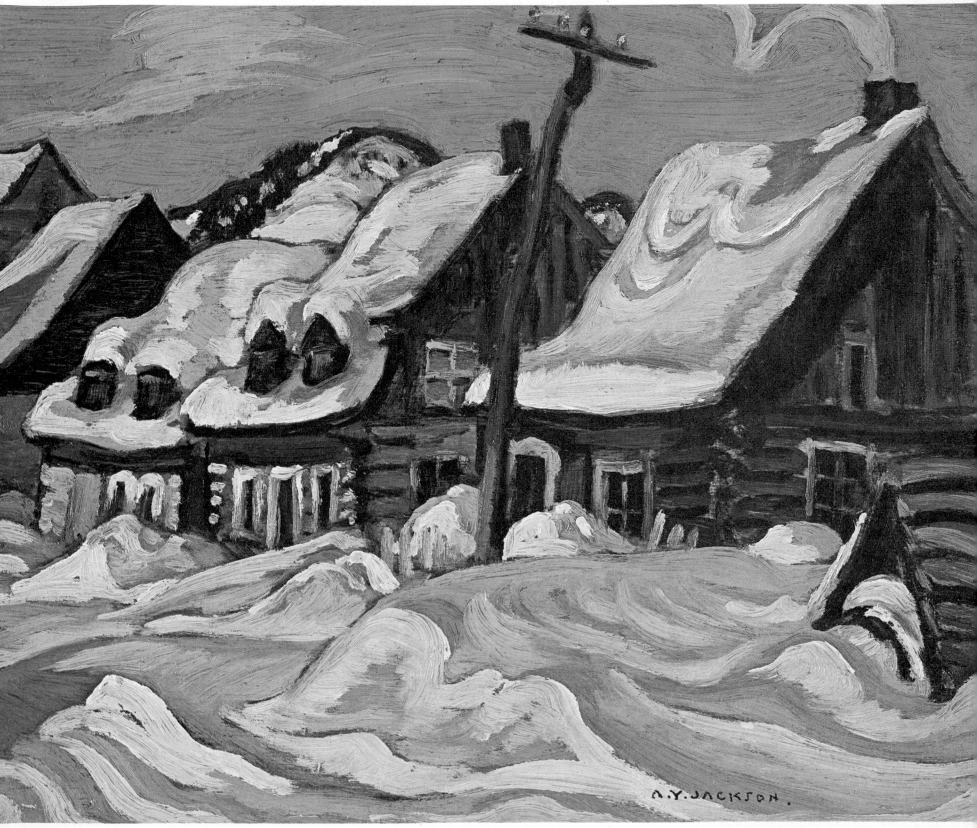

Houses, St. Urbain. c. 1934
8¹/₂ x 10¹/₂

A.Y. JACKSON.

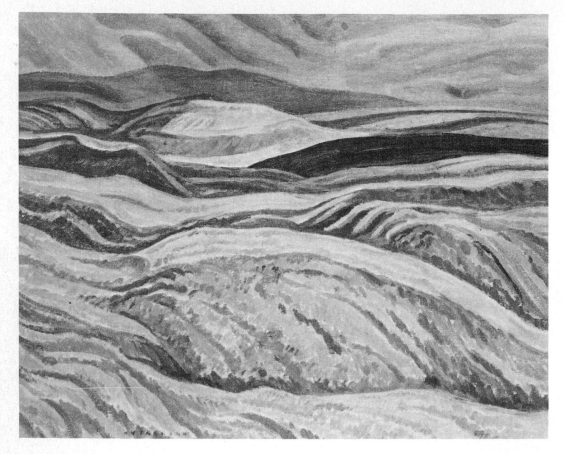

Alberta Foothills. 1937
25 x 32

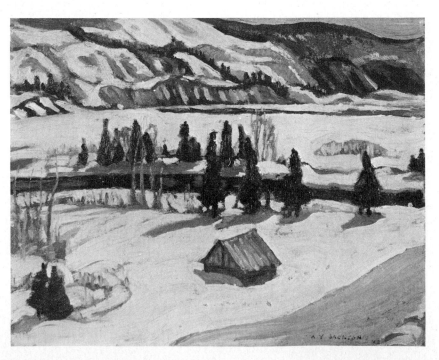

River, St. Urbain. 1930
8½ x 10½

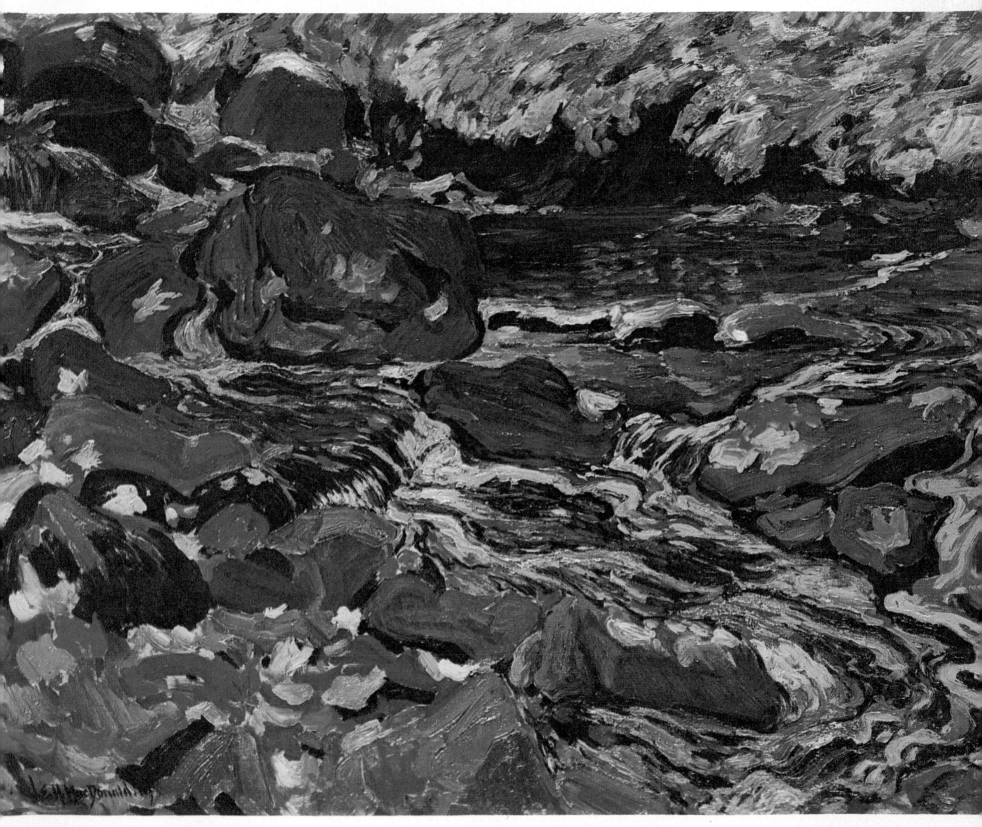

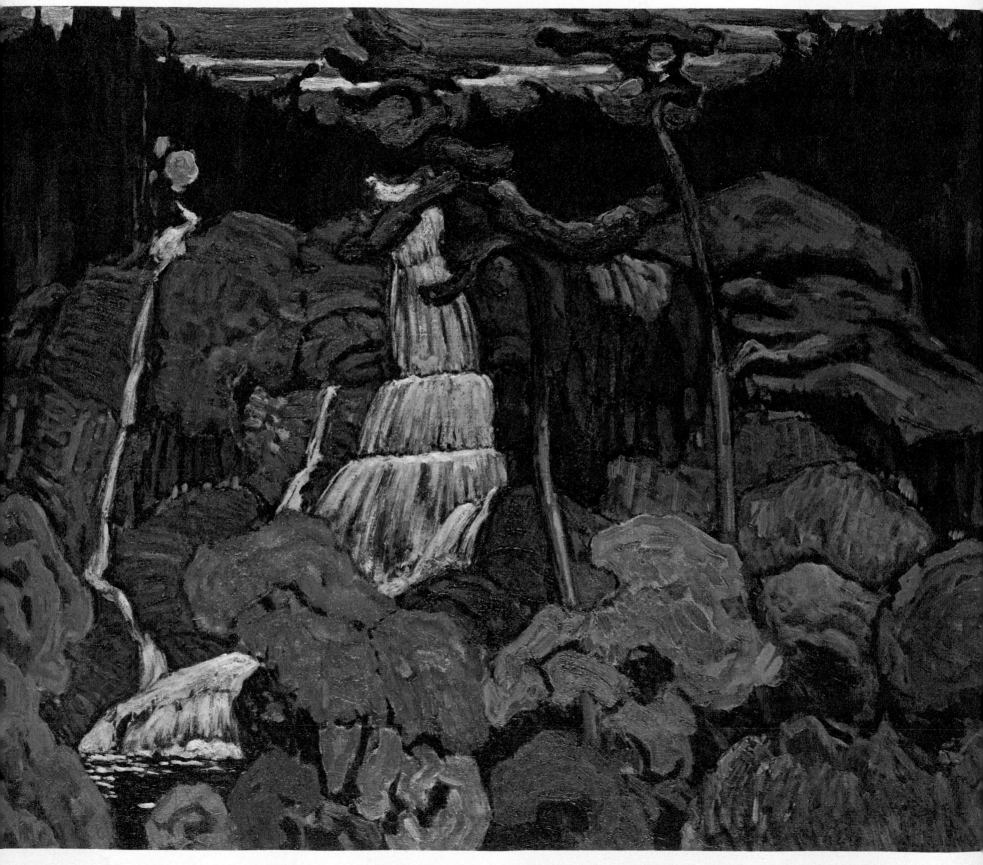

J.E.H. MacDONALD 1873-1932

No Canadian landscape painter possessed a richer command of colour and pigment than J.E.H. MacDonald. His finest achievements weave together glowing pigment, brushwork and design into tapestry-like compositions. The best of these are now familiar touchstones of Canadian culture.

MacDonald was known to his fellow-artists as a gentle, reserved man, yet his paintings are among the most powerful by the Group of Seven and present the most commanding orchestrations of colour. MacDonald could merge surprising combinations of oranges, reds, greens and violets together with dramatic and controlled effect. His early skills as a draughtsman enabled him to join brilliant drawing to his singular colour sense. His actual brushwork is at once disciplined and vigorous. His best on-the-spot sketches possess an intensity and freshness of execution not dissimilar from Van Gogh.

MacDonald began his career as a commercial designer and in that capacity met Tom Thomson and encouraged the younger artist to paint landscapes. MacDonald was undoubtedly the biggest single influence upon Thomson. From his earliest years, MacDonald was a natural teacher, eager to share his knowledge, enthusiasm and experience. Many painters benefited from his instruction and the last ten years of his life were devoted to teaching at the Ontario College of Art. He was principal of the College when he died in 1932.

In 1909, MacDonald was one of the first to paint in Northern Ontario. His early impressions of that period are muted, almost monochrome studies. In the following years, he was laying the disciplined groundwork for such blazing outbursts of colour as *The Tangled Garden* of 1916, a *tour de force* of hue and texture that represented a revolution in Canadian painting. MacDonald usually reserved his rebel statements to paint itself, a medium which he knew could speak more eloquently for him than words. When MacDonald did write for publication, it was usually lyric poetry and a number of these were collected together in the volume *West By East*, illustrated by his son, Thoreau.

MacDonald travelled less frequently than many other members of the Group of Seven. His obligations as a commercial artist and later as a teacher limited his sketching journeys. Of all the places he did visit, the Algoma area of Northern Ontario inspired him the most. What Mont Ste. Victoire was to Cezanne or Arles to Van Gogh, Algoma was to MacDonald. It represented for him a landscape talisman that brought forth his most complete creative response. In Algoma, his art reached its zenith. In brief trips to the area in 1918 and 1919, he amassed the brilliant sketches from which he composed such unforgettable masterpieces as *The Solemn Land, Leaves In The Brook, Autumn In Algoma, Falls On The Montreal River, Algoma Waterfall* and *Forest Wilderness*.

In the McMichael Canadian Collection, MacDonald is represented by several famous canvases and an unrivalled selection of his oil sketches, on panel. Among his major works on view is the great close-up composition, *Leaves In The Brook* and the magnificent, panoramic *Forest Wilderness*, originally in the R.S. McLaughlin Collection. These two works are rivalled in textural and chromatic richness by *Algoma Waterfall*, painted at the same period. The later, more restrained, mountain phase of MacDonald's art is well represented by *Goat Range, Rocky Mountains*, of 1932. MacDonald's small, on-the-spot sketches rival Thomson's in their variety, richness of colour and technical dexterity. Each one of these marvelous small creations is a complete painting in itself. Although many did serve as models for later studio canvases, MacDonald clearly considered his sketches totally realized impressions at the time of their execution.

Buckwheat Field. 1923
8½ x 10½

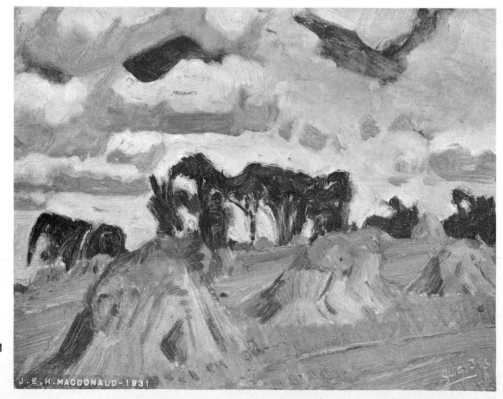

Wheatfield, Thornhill. 1931
8½ x 10½

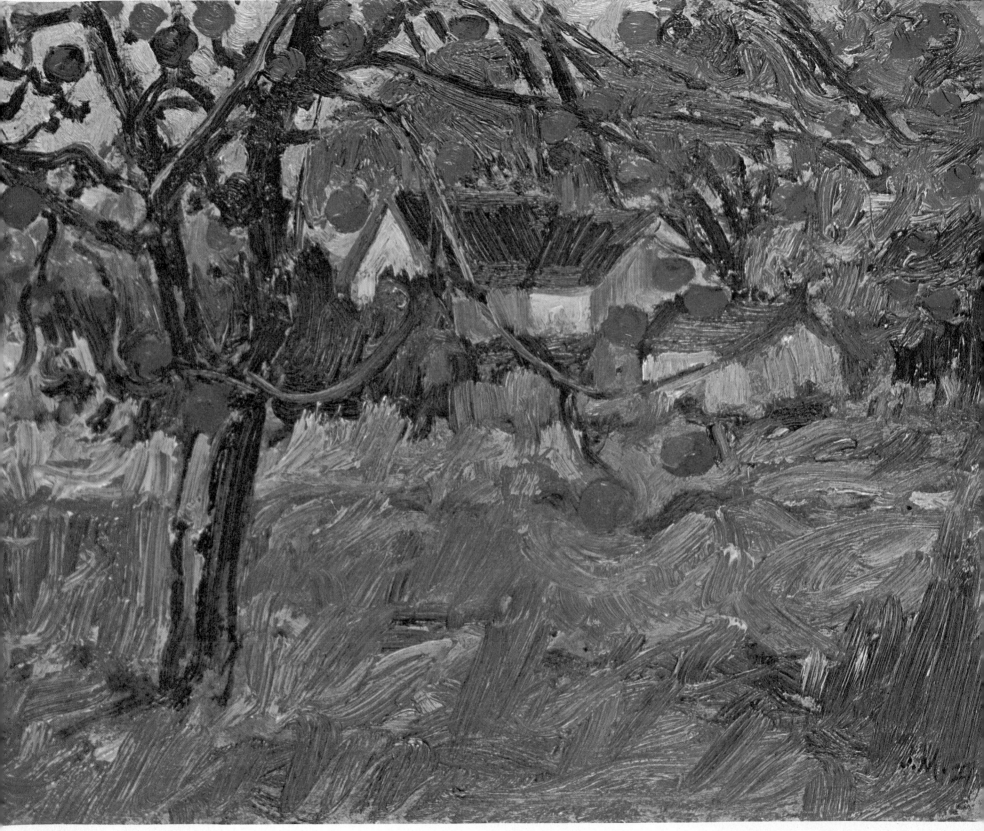

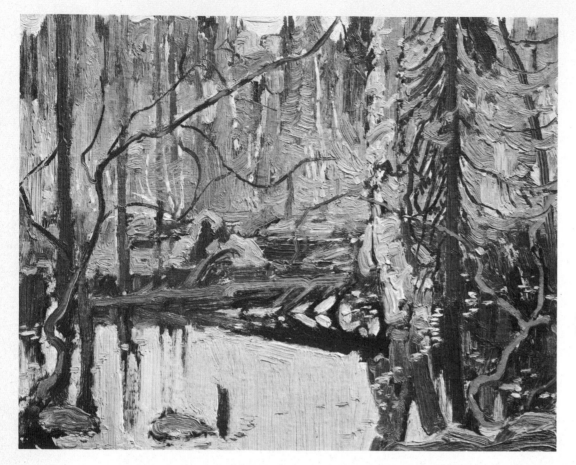

Silver Swamp, Algoma. 1919
8¹/₂ x 10¹/₂

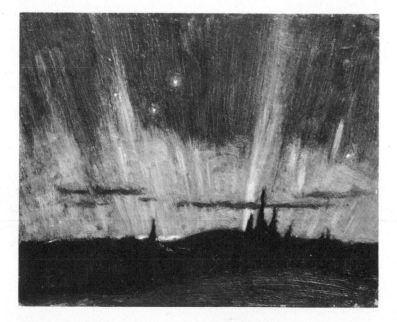

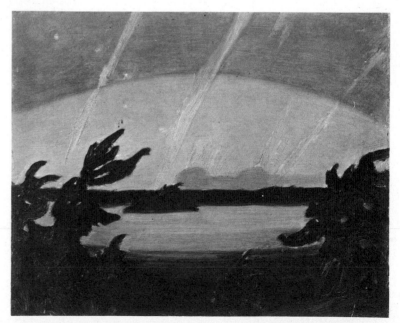

Northern Lights. 1916
8 x 10

Aurora. 1931
8¹/₂ x 10¹/₂

Forest Wilderness. 1921
48 x 60

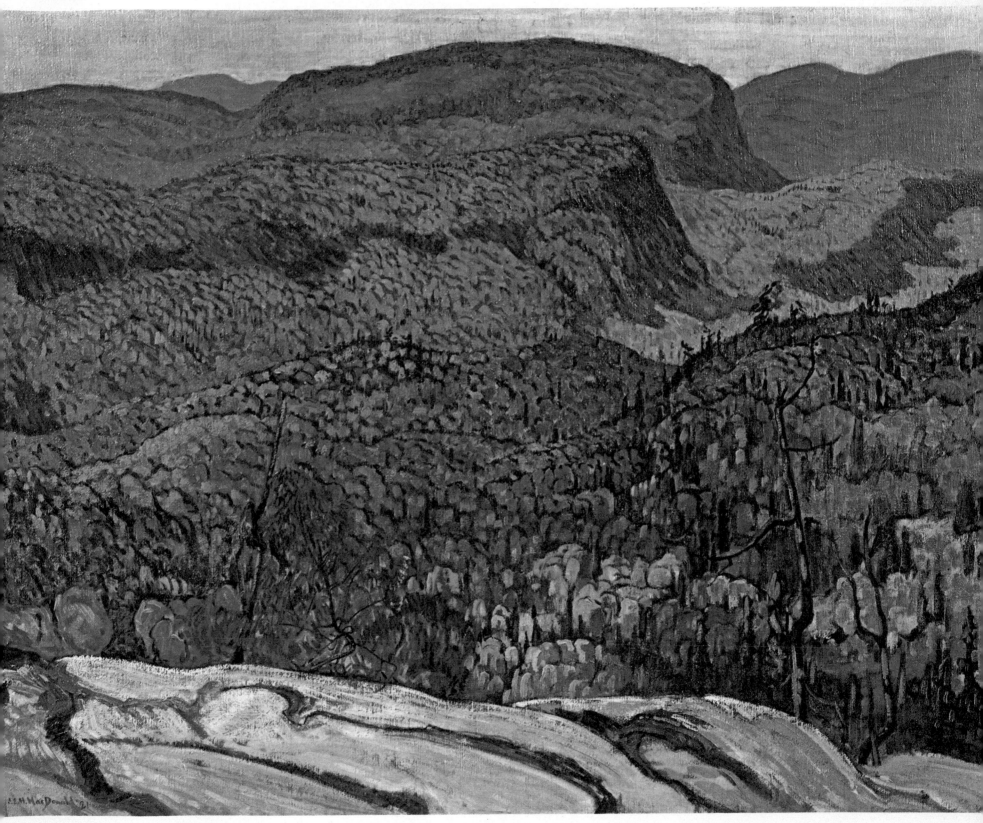

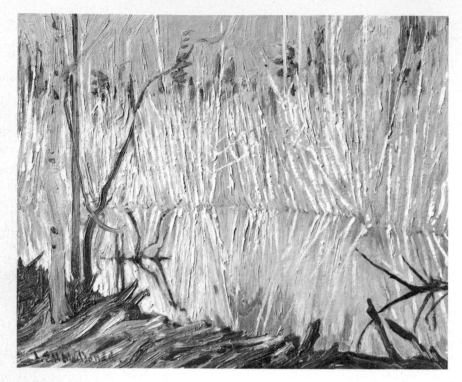

Beaver Dam and Birches. 1919
8¹/₂ x 10¹/₂

Autumn, Algoma. 1918
8¹/₂ x 10¹/₂

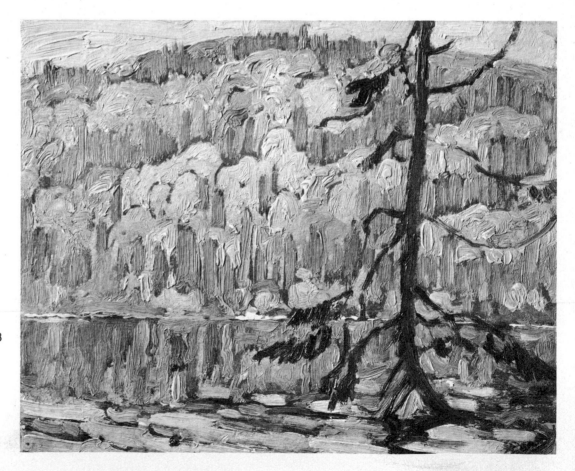

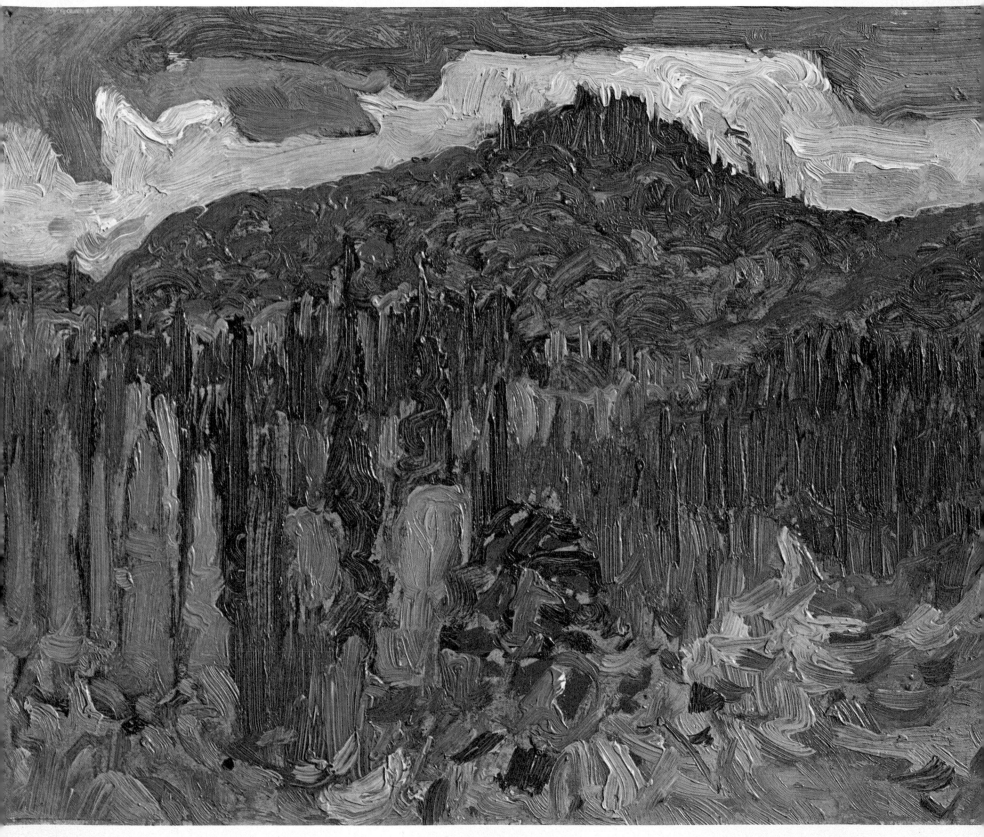

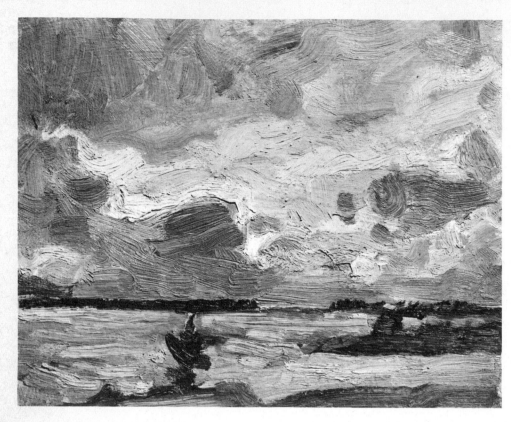

Wild Ducks. 1916
8 x 10

Lichen Covered Shale Slabs. 1930
8½ x 10½

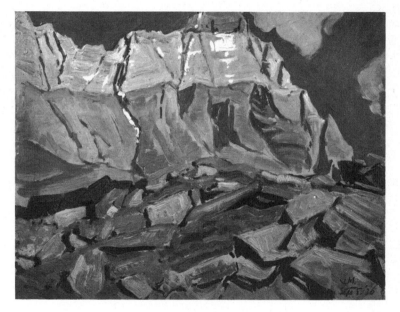

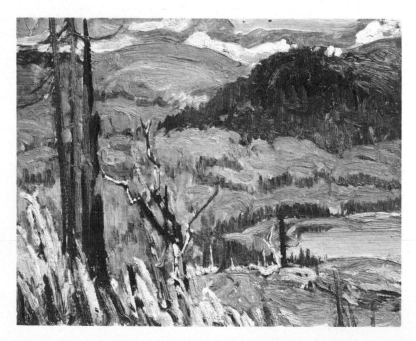

Agawa Canyon. 1920
8½ x 10½

Young Maples, Algoma. 1920
8¹/₂ x 10¹/₂

J. E. H. MacDONALD

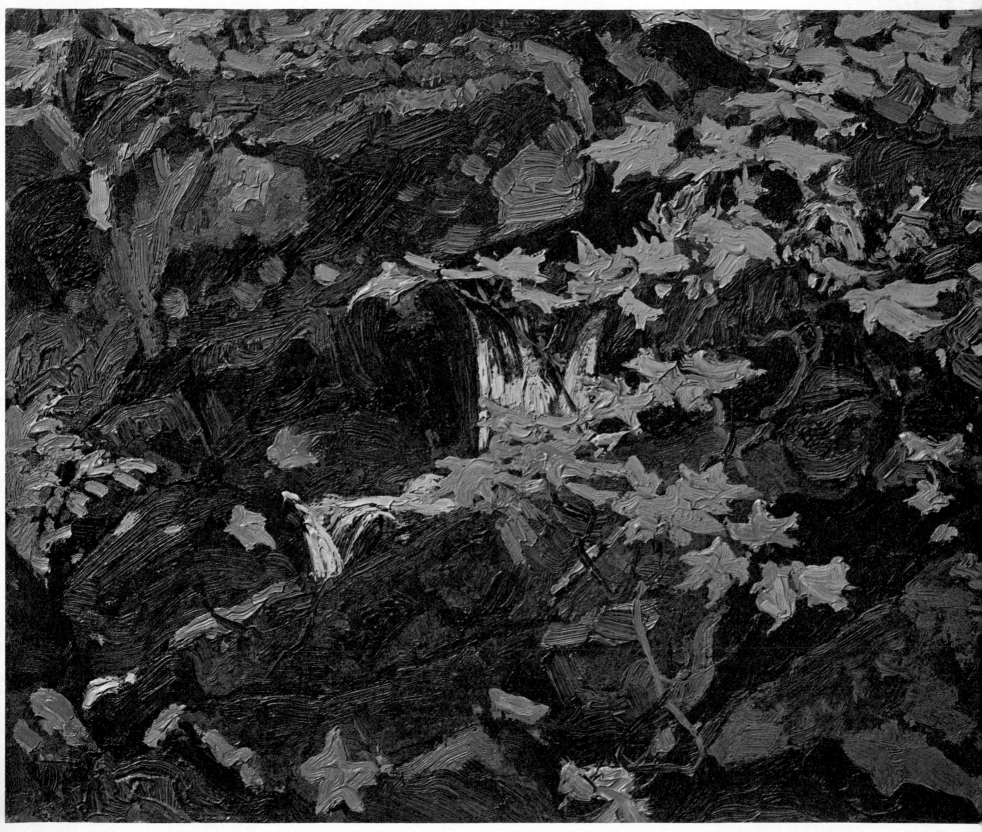

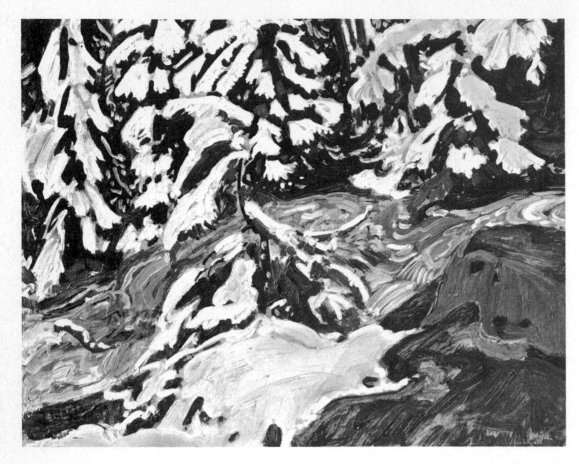

Mountain Stream. 1928
8¹/₂ x 10¹/₂

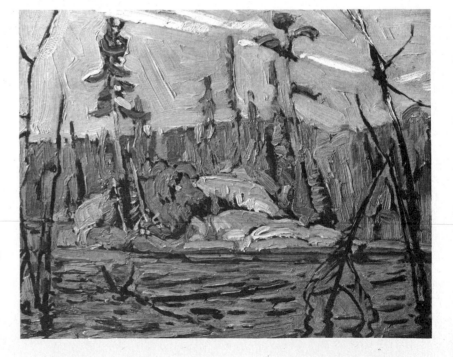

Moose Lake, Algoma. 1919
8¹/₂ x 10¹/₂

Goat Range, Rocky Mountains. 1932
21 x 26

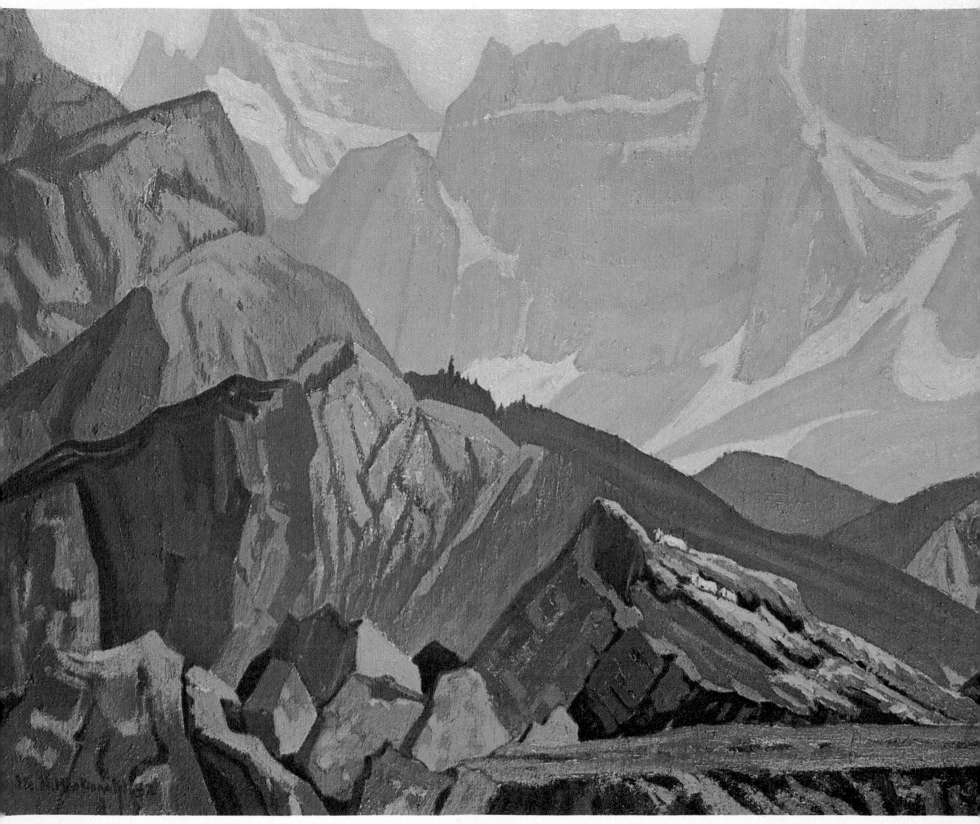

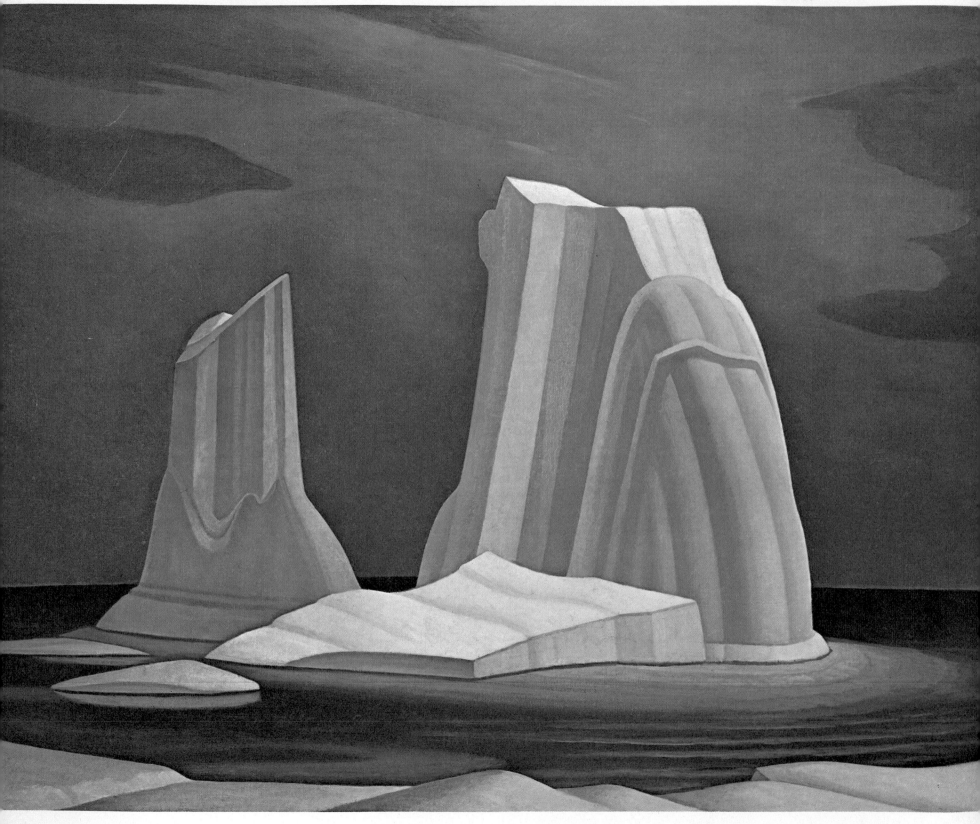

LAWREN HARRIS

1885-1970

Lawren Harris was the prime leader of Canadian art for many decades. He was the main force that brought together and joined the varying talents and temperaments which formed the Group of Seven. For many years after the disbanding of the Seven, he remained a powerful force in Canadian painting, aiding and encouraging Emily Carr and a host of younger artists. He was also a founder of the now famous Canadian Group of Painters, which succeeded the Group of Seven in 1933.

Harris was a constant experimenter. He did not hesitate to launch into a new style when he was convinced that he had completely explored the one preceding. No painter of his country approached the variety of pictorial expression commanded by Harris. Throughout a long lifetime of searching, his work passed through five major periods—ranging from the impressionistic Toronto "house" paintings of the early 1900's, through richly pigmented, tapestry-like landscapes of Algoma, dramatically designed compositions of the North Shore of Lake Superior, the blue and white crystal-like compositions of the Arctic and the Rockies, to his last phase of total abstraction.

Born in Brantford, Ontario, in 1885, Harris' career took him to Toronto, Massachusetts, New Mexico and Vancouver; but wherever he went Harris held firm to his dedication to the native Canadian outlook he first stated in the catalogue of the 1920 Group of Seven exhibition: "The group of seven artists whose pictures are here exhibited have for several years held a like vision concerning art in Canada. They are all imbued with the idea that an art must grow and flower in the land before the country will be a real home for its people."

Harris' paintings have indeed helped make Canada a real spiritual home for millions of its people. His vision was primed for the far horizons of his own country, and he had need to nurture his eyes on its open spaces. He made several trips to Europe, but each time he returned home complaining that "everything was too close." He recognized the supreme traditions of European art, but his own pressing desire was to create something individual and fresh. In his finest works he achieved that goal magnificently.

It would be difficult to visualize a richer representation of Lawren Harris' varied styles than can be seen in the McMichael Canadian Collection. His career began with a series of almost sombre landscapes painted in 1910 and 1911, mostly of the environs of Toronto. These undistinguished early efforts were followed by works done on trips to the Laurentians, Algonquin Park and Georgian Bay in 1912, when he emerged as a painter with a developing style of his own. The resonant gold and brown Laurentian studies is typified in the Collection by *Laurentians* 1912. From the same year come his *Algonquin Park Sunburst* and *Old Houses Toronto*. In the years between 1912 and 1920, Harris portrayed his houses and landscapes in heavy tapestry-like paint textures. Among the brilliant sketches from this period on view are *Algoma Woodland* 1919, *Beaver Dam* 1919, *Montreal River* 1920 and *Red Maples* 1920.

Of Harris' monumental blue and white phase which began in the early 1920's, the Collection owns many masterpieces, including *Pic Island* 1923, *Lake Superior Island* 1923, *Mt. Lefroy* 1930, *Mountains and Lake* 1929 and *Lake and Mountains* 1927. The superb Arctic paintings of 1930 include *Eclipse Sound and Bylot Island*, *Ellesmere Island* and the monumental *Icebergs, Davis Strait*. These Arctic works of 1930-31 seem an inevitable extension of his Lake Superior and Rocky Mountain experiences. From unpopulated lands of rock he moved into a scene even more remote where there was almost no land, only floating ice and sky and water.

The Arctic voyage and the pictures resulting from it virtually brought Harris' career as a landscape painter to a close and ushered in his period of non-objective art.

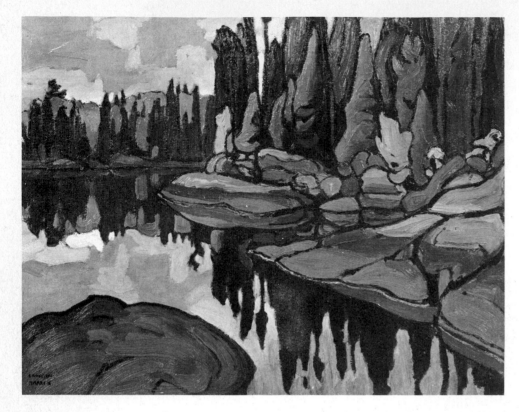

Algoma Reflections. 1919
$10^3/_8 \times 13^1/_2$

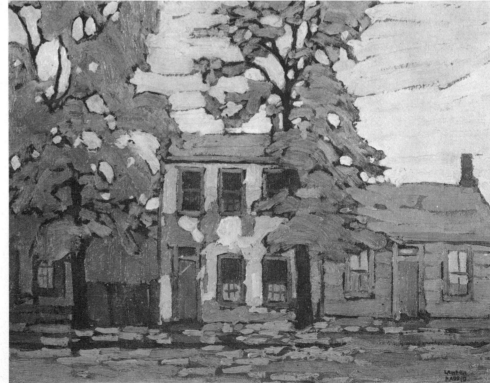

Early Houses. 1913
10 x 12

Mt. Lefroy. 1930
52¹/₄ x 60³/₈

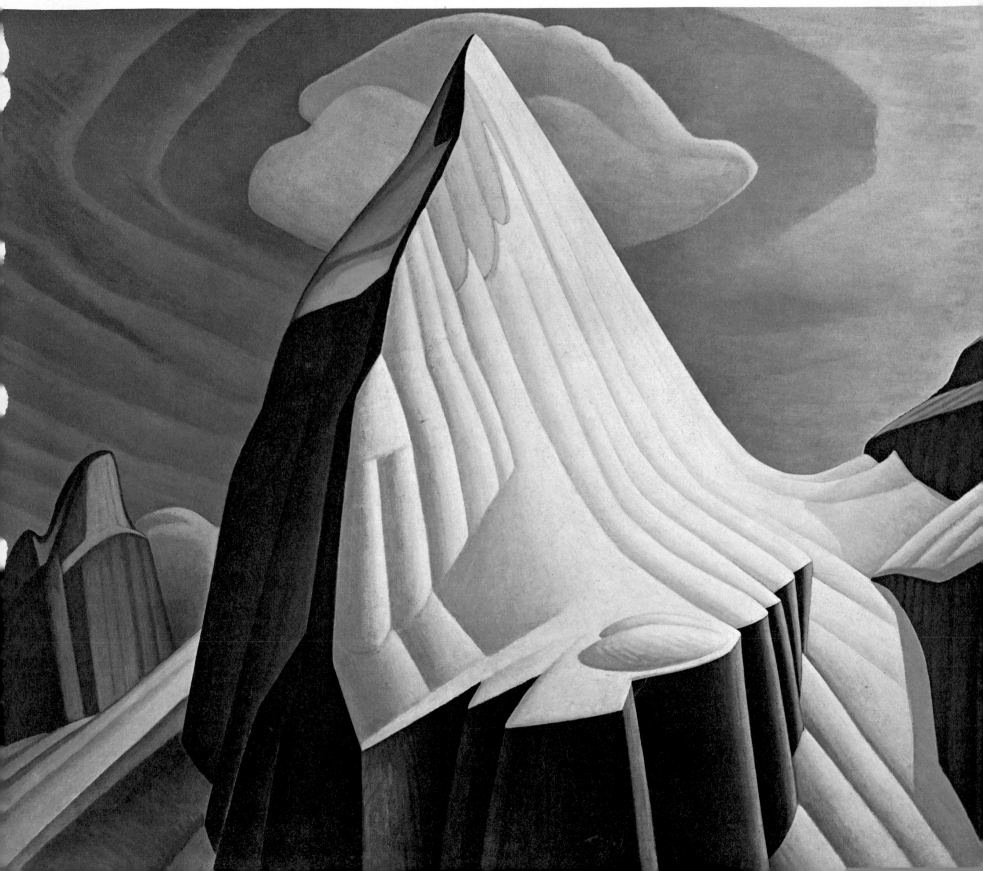

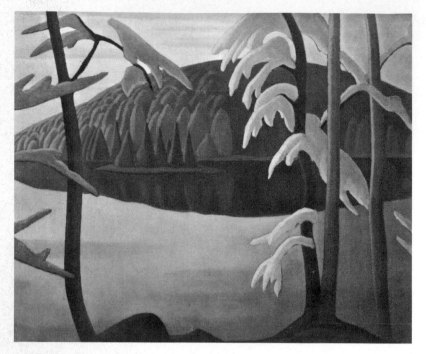

Northern Lake. c. 1923
32 x 40

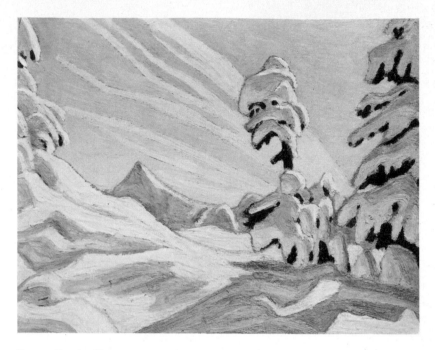

Snow, Rocky Mountains. 1925
$10^{1}/_{2}$ x $13^{7}/_{8}$

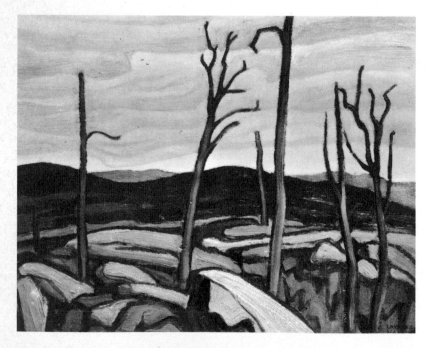

Country North of Lake Superior. 1921
$10^{1}/_{4}$ x $13^{5}/_{8}$

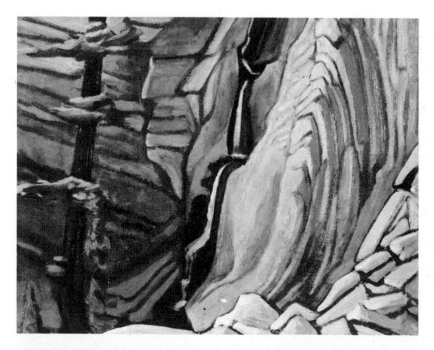

Algoma Canyon. 1923
$11^{3}/_{4}$ x $14^{5}/_{8}$

The Ice House. 1923
12 x 15

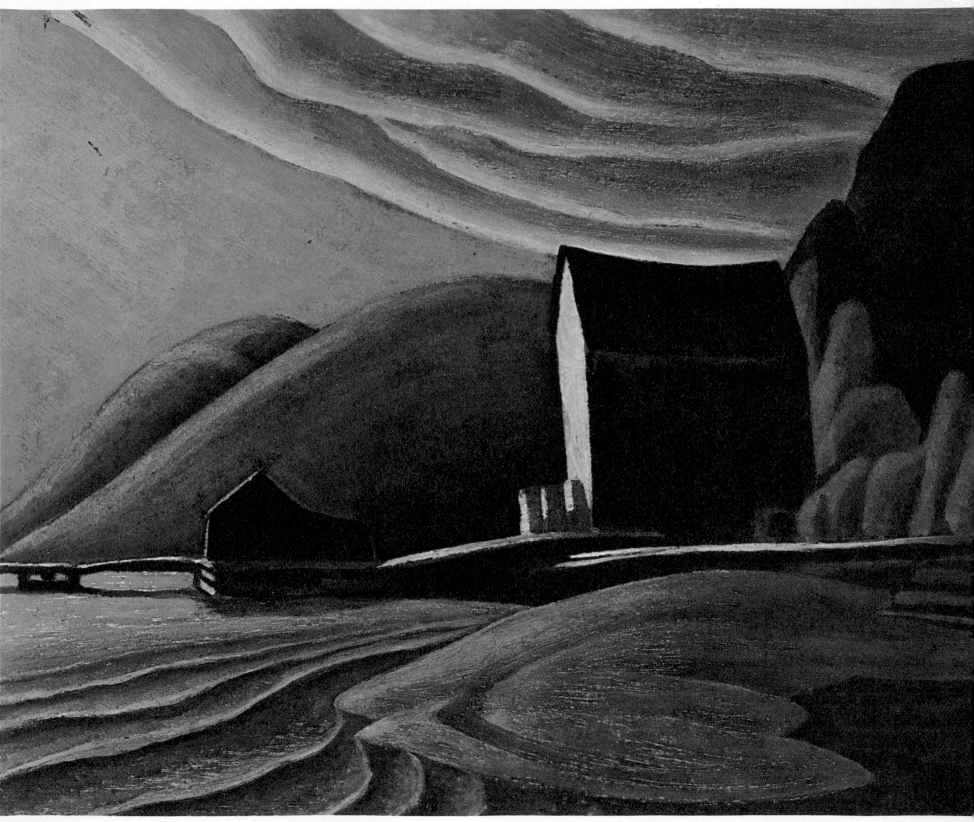

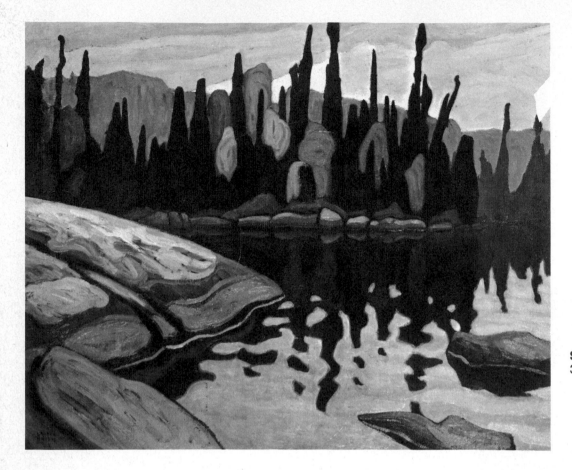

Shimmering Water, Algonquin Park. 1922
32 x 40

Newfoundland Coast. 1921
10$^{1/2}$ x 13$^{5/8}$

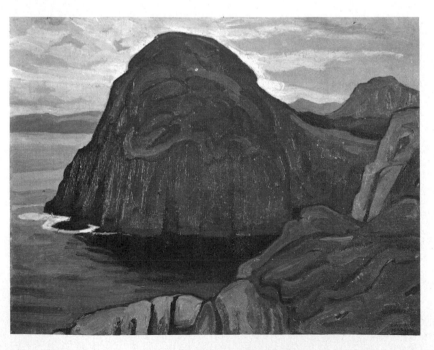

Mountains and Lake. 1929
35³/₄ x 44¹/₂

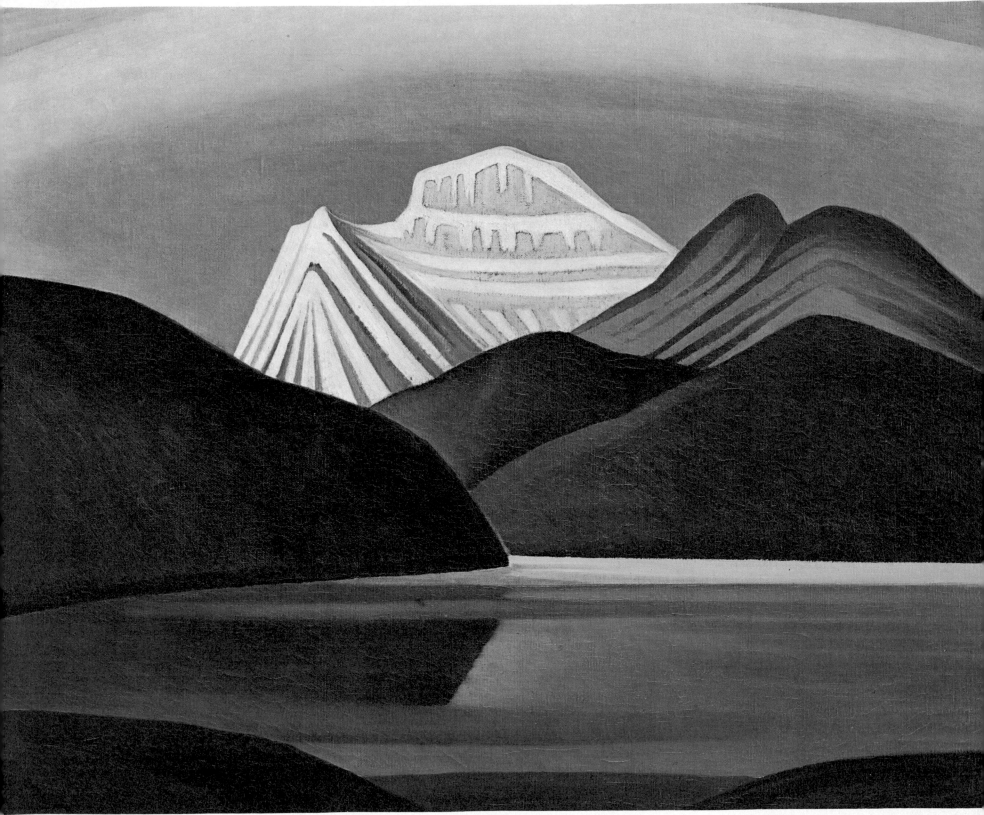

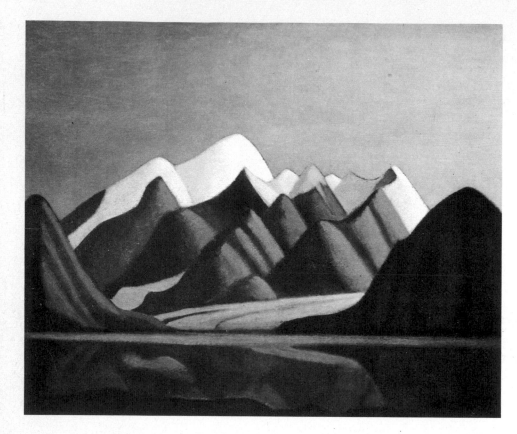

Eclipse Sound and Bylot Island. 1930
12 x 15

Ellesmere Island. 1930
12 x 15

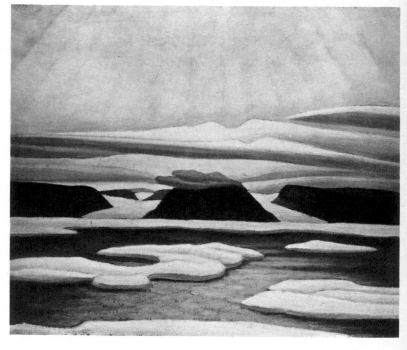

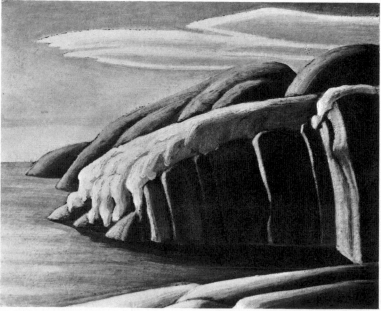

Lake Superior Cliffs. 1921
11³/₄ x 14¹/₂

Algoma Woodland. 1919
10¹/₂ x 13⁵/₈

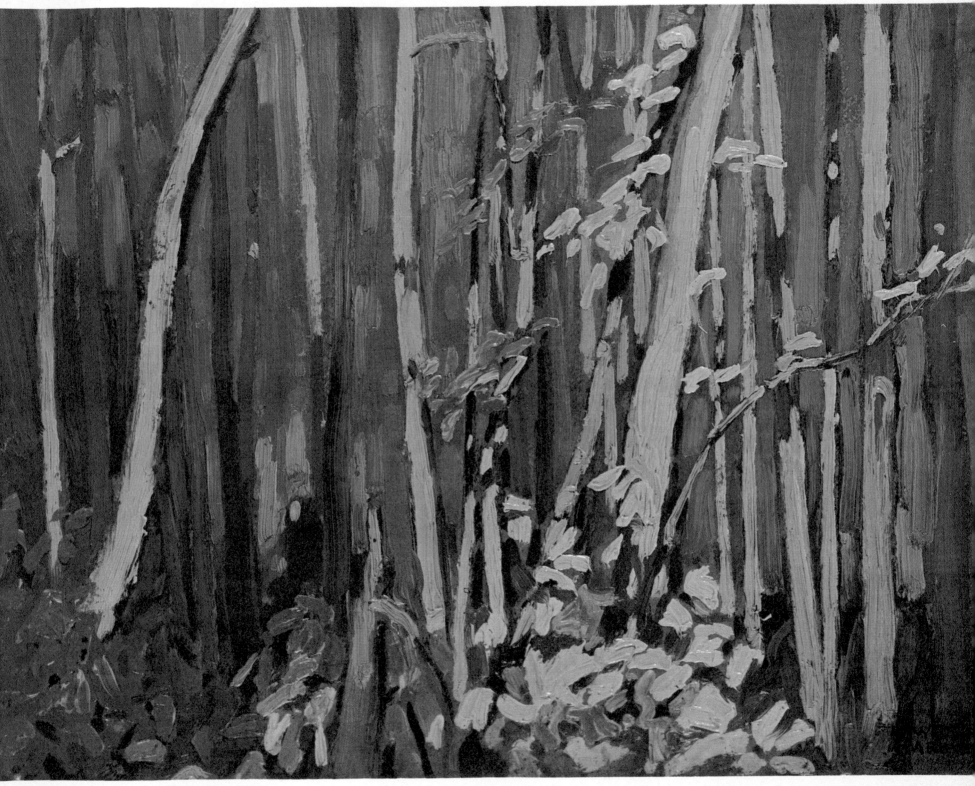

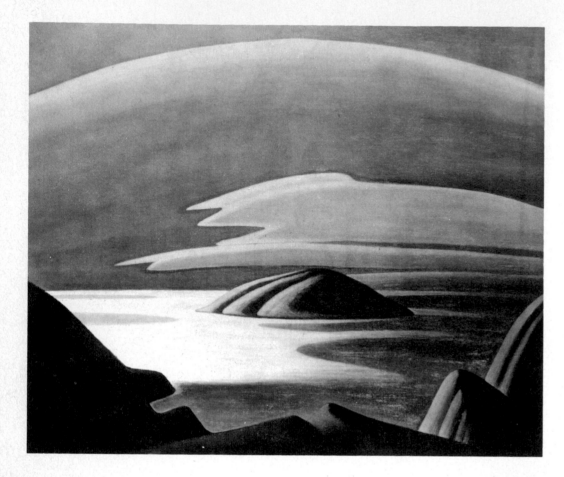

Lake Superior Island. 1923
28 x 35

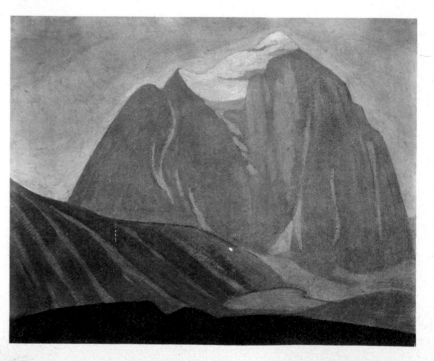

Mount Temple. 1924
12 x 15

Montreal River. 1920
10 1/2 x 13 3/4

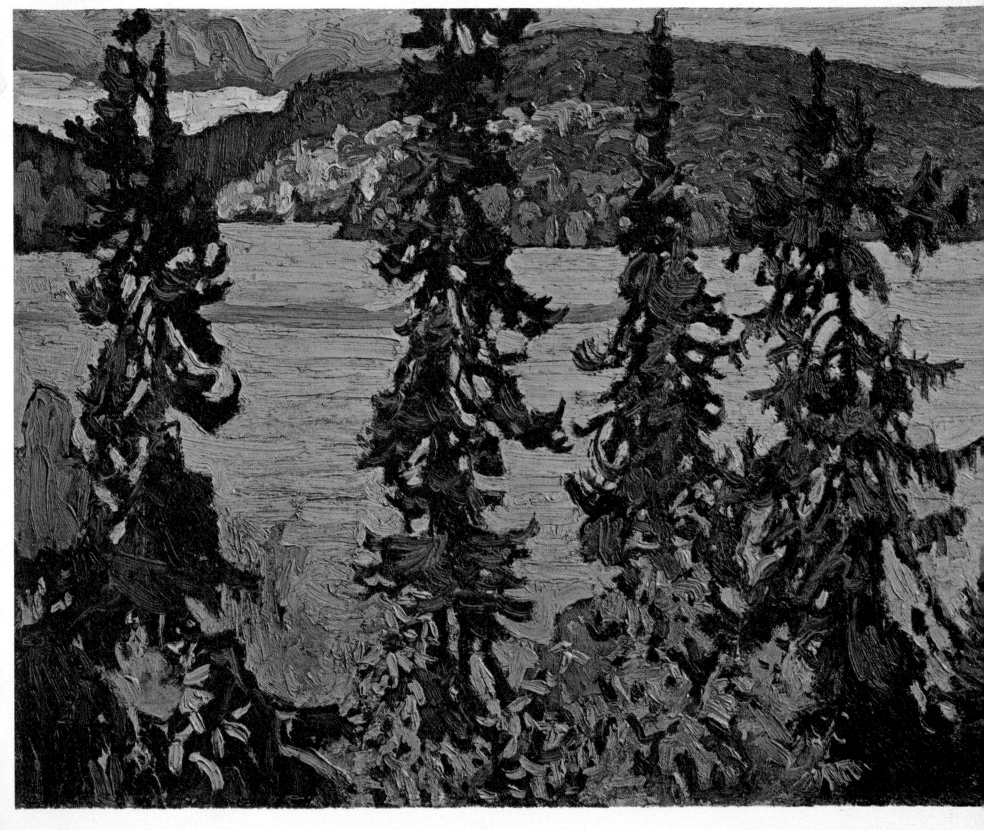

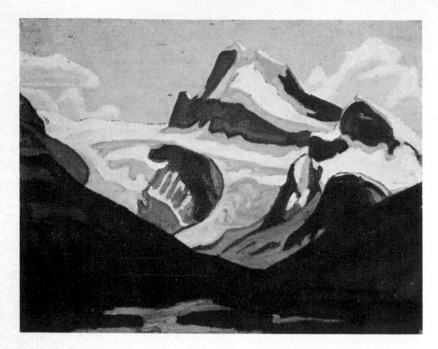

South End of Maligne Lake. 1925
$10^{1}/_{4}$ x $13^{5}/_{8}$

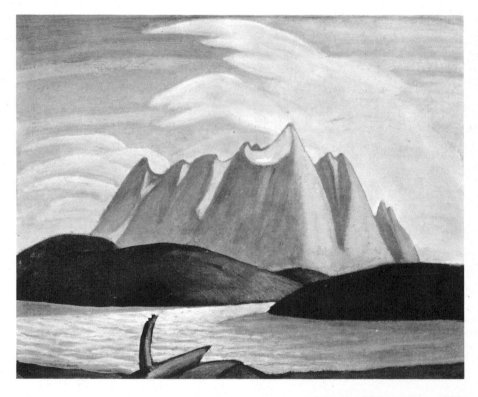

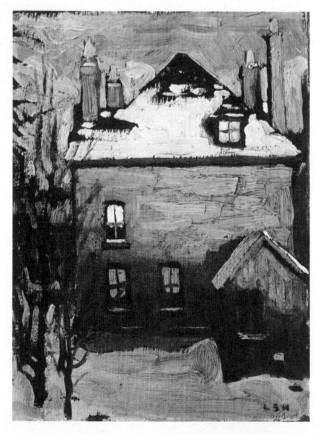

Lake and Mountains. 1927
$11^{1}/_{2}$ x $14^{1}/_{2}$

Little House. 1911
$7^{3}/_{8}$ x $5^{1}/_{8}$

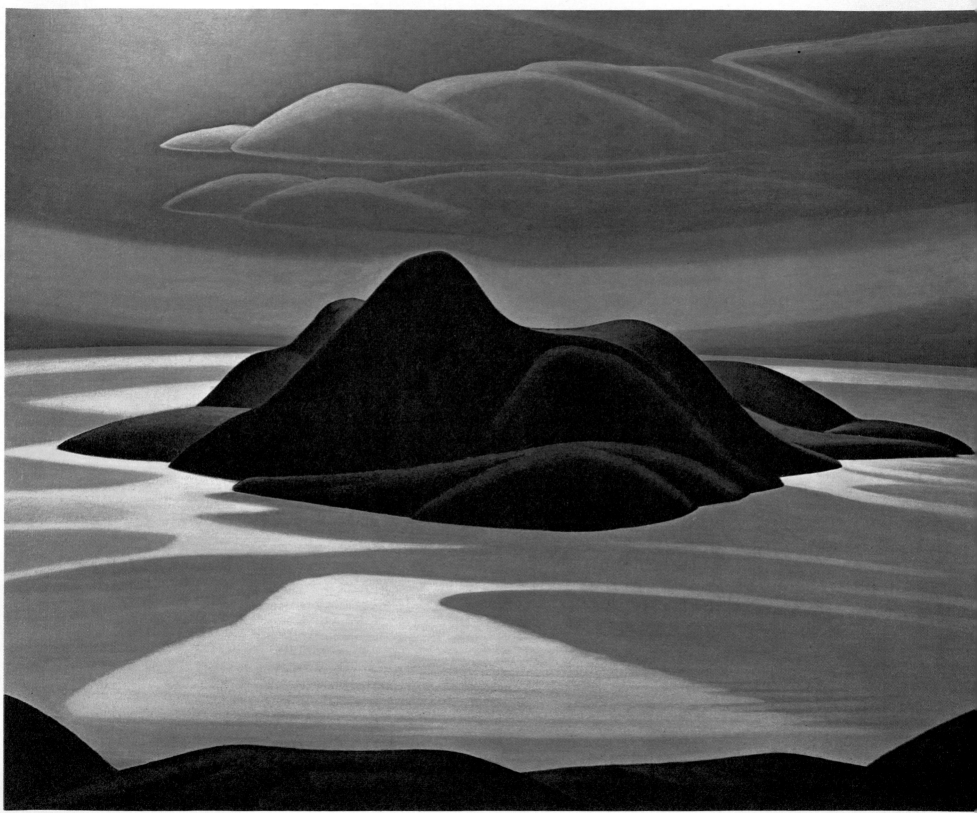

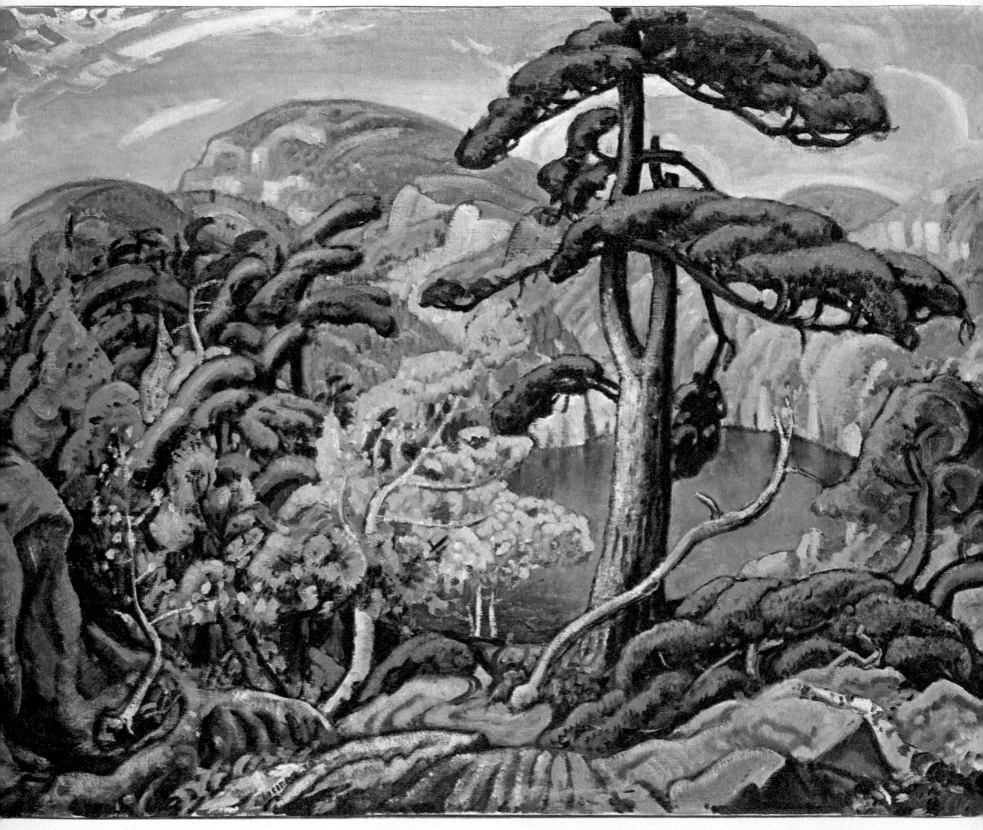

ARTHUR LISMER 1885-1969

Arthur Lismer was the great teacher of the Group of Seven. From 1915 until his death, he taught at many institutions, including the Ontario College of Art, the Nova Scotia College of Art, the Montreal Museum of Fine Arts and McGill University. He devoted much of his life to directing art education for children and received wide international recognition for his achievements in the field. After founding children's classes at the Art Gallery of Toronto in 1929, he was invited to South Africa and Columbia University to initiate courses in the field of art education.

As a teacher and painter, Lismer remained eternally youthful. He possessed an infectious wit and humour which expressed themselves in both words and images. As the Group of Seven's pictorial Boswell, Lismer created a brilliant series of caricatures portraying his colleagues during their meetings and sketching trips. Many of these rapid, visual commentaries round out the outstanding collection of Lismer's works in the McMichael Collection.

Lismer achieved the richest landscape drawings of the Group. These were usually done as ends in themselves and not as studies for paintings. Most of these black and white landscape studies are executed in brush or reed pen and are almost lush in their impact. The best of Lismer's drawings are at the very pinnacle of Canadian graphic art. Marked by a confident bravura, their spirited calligraphy recalls the sweeping shorthand of the finest Oriental masters.

Lismer painted in many parts of Canada. The extent of his travels is well represented in the McMichael Canadian Collection. His fondness for the Maritimes is reflected in works done as far apart in time as *Maritime Village* of 1919 and *Red Anchor*, painted thirty-five years later. The Lake Superior area of Northern Ontario, Quebec and British Columbia are also represented in his sketches and canvases.

Like F.H. Varley, Arthur Lismer attended the Sheffield School of Art in that English city where he was born, and later spent a period at the Antwerp Academy in Belgium. Thus, when he emigrated to Canada in 1911, he was a completely trained artist in an academic tradition. It was the impact of the Canadian landscape, especially that of Northern Ontario, that released Lismer's vigorous sense of design and colour to their utmost. As early as 1914, he was expressing his enthusiasm for the wilderness of Algonquin Park in both paint and words. On his very first trip to the Park, he wrote: "The first night spent in the north and the thrilling days after were turning points in my life". Such letters reveal the eagerness and eloquence he was to later utilize as a spokesman in defence of his own work and that of his fellow members of the Group of Seven.

Although Lismer painted in many parts of Canada, he is best known as the Group of Seven's painter-biographer of the Georgian Bay district. His lush oil sketches of the Bay's vegetation and pine-etched island horizons compose the richest part of his life's work. Summer after summer, he returned to Georgian Bay to search out the lichen-made patterns of its rocks and to track with brush and pen the tangle of its undergrowth. The canvas *Canadian Jungle* in the McMichael Canadian Collection is a key example of Lismer's consuming interest in texture in nature. *Evening Silhouette* is his vision of the Bay islands at their most romantic. The radiant and compelling *Bright Land* captures the essence of Lismer, brilliant, happy, and eternal optimist who justified his joyful faith in life through his long, outgiving career.

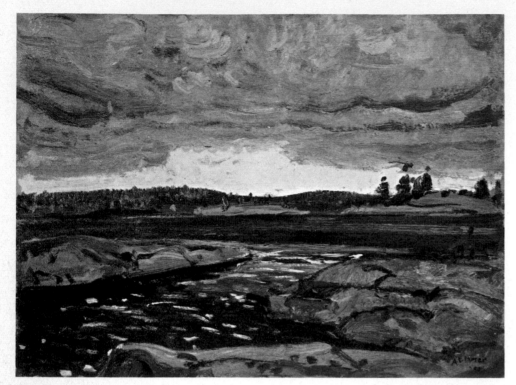

Stormy Sky, Georgian Bay. 1928
11³/₄ x 15⁵/₈

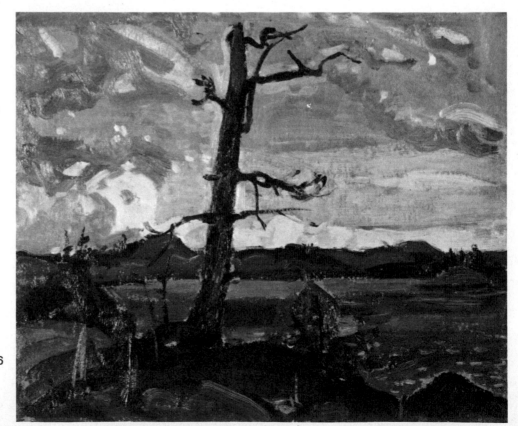

Dead Tree, Georgian Bay. 1926
12⁷/₈ x 16

Canadian Jungle. c. 1946
17¹/₂ x 22

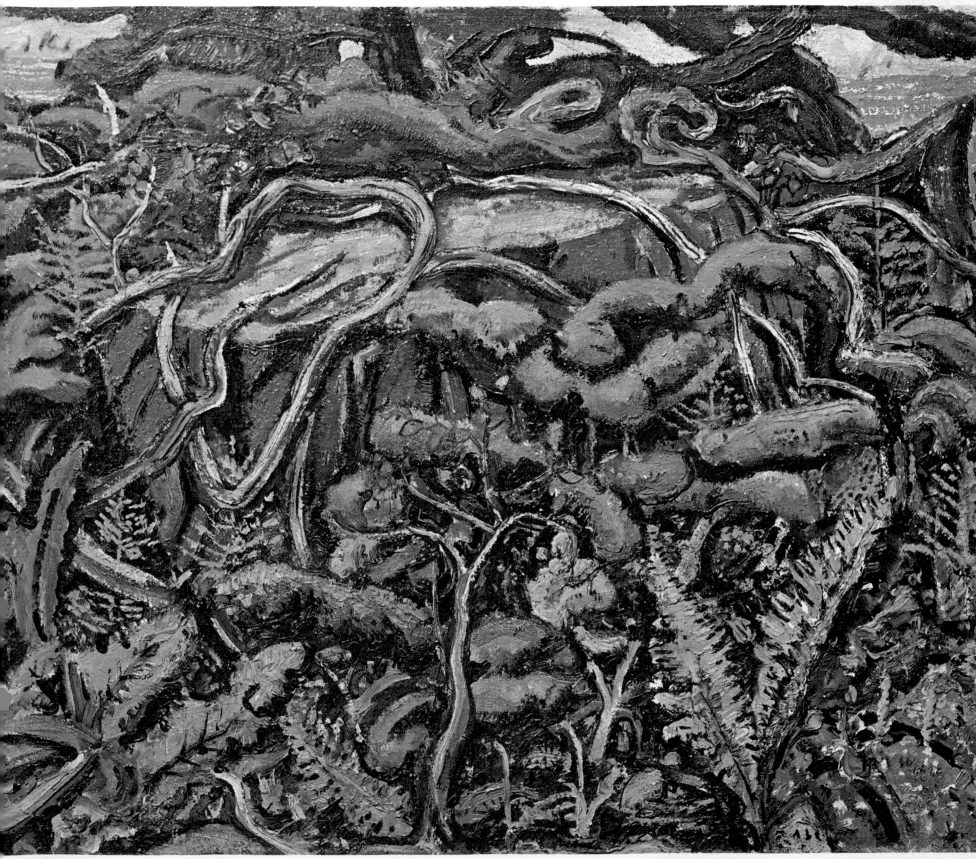

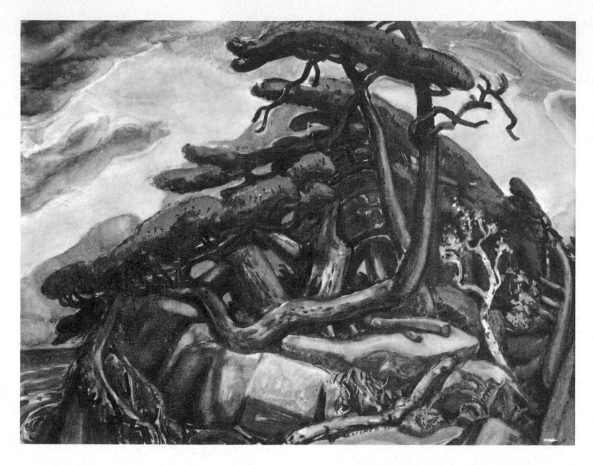

Pine Wrack. 1939
21¹/₂ x 30

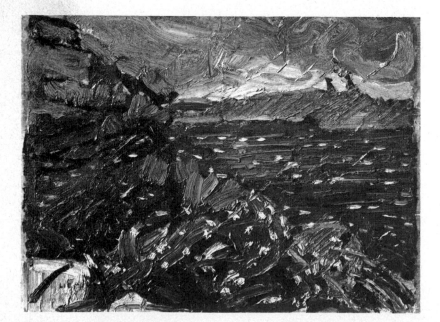

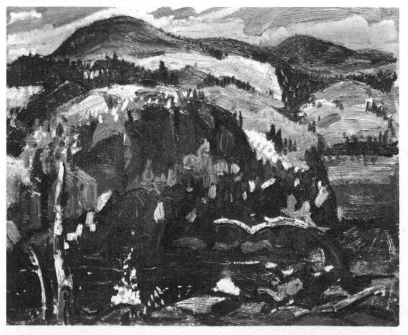

Rain in the North Country. 1920
8³/₄ x 12¹/₈

Lake Superior. 1927
12⁵/₈ x 15⁷/₈

Forest, Algoma. 1922
28 x 36

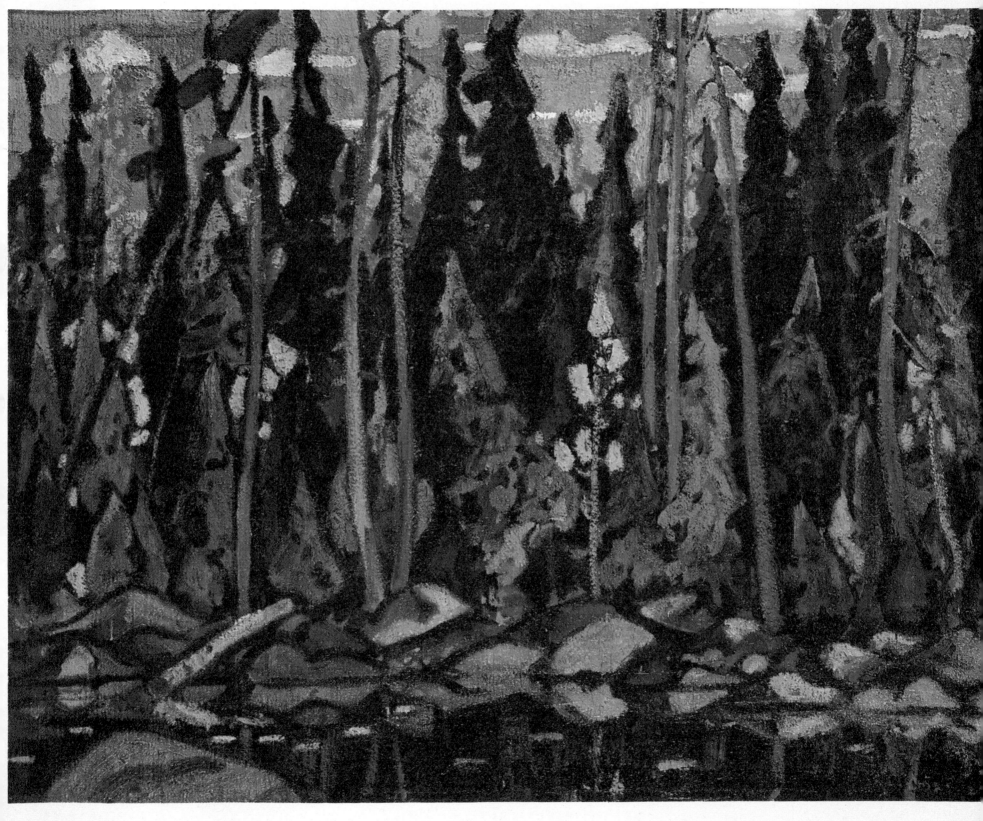

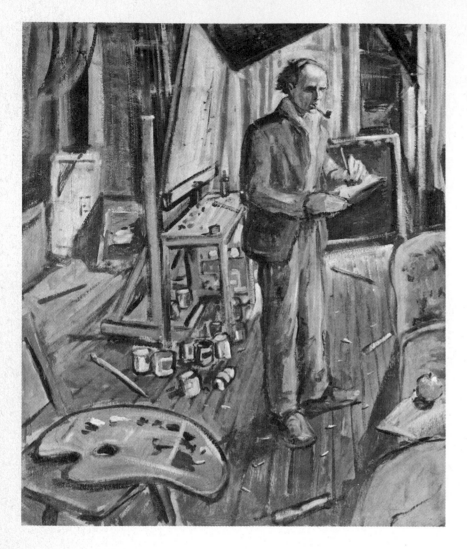

In My Studio. 1924
36 x 30

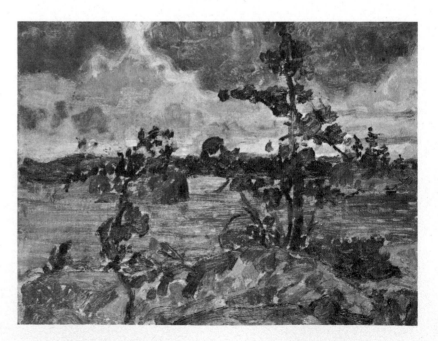

Gusty Day. 1926
9 x 11⅞

Evening Silhouette. 1926
12³/₄ x 16

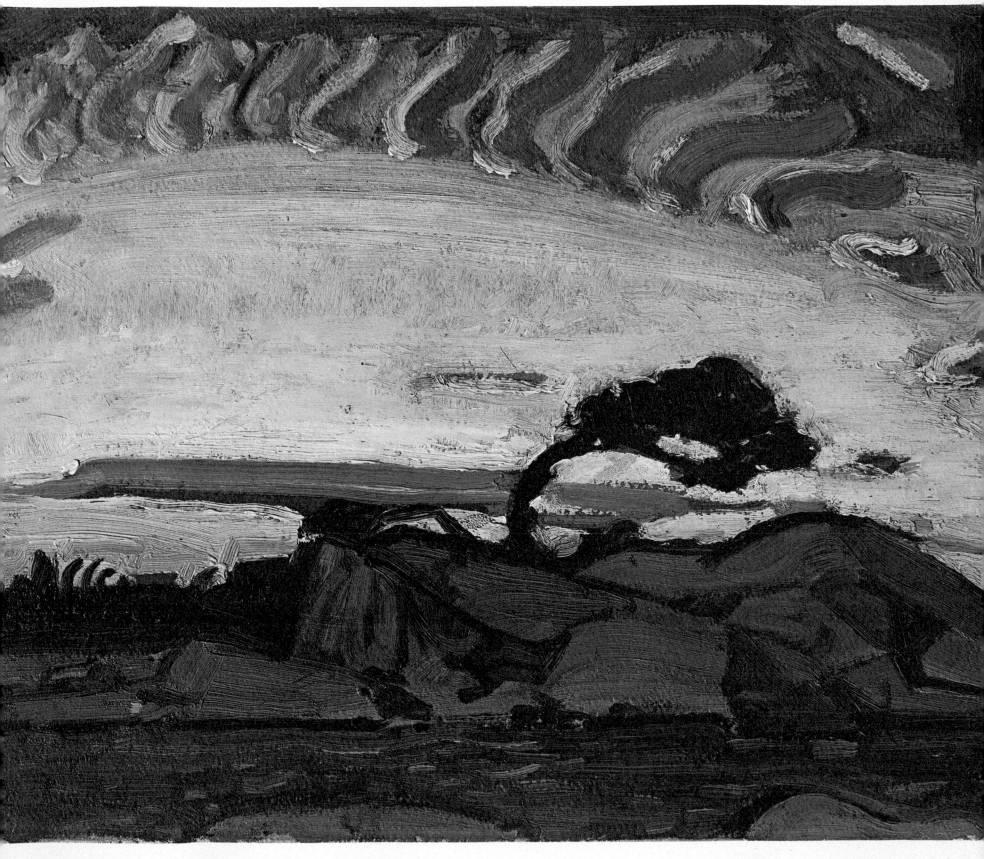

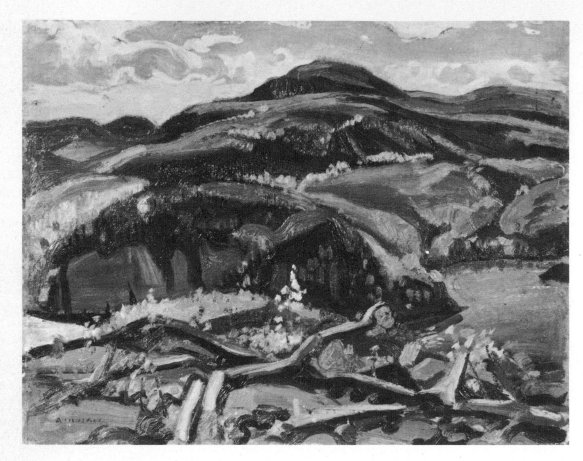

October on the North Shore. 1927
12¹/₂ x 15¹/₂

McGregor Bay. 1933
11 x 15¹/₂

Near Amanda, Georgian Bay. 1947
11¹/₂ x 14³/₄

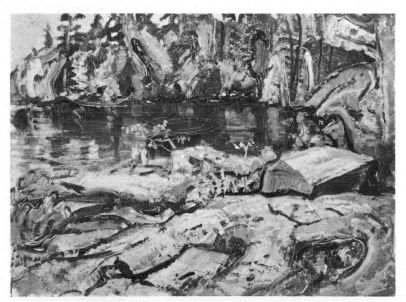

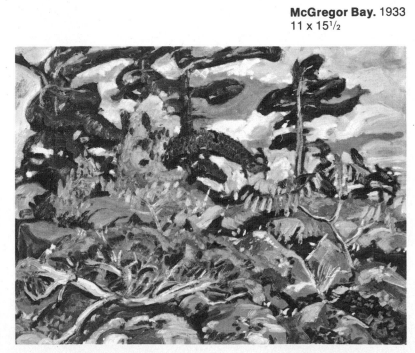

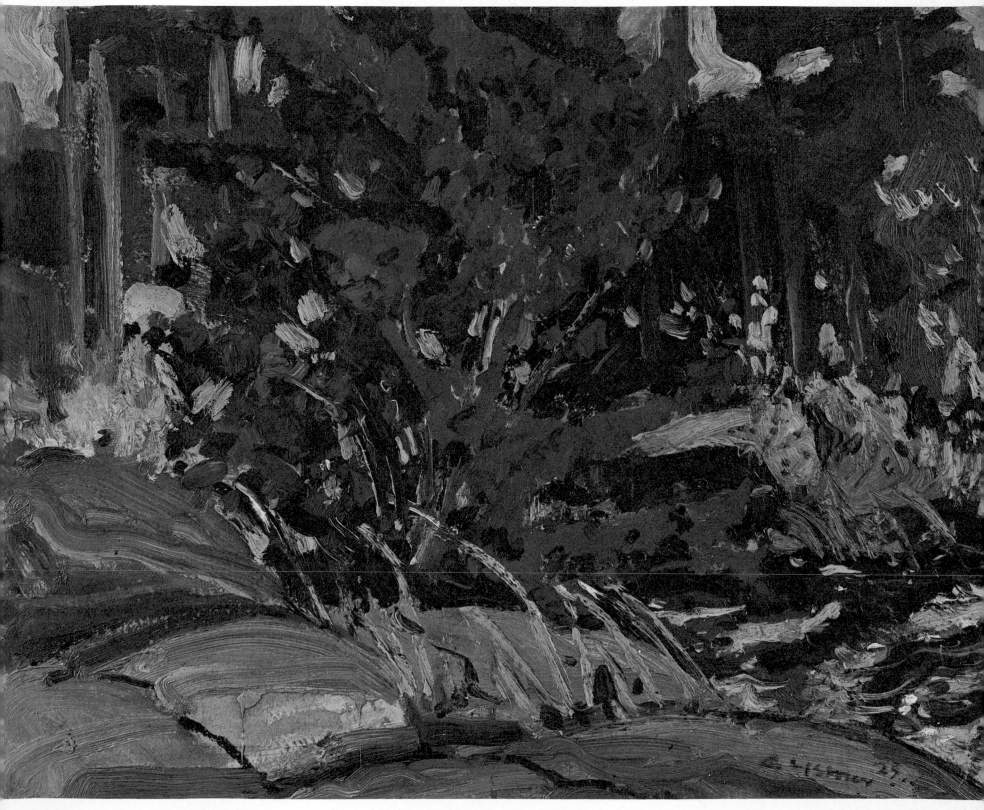

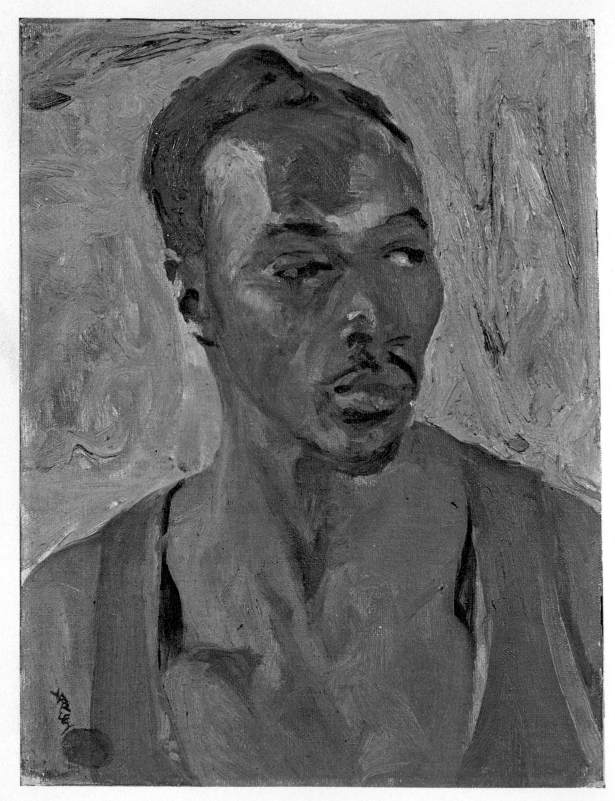

Negro Head. 1940
15³/₄ x 11⁵/₈

FREDERICK VARLEY 1881-1969

Varley was the romantic of the Group. His life possessed the same will-of-the-wisp quality that marks many of his poetic landscapes. Until his last years, he was constantly on the move, a questing gypsy of the arts, always, it seems, in search of the perfect landscape, the ideal model.

Varley was tied more closely to European tradition than the other members of the Group. He loved Turner and such other early English landscape painters as Cotnam and Samuel Palmer. His portraits are based in the best tradition of British portrait painting and they have been compared with the works of such masters as Augustus John and Ambrose McEvoy.

In his attitude to his subjects, Varley possessed much of the attitude of a mystic. He usually shunned the hard, clear afternoon light favoured so often by his fellow Group painters. He favoured dawn, dusk and twilight and painted more nocturnes than any of his colleagues. Many of his finest canvases, such as Night Ferry, Vancouver and Moonlight at Lynn are night-pieces. He valued colours for their mystical qualities. Blue, gold, violet and green, he said, were the spiritual hues and these are often dominant in his pictures, even his portraits.

Varley is unquestionably the finest portrayer of people Canada has so far known. He had the imaginative vision, the independence and the technical skills demanded of a great portrait painter. His spirit of independence permitted him to select his sitters and refuse commissions that did not appeal to him.

Varley's best portraits of men are penetrating and vigorous, but unquestionably his most memorable studies are those of women. From time to time throughout his life, Varley would have a special model from whom he realized a series of haunting souvenirs in paint. The best of these combine an affectionate tribute to a favoured sitter with consummate craftsmanship.

Varley's greatest strength as a portrait painter was his masterly draughtsmanship. His drawings in pencil, chalk and ink compose an unrivalled Canadian gallery of graphic art. He could draw with a silver-point sensitiveness without sacrificing any of his characteristic vigor. Varley was a singularly masculine painter and even in his most poetic portraits and atmospheric landscapes, he retains the underlying power of a true master of his craft.

Varley emigrated to Toronto from England in 1912. He was introduced to Algonquin Park by Tom Thomson in 1914 and first came to know the Georgian Bay through Thomson's patron, Dr. J.M. MacCallum. It was in the Bay area that Varley discovered the material for his early Group landscapes, including his masterpiece, *Stormy Weather, Georgian Bay*. A sketch bearing the same title, painted about the same time, is in the McMichael Canadian Collection. The landscape in this sketch is incorporated in the background of the powerful composition, *Indians Crossing Georgian Bay*, also in the Collection. After Georgian Bay, Varley gave his deepest creative loyalty to the British Columbia landscape. There he found an outlet for his romantic nature in a land of mountains, mists and glaciers that would have enchanted Turner. On the Pacific Coast, between 1926 and 1934, Varley painted the most poetic landscapes in Canadian art. These included the lyrical blue and green *Moonlight At Lynn* of 1933 and the expressionistic canvas *Sphinx Glacier, Mt. Garibaldi*, both in the McMichael Canadian Collection. Varley is also well represented in the Collection as a portrait painter and draughtsman. His examples in this genre include one of his finest feminine studies, *Girl In Red* of 1926, the strongly rendered *Negro Head* of 1940 and the eloquent drawings, *Little Girl* of 1923 and *Indian Girl* of 1927.

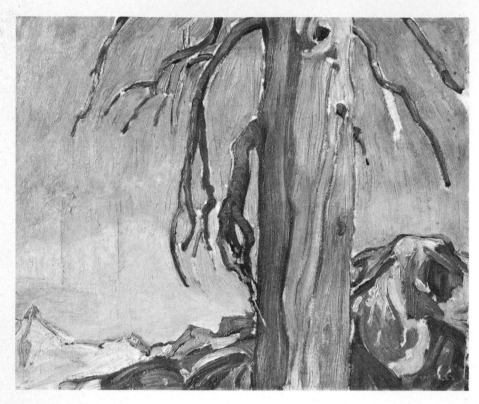

Dead Tree, Garibaldi Park. c. 1928
12 x 15

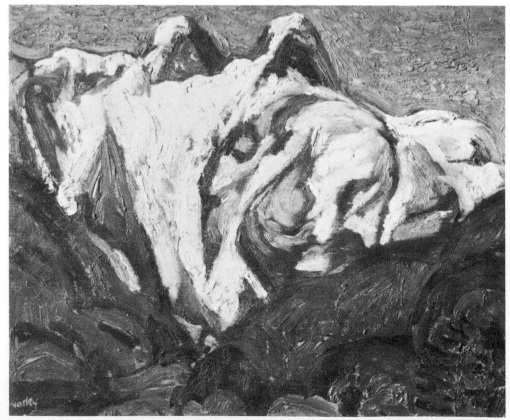

The Lions. c. 1931
12 x 15

Mountain Portage. 1925
20 x 24

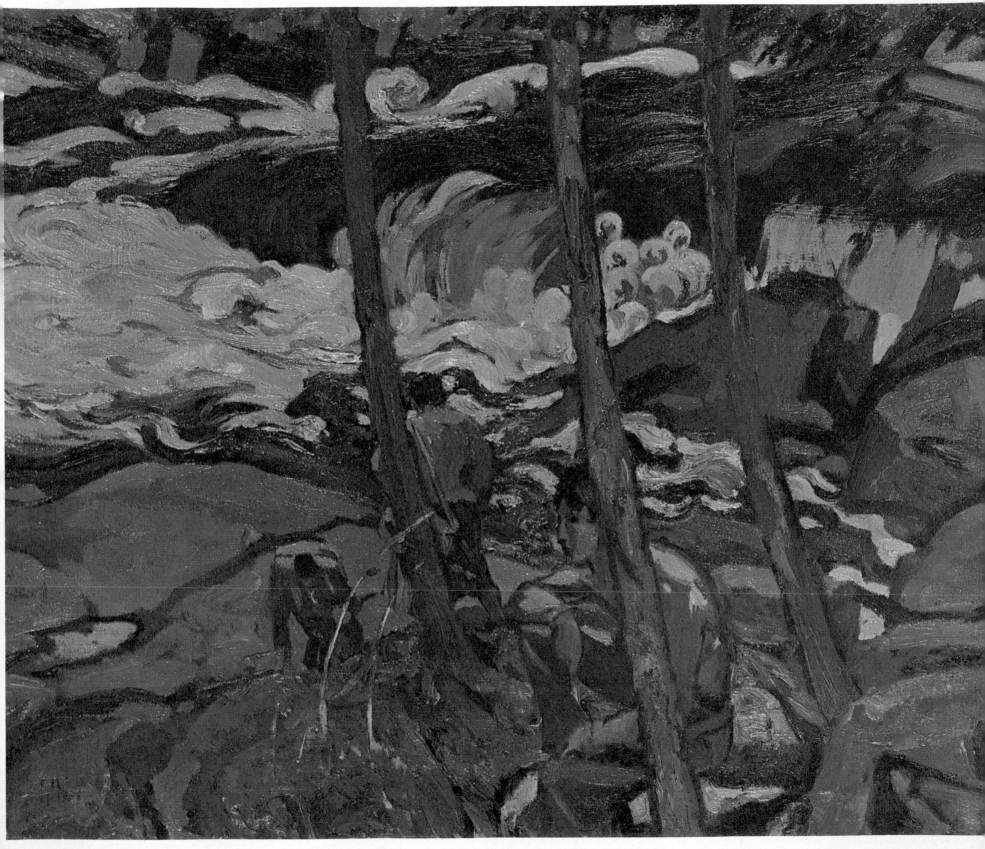

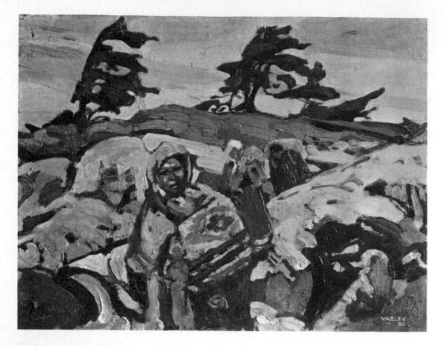

Indians Crossing Georgian Bay. 1920
11½ x 15½

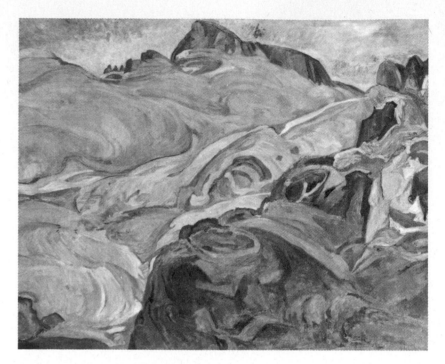

Sphinx Glacier, Mt. Garibaldi. c. 1930
47⅛ x 55⅛

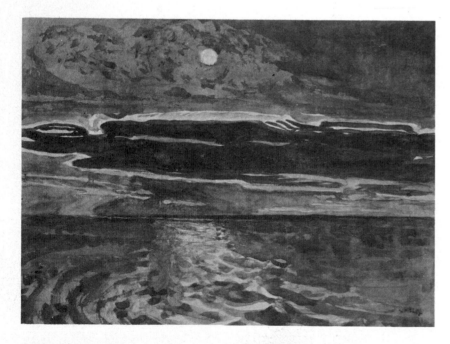

Arctic Waste. 1938
8¾ x 12

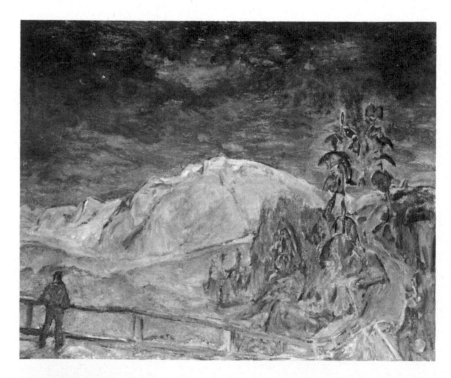

Moonlight at Lynn. 1933
23½ x 29¾

Girl in Red. 1926
21 x 20³/₈

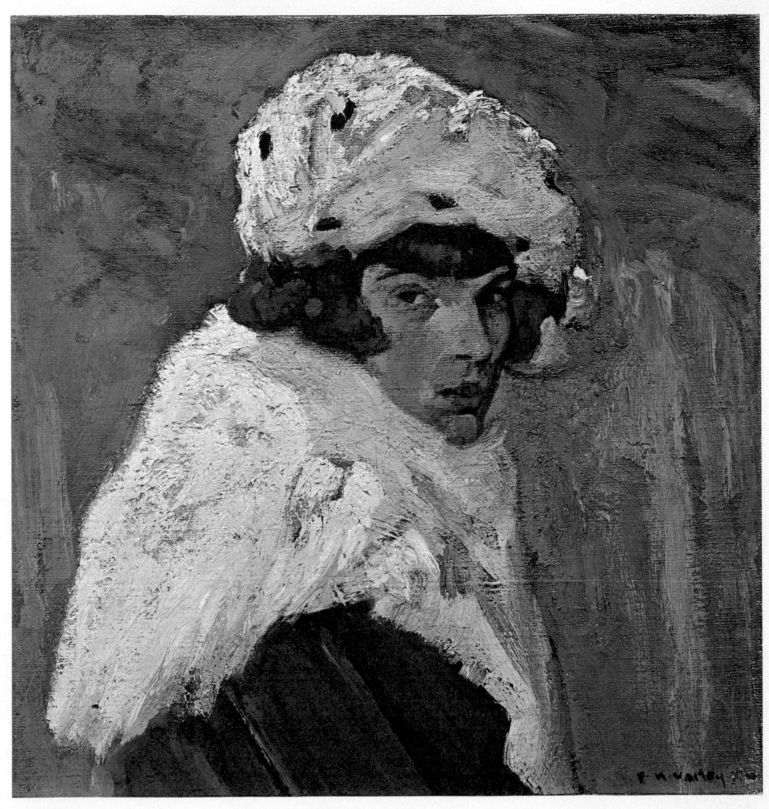

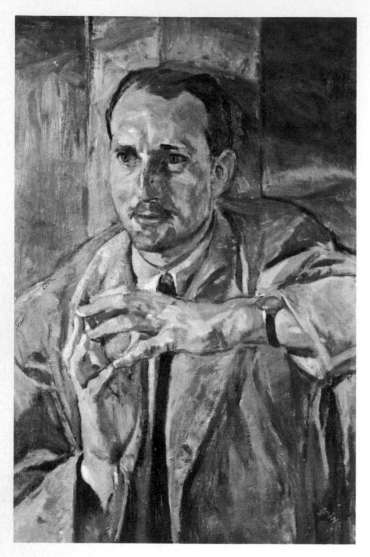

Portrait of a Man. 1950
27 x 18

Little Girl. 1923
11½ x 15

Stormy Weather, Georgian Bay. 1920
8½ x 10½

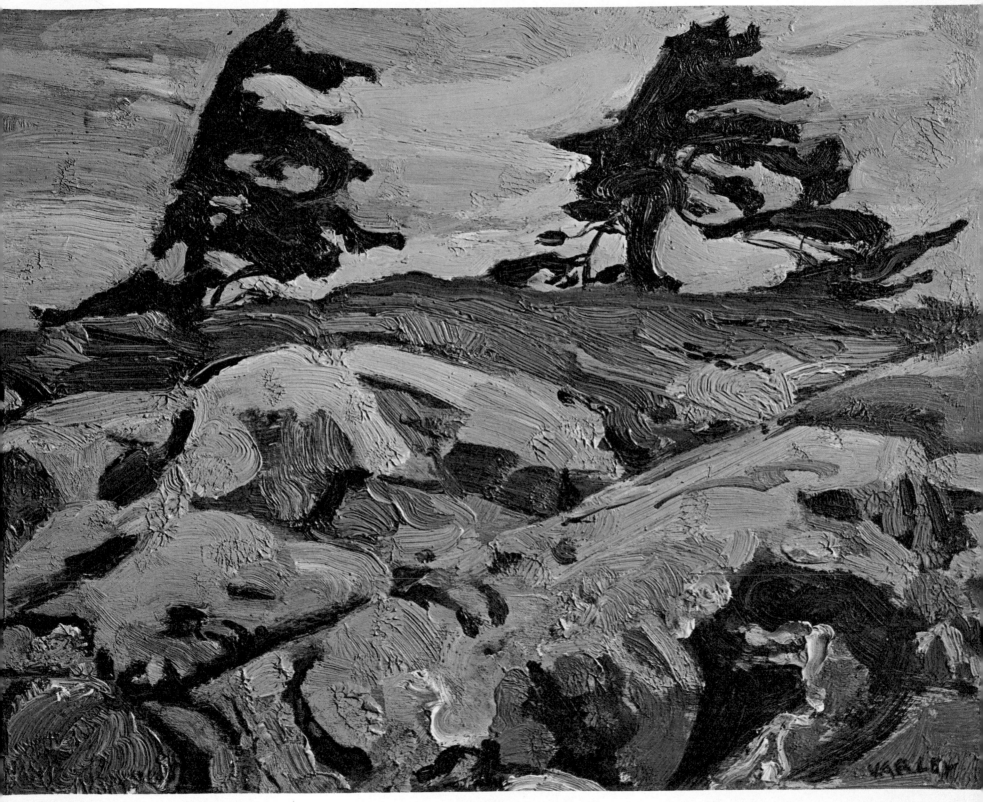

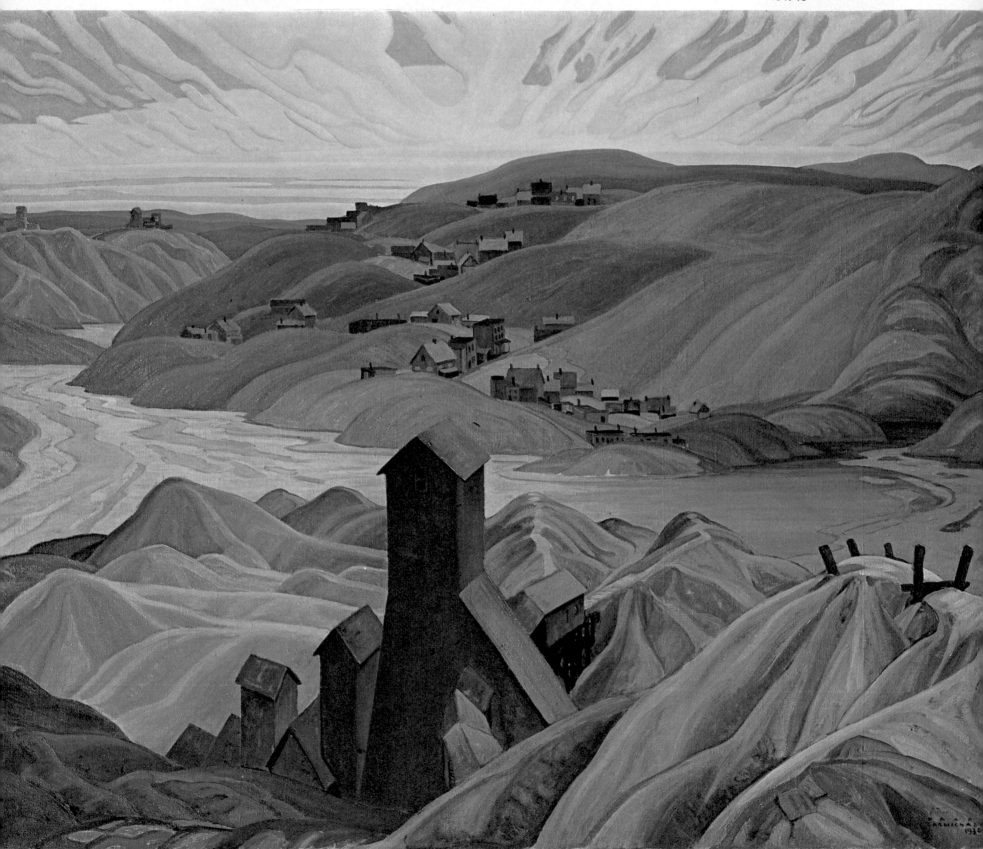

FRANKLIN CARMICHAEL 1890-1945

Many of Franklin Carmichael's finest sketches and canvases were painted near his hometown of Orillia during the early 1920's. During those early Group of Seven years, Carmichael was working fulltime as a commercial designer, and was obliged to find his subject matter on journeys relatively close to Toronto. Despite this, his Orillia paintings lack none of the richness or grandeur of his colleagues' compositions created in the wilderness much further north. Carmichael's early Group period works reveal a rich paint impasto and glowing colour, suggesting an almost buoyant enthusiasm. He delighted in the rich fabric of autumn foliage and excelled in its depiction. Such sketches as *Autumn Tapestry, Autumn Woods, Scarlet Hilltop* and *Autumn Orillia* in the McMichael Canadian Collection show the artist's love of natural pattern at its best.

Like his younger colleague, A.J. Casson, Carmichael had a fondness for portraying the characteristic stores, barns and houses of rural Ontario settlements. During the 1930's, throughout the southern part of the Province and along the shore of Lake Superior, he found isolated dwellings or small villages from which he composed many watercolours, drawings and a few oils.

His renderings of farmhouses, barns and old homesteads in Whitefish Village, Severn Bridge and many other Ontario communities suggest the same lived-in intimacy as A.Y. Jackson's portrayals of such Quebec villages as St. Tite Des Caps, St. Urbain and St. Pierre.

Franklin Carmichael's large canvases are relative rarities. Although he was dedicated to painting landscape, economic necessity led him to spend much of his lifetime at commercial art and teaching. Unable to concentrate for long periods on major works, he turned to the medium of watercolour for many of his best achievements. His large watercolours possess a crystaline clarity of colour and authority of design in their transparent washes. Carmichael's dedication to watercolour made him a co-founder of the Canadian Society of Painters in Water Colour.

Carmichael's first visit to Lake Superior in 1925 opened up new worlds of form and space to him. The vast panoramas of hills and lakes unrolling before his vision as far as the eye could see captured his imagination. His landscape compositions opened up to include large expanses of sky and simplified silhouettes of whale-back rises, the very opposite to his earlier close-up bush-land paintings. His colour changed also, from thick golds, vermilion, and emerald greens to smoother, dark ultramarines, greys, ochres, siennas and blacks. The emphasis in these compositions became mainly horizontal — a tendency that continued throughout the balance of his career, persisting into the superb impressions of the LaCloche hills painted during the 'thirties. Carmichael's fondness for panoramic compositions can be studied in the McMichael Canadian Collection through such a typical canvas as *Northen Tundra* of 1931, *Grace Lake* of 1933, and such later sketches as *LaCloche Panorama* and *La Cloche Silhouette*, both painted in 1939.

Carmichael was a superb designer and graphic artist. With Edwin Holgate, Carmichael was the only Group of Seven member to devote much attention to the art of wood-engraving. His disciplined dedication to the craft resulted in many sparkling prints, including the pristine small illustrations for the book, *Thorn Apple Tree*, published in 1943. These tiny engravings, which measure less than three by four inches, are replete with vigorously rendered detail and are masterpieces of their kind. They rank Carmichael among the few distinguished book illustrators produced in Canada. Another, very different example of Carmichael's remarkable sense of design can be seen in his crisp tempera translation of landscape, *Waterfall*, in the McMichael Canadian Collection.

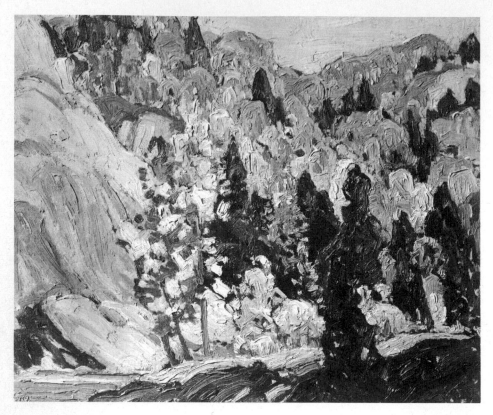

Bolton Hills. c. 1922
9³/₄ x 12

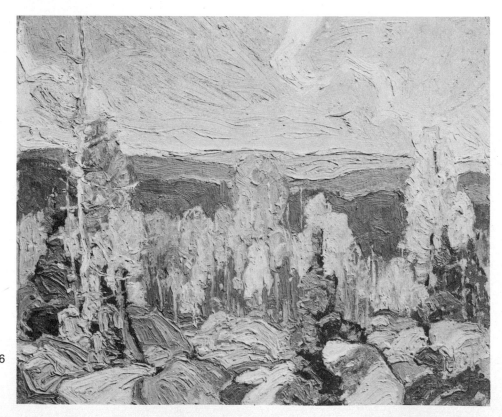

Autumn, Orillia. 1926
9³/₄ x 12

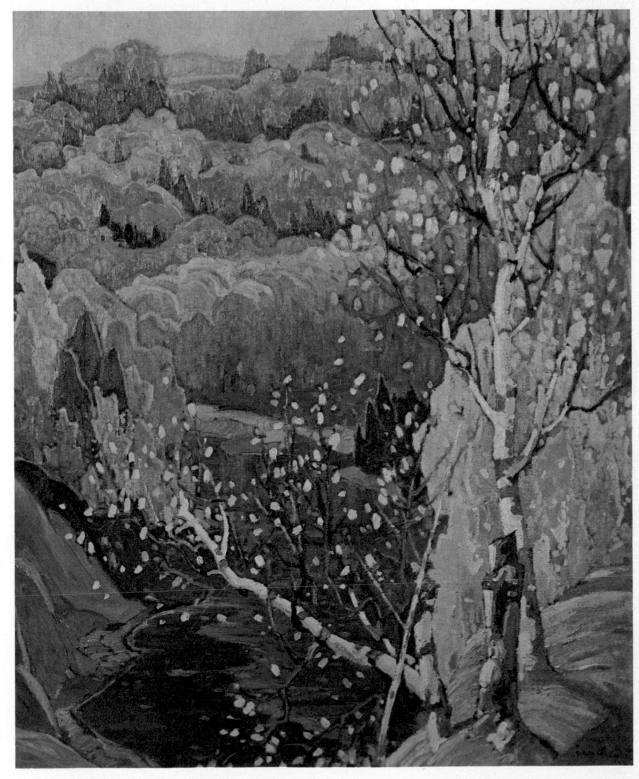

October Gold. 1922
47 x 38¾

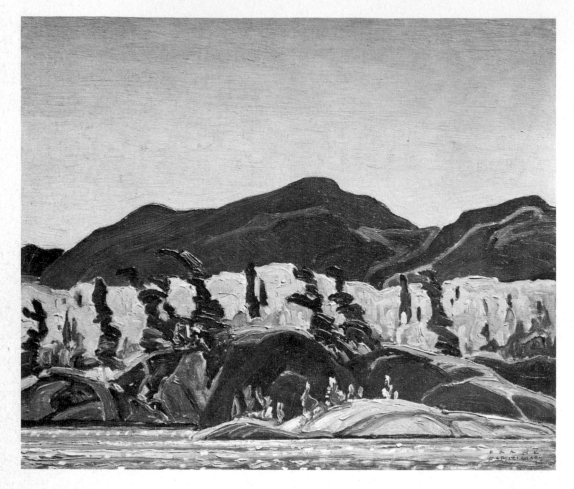

La Cloche Silhouette. 1939
10 x 12

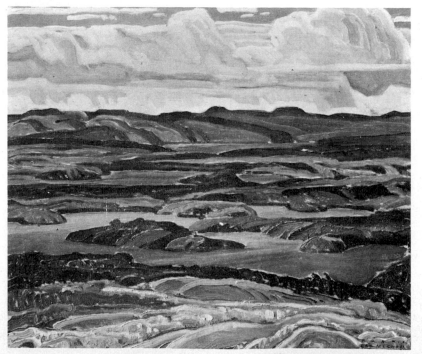

La Cloche Panorama. 1939
10 x 12

Spring Garland. c. 1928
10 x 12

FRANKLIN CARMICHAEL

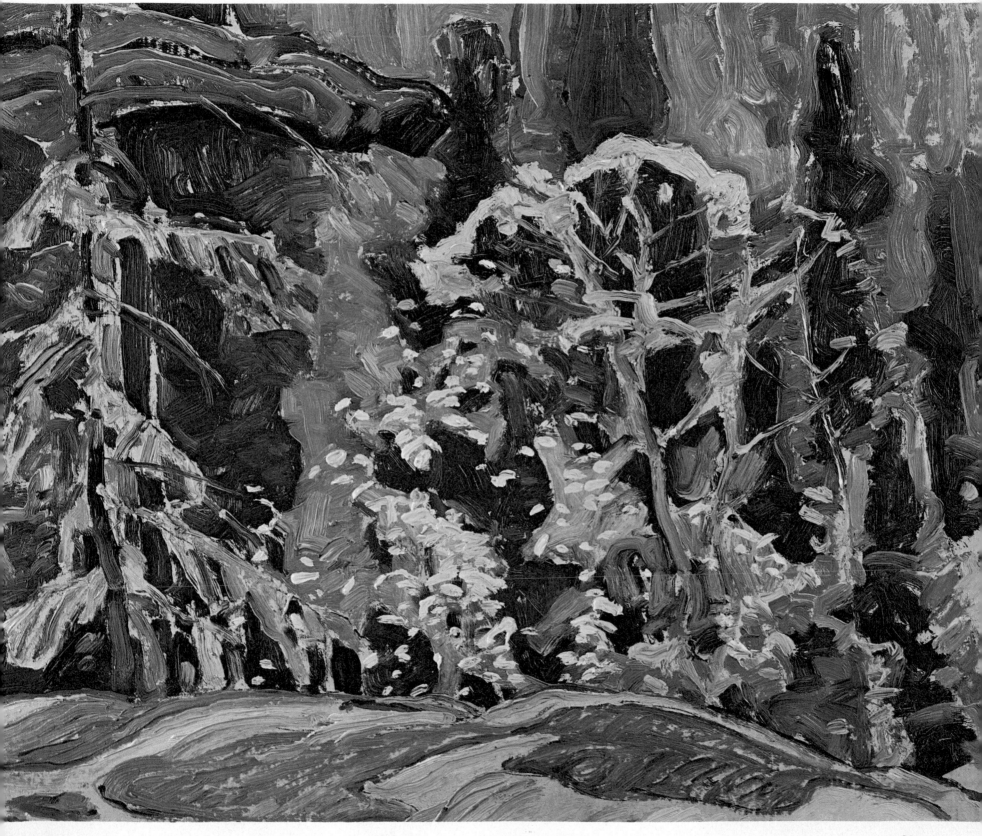

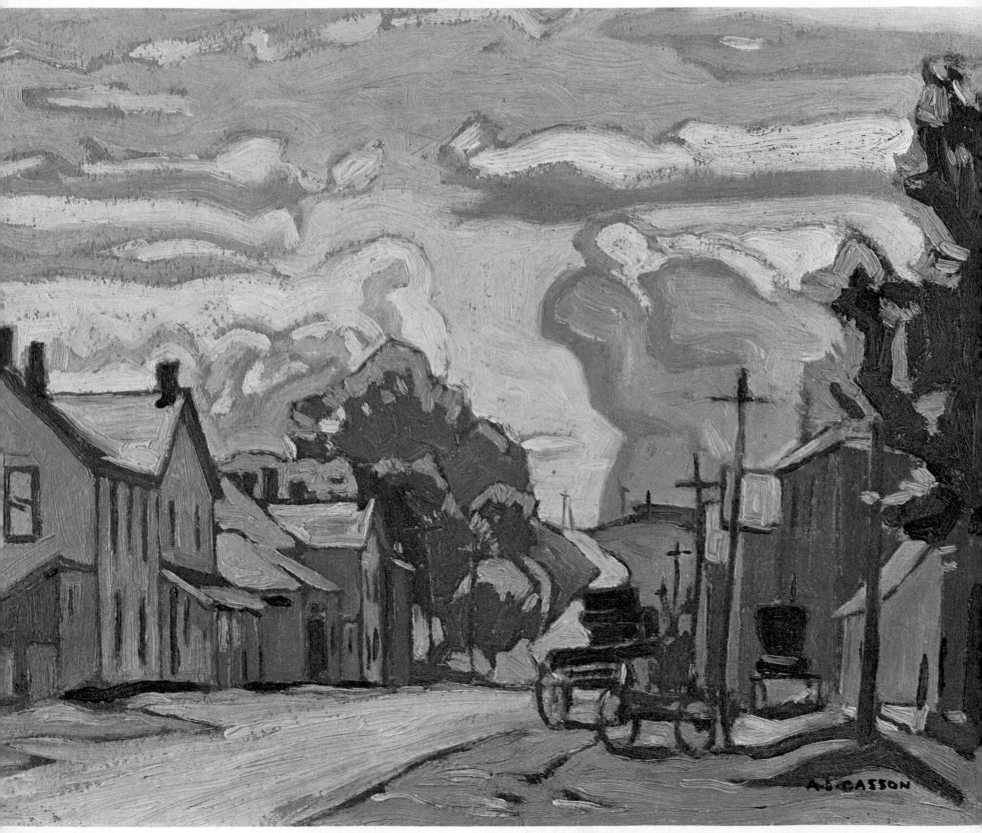

A.J. CASSON 1898-

For the most part, A.J. Casson left the more elemental and epic landscape of the northland to other members of the Group of Seven. His serene pictorial compositions have emerged mainly from southern and central Ontario settings. Particularly, he has been the pictorial biographer of the small communities of Ontario. He has celebrated such towns and villages as Bancroft, Glen Williams, Kleinburg, Parry Sound, Norval and Salem. His crisp, deliberate style has been ideally suited to depict the tidy rustic architecture, with its neat verandahs, almost puritan air of no nonsense form, dressed up with an occasional flight of fancy in the guise of gingerbread "fretwork". Although human figures usually play only bit parts in Casson's canvases, his village paintings are nevertheless redolent of humanity. His houses, barns and churches usually have the air of being lived in. This impression is only fortified when he introduces inhabitants hanging out washing, hauling water or bending before a March blizzard.

Casson was basically a conservative within the Group of Seven. He inherited from his older colleague, Franklin Carmichael, a high regard for craftsmanship. There are no accidents or meaningless flourishes in his creative vocabulaire. Although his small on-the-spot oil panels are executed with a fresh and direct vigor, his larger canvases based on them are composed slowly and with great care. As a result, Casson's stylistic evolution has been a gradual one, moving with a seeming inevitability, and without any sudden leaps into new techniques or thematic novelties.

Casson's independence and respect for tradition brought him the respect of a wide spectrum of artists and allowed him to be a President of the Royal Canadian Academy as well as a member of the pathfinding Group of Seven and the Canadian Group of Painters.

For many years, Casson joined his career as a painter with that of a designer and executive for Sampson-Matthews Limited, a Toronto printing house, where Carmichael and other distinguished Canadian painters were employed. There, Casson produced some of the most outstanding commercial art ever produced in Canada.

Casson is one of the finest watercolourists in Canadian art. He learned his technique from Carmichael and, with him, was a founding member of the Canadian Society of Painters in Water Colour. It is in his watercolours that Casson's design sense can be seen at its purest. Crisp, almost dry, in their rendering, their washes are placed with precision within a careful framework of drawing. Some of Casson's best-known large paintings, such as *The White Pine* in the McMichael Canadian Collection, existed originally as watercolours.

Casson is represented in the McMichael Canadian Collection by half-a-century of his art. The earliest examples are a number of nude studies in pencil and wash executed in 1917. The landscapes on view begin with a number of superb sketches from the early 1920's—*Trees* 1920, *Rock And Sky* 1921, *Haliburton Woods* 1924 and *Poplars* 1925. Casson's most personal vision is first revealed in the *Sombreland, Lake Superior* and *Pike Lake* sketches of 1929 and the early village studies, *Norval* and *Kleinburg* of 1929. Casson had by then found his own manner and themes and from then on, through to his LaCloche, Bancroft and Quebec paintings, his evolution was a continuing enrichment of familiar themes.

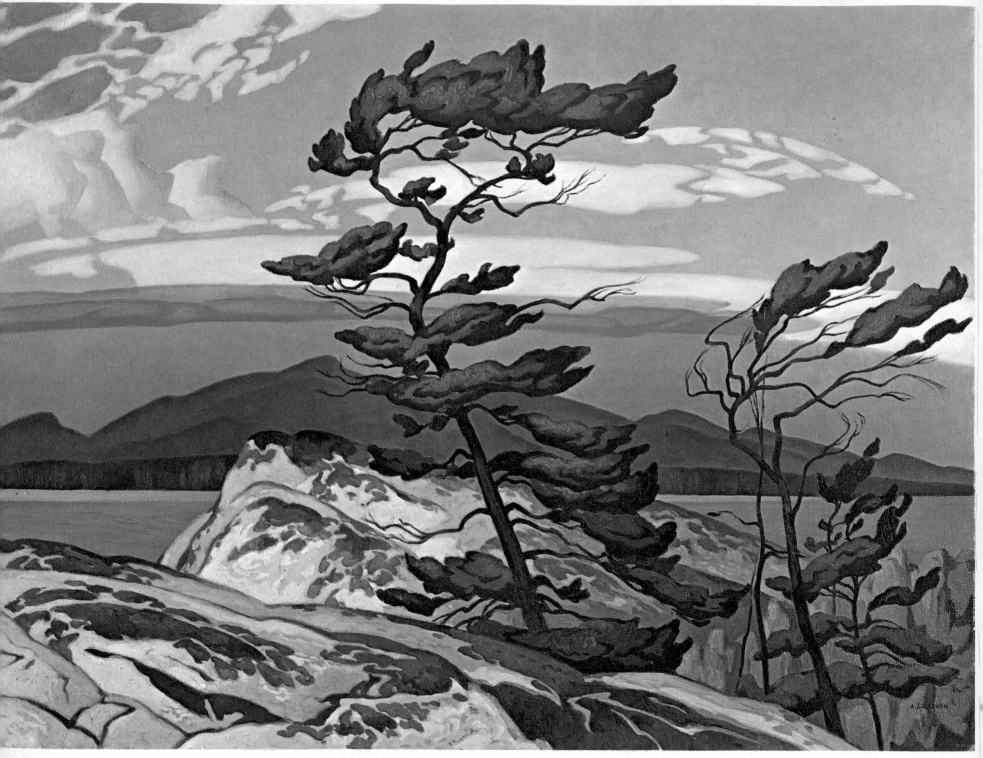

Kleinburg, 1929
9¹/₂ x 11¹/₄

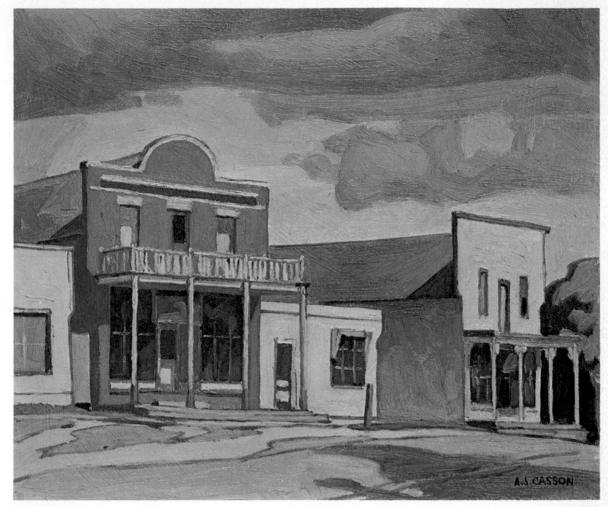

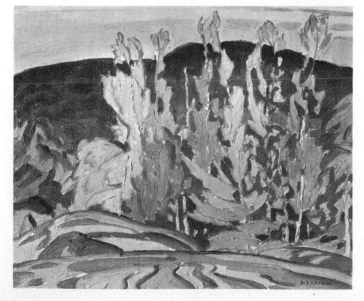

Flaming Autumn. 1936
10 x 12

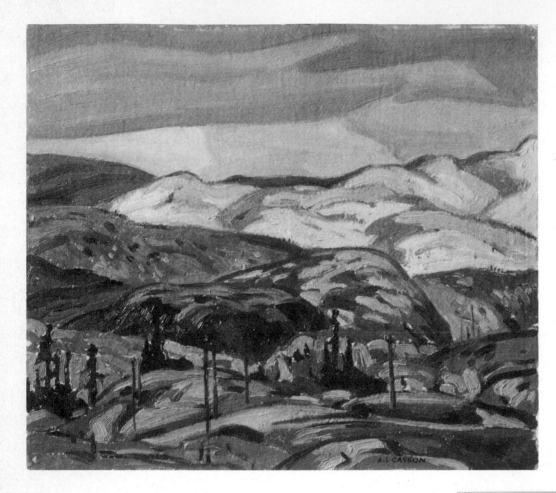

Sombre Land, Lake Superior. 1928
9 x 11

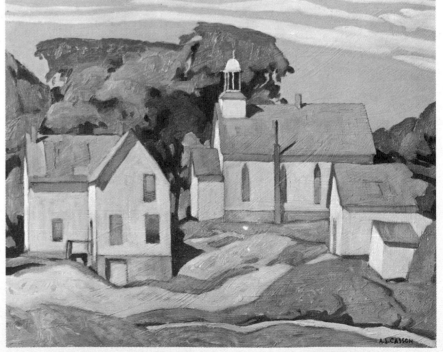

Houses, Bancroft. 1955
$11^7/_8$ x $14^7/_8$

Algoma. 1929
17 x 20

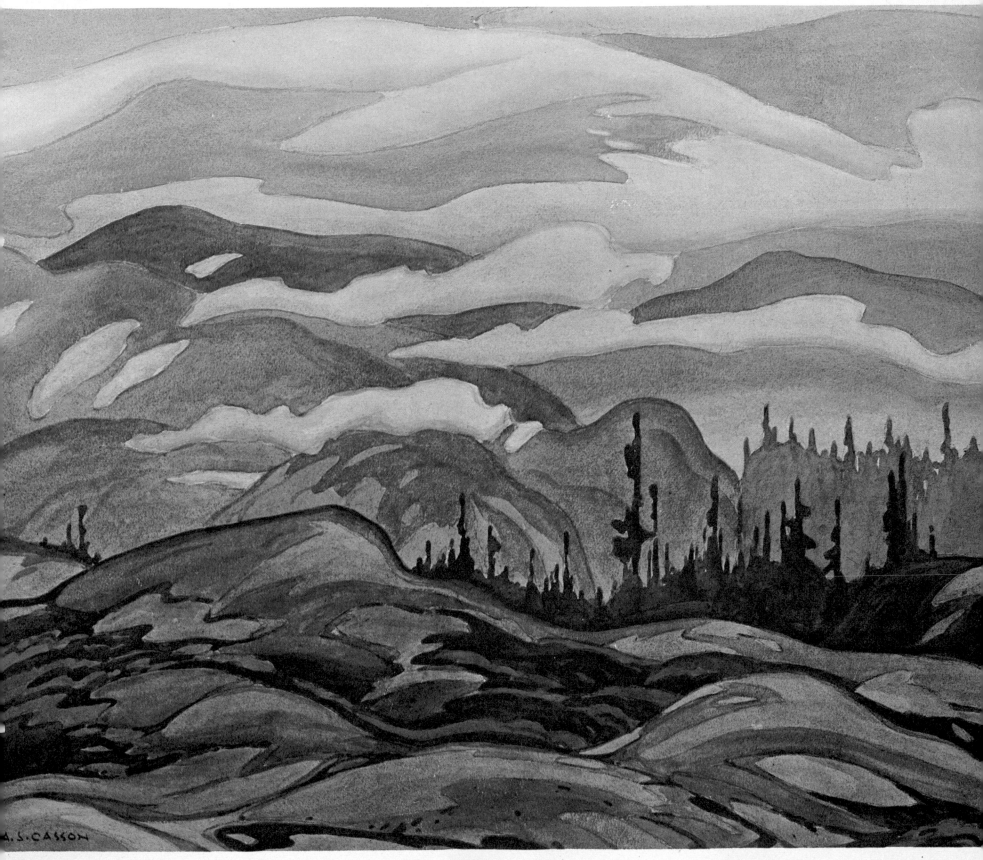

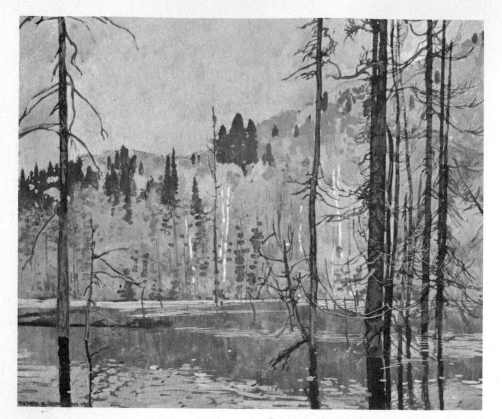

Drowned Land, Algoma. 1918 18 x 21

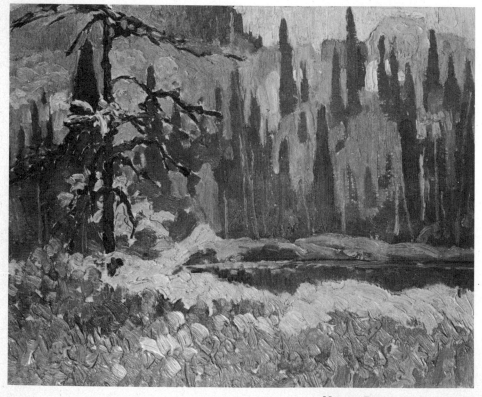

Moose Pond. 1918 10 x 13

FRANK JOHNSTON

1888-1949

Frank Johnston's 1918 paintings of Algoma are as compelling as anything done by the Group of Seven at that time. Although he remained with the Group only briefly, Johnston's short contribution to it was a very eloquent one. The best of his sketches of the period are consummately designed, richly painted tangles of branches, evergreens and foliage. From the beginning of his career, Johnston had a highly developed dramatic sense in his approach to nature. In his tempera paintings done shortly after World War I, he captured the immensity of the northern solitudes in compositions bearing such titles as *The Guardian of the Gorge*. Pictorial drama is present, too, in such large northern canvases as *Fire Swept Algoma* of 1920. Like so many of his colleagues, Johnston for many years made his main living as a teacher. After leaving the Group, he turned to teaching for twenty years, first as Principal of the Winnipeg School of Art and then as a teacher at the Ontario College of Art and later as Director of his own Art School on the shores of Georgian Bay. In the latter part of his career, Johnston devoted himself to a technique of almost photographic realism with which he recorded life in Southern Ontario farm and bushland, and life in the Canadian Arctic. These later paintings are executed in a medium which allowed the artist to capture the glitter of sunlight and the smallest details of texture. His obvious technical brilliance made Johnston one of the most popular and financially successful artists of his time.

Patterned Hillside. 1918
10 x 13

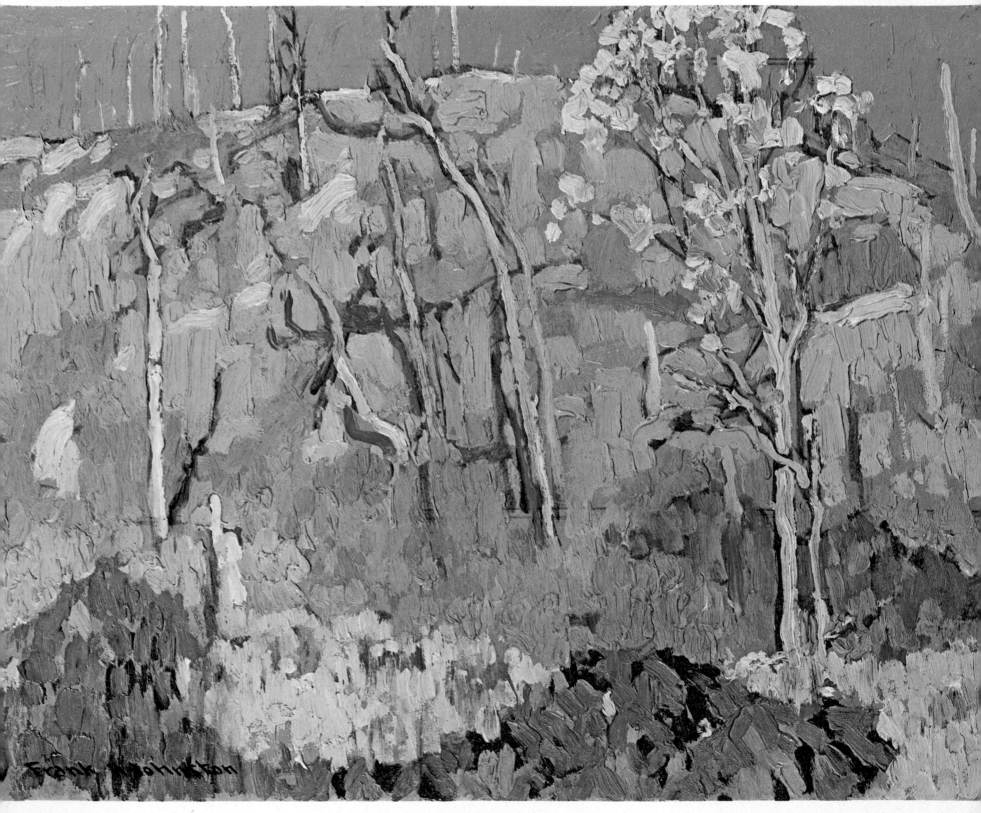

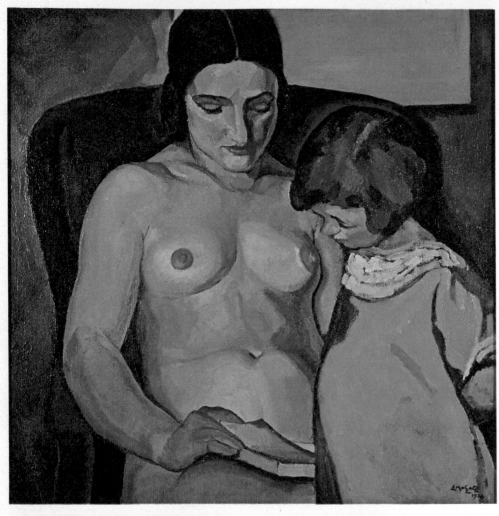

Mother and Child. 1926
24 x 24

EDWIN HOLGATE

1892-

Edwin Holgate became a late addition to the Group of Seven in 1931. By then, he had already established a firm reputation for his figure paintings and West Coast and Laurentian landscapes. A student in Montreal under the same William Brymner who had taught A. Y. Jackson, Clarence Gagnon and many other important painters, Holgate early showed a preference for painting humanity, an inclination shared in the Group of Seven only by F. H. Varley. Holgate spent a number of years in Paris painting the figure before returning to Canada in the early 1920's to begin the series of nudes in northern landscapes for which he is best known. Apart from a trip to the Skeena River area of British Columbia with A. Y. Jackson in 1926, Holgate has remained a Quebec-based painter. His landscapes have mostly been painted in the Laurentians, where he has lived much of his life. These are carefully patterned, ruggedly executed compositions, but rarely achieve the creative involvement found in his best figure and portrait studies.

Holgate's robust portraits form an eloquent gallery of Canadians, including lumberjacks, habitants, pilots, and such familiar creative figures as humorist Stephen Leacock. At their finest, there is a masculine monumentality to Holgate's portrayals. He has always used a direct, no-nonsense manner of painting which has its origins in the Cezanne oriented painters of the first two decades of the century. The same vigorous approach marks his large portrait drawings in charcoal.

During periods of his career, Holgate shared the same financial difficulties that beset some other members of the Group of Seven. They solved their economic difficulties by teaching,

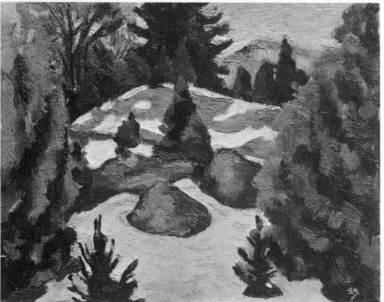

Melting Snow. 1948
8½ x 10½

but Holgate turned to wall decoration. He did many murals of varying distinction, the best known being his effective designs for the Totem Pole Room at Ottawa's Chateau Laurier which regrettably no longer exist except in photographs.

It was only after the Group of Seven years that Holgate finally undertook to teach at the Art Association of Montreal from 1935 to 1940. Many of Canada's most gifted contemporary painters, including Jean-Paul Lemieux and Stanley Cosgrove, benefited from his instruction. Among the talents Holgate brought to his teaching post were his skills as a book illustrator and wood engraver. His wood engravings of nudes and French Canadian interiors include some of the finest of all original Canadian prints. Holgate shared a passionate concern for rural Quebec with such artists as Clarence Gagnon and Horatio Walker. In his own dramatically designed black and white compositions, he made permanent that passing phase of history.

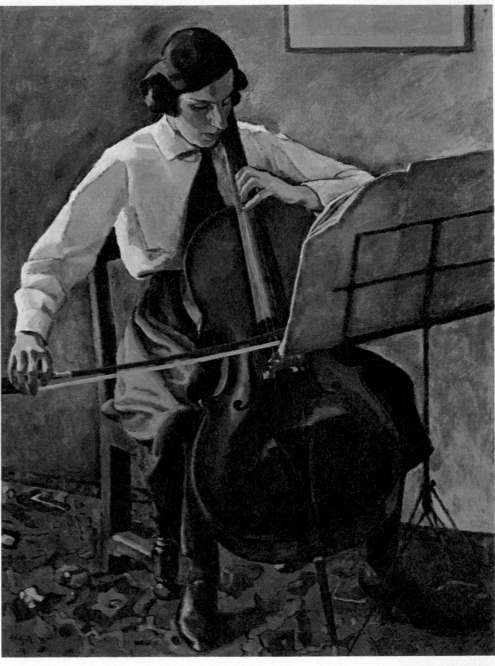

The Cellist. 1923
51 x 38½

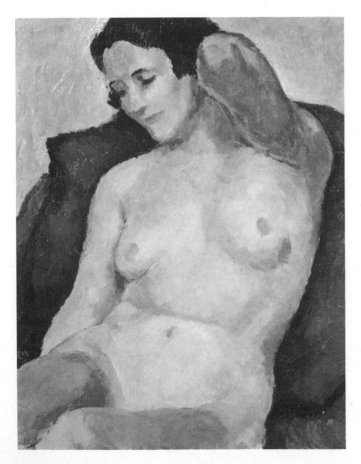

Nude. 1922
11½ x 10

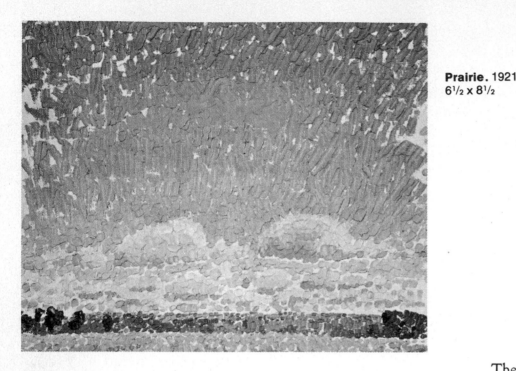

Prairie. 1921
6½ x 8½

LEMOINE FITZGERALD 1890-1956

LeMoine FitzGerald was the only western Canadian painter to become a member of the Group of Seven. FitzGerald's membership came at the very end of the Group's existence, too late to have any but an honorary significance. He was, in fact, too removed physically, in Winnipeg, and too different in his approach to landscape painting to have fitted in with the Group in their heyday.

FitzGerald was exceedingly individualistic, both as a personality and artist. Although he was involved in teaching at the Winnipeg School of Art for a quarter of a century, he was very much of a loner as a creative painter. His serene, pointilist canvases were achieved mostly during his holidays, using an immensely painstaking technique. It is not surprising that FitzGerald's paintings are few in number when one realizes how slowly his style obliged him to work and how little free creative time was at his disposal.

The paintings FitzGerald did achieve earned him a major place in Canadian art. He might fairly be described as the Seurat or Vermeer of our country's painting. He usually chose the simplest, most commonplace of themes—a garage, a backyard, a few apples, a milk pitcher or a plant in a window—and by the sheer intensity of his vision and refinement of craftsmanship converted these into works of art that, once seen, impress themselves upon the memory. FitzGerald studied for a short period at New York's Art Students League and, as a realist, shared the special magic to intensify ordinary visual experience that marks such great Americans as Charles Sheeler and Georgia O'Keefe.

Because of the limited creative time at his disposal, FitzGerald spent much of it executing drawings in pencil and pen and ink. These are as considered and complete as any of his paintings, and take an outstanding place in Canadian graphic art. They are drawings complete as an end in themselves and not preparatory notes for later development into canvases. In his last years, FitzGerald did a number of pure abstractions which reveal the same stylistic and technical concentration which typify his earlier still-lifes and landscapes. These abstractions represented a logical extension of the artist's lifetime pursuit of form.

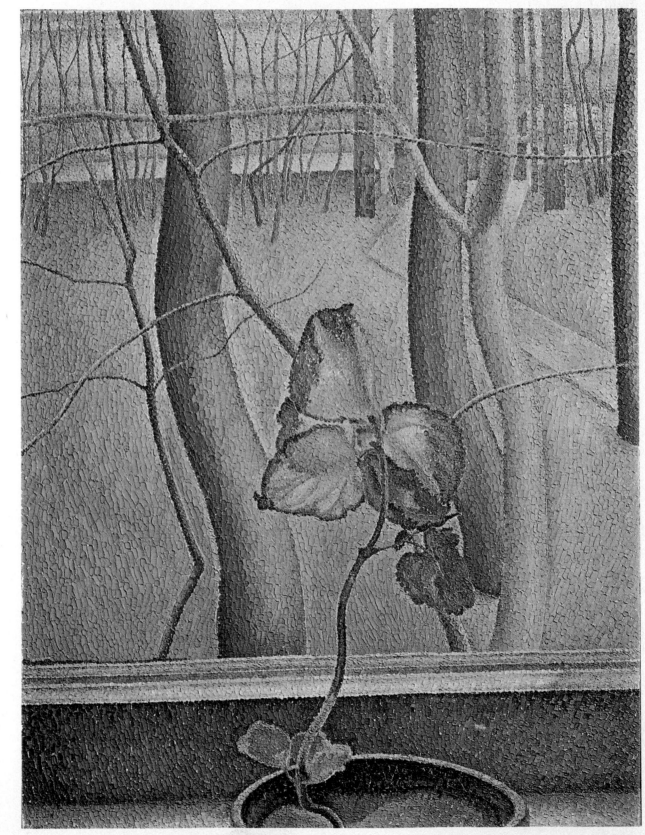

The Little Plant. 1947
24 x 18¼

Tree Trunk. 1939
11¼ x 15

Williamson's House. 1933
60½ x 44

The Embrace. c. 1925
10½ x 12⅞

The Harvester. 1921
27 x 24¹/₂

LIONEL LEMOINE FITZGERALD

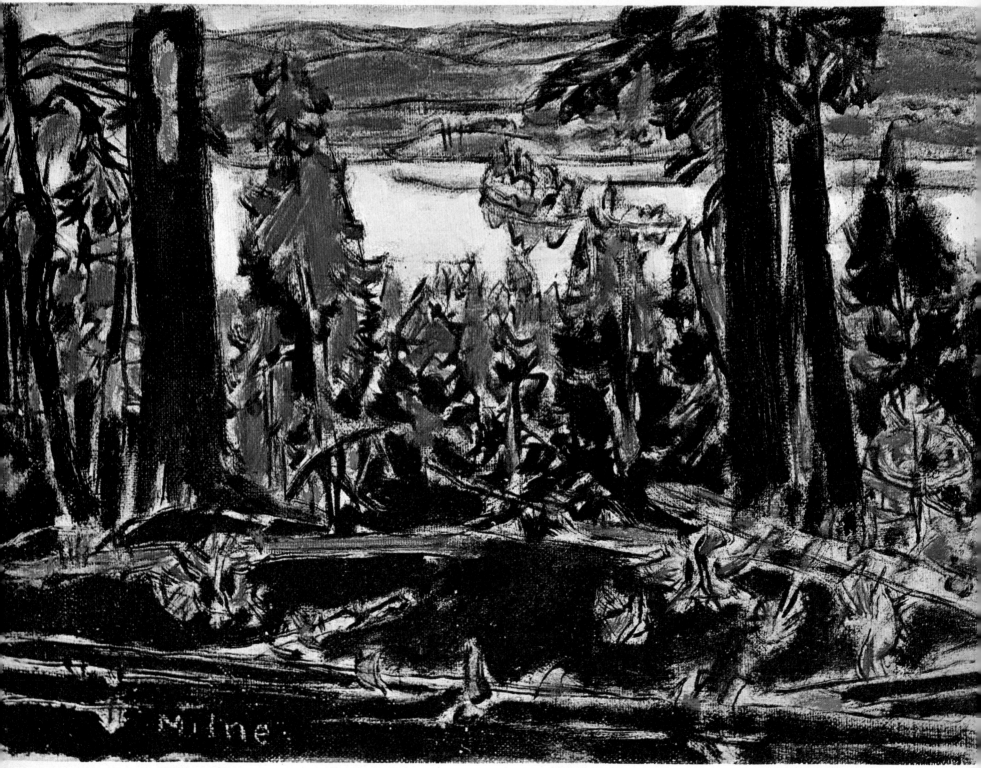

DAVID MILNE 1882-1953

David Milne was the quiet man of his generation of Canadian artists. Eloquent in paint, a descriptive writer in his occasional prose, Milne talked little about his art. Unlike the sociable Group of Seven members, Milne only rarely came into contact with his fellow painters. A loner—virtually a recluse—for most of his life, he was the opposite of a self-propagandist. Like Tom Thomson, he allowed his work to speak for him, and it did, in an original, intense and unforgettable way.

As an artist, David Milne made great demands upon his talent. He was a perfectionist, who could paint a dozen variations of the same theme until he was finally satisfied that he had refined his statement down to its essentials. As a result of this approach to art, Milne's compositions may appear deceptively simple at first glance. The depth of experience, judgment and technical skill required to compress such pictorial poetry into a few lines and colours can only be appreciated through acquaintance with his art. Economy of style in Milne's case is the result of an almost monastic dedication. Milne's art is the closest to the great Oriental painters in its eloquent simplicity and pure visual poetry.

The refinement of Milne's style grew through a progression of styles over a period of more than forty years. His canvases before the First World War were heavily pigmented, and boldly drawn in pure vermilions, olive greens, blues, ochres and black.

These brought him international notice in the famous Armory Show at New York in 1913. Milne was one of the many leading Canadian painters who studied at New York's Art Students League and much of his career was spent in the northern part of New York State until 1928. His lean, luminous dry brush watercolours and oils done in the Catskills, the lower Berkshires and the Adirondacks remain among his most commanding achievements. Upon his return to Canada, Milne painted for varying periods, at Timagami, Palgrave, Six Mile Lake and in Toronto. His colour drypoint etchings of Toronto buildings take a special place in his graphic work.

The McMichael Canadian Collection includes significant examples of Milne's achievement from early canvases of the 1914 period to the almost calligraphic watercolours of his last years.

Milne's early New York oils are the most richly coloured and robust of all his works. They are painted with a loaded brush and are almost encrusted in texture. The importance of these early canvases is underlined by the fact that several of them were included in the great, revolutionary Armory Show of 1913 in Manhattan. In that historic exhibition, Milne's work was displayed on the same walls as Picasso, Cezanne, Kandinsky, Matisse and Gauguin. His work can be compared with that of the American master, Maurice Prendergast. In the McMichael Canadian Collection, the early phase of Milne may be seen in the oils *West Saugerties* 1914, *Patsy* 1914, *The Lilies* 1915 and the watercolour *Relaxation* of 1914. In the years following, Milne's style became increasingly leaner in technique and more restricted in colour.

The canvases and watercolours of Boston Corners, Lake Placid and the Adirondacks painted between 1920 and 1928 are lean in execution to the point of a drybrush technique. They are almost Oriental in their subtlety of drawing and restricted hues. In the McMichael Canadian Collection, this phase of Milne's art is richly revealed in such oils as *Boston Corners* 1916, *The Gully* 1920, *Blue Church* 1920, *Haystack* 1923, *Mountains And Clouds* 1925 and the two small canvases of *Clarke's House* of 1923.

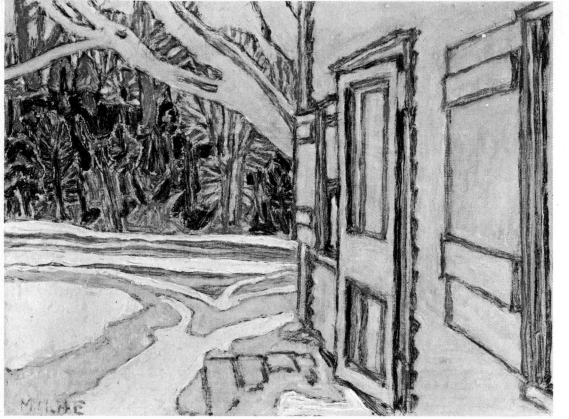

Clarke's House. 1923
12 x 16

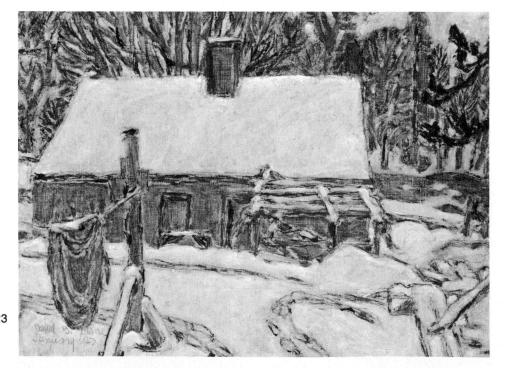

Clarke's House. 1923
12 x 16

Haystack. 1923
15¾ x 19¾

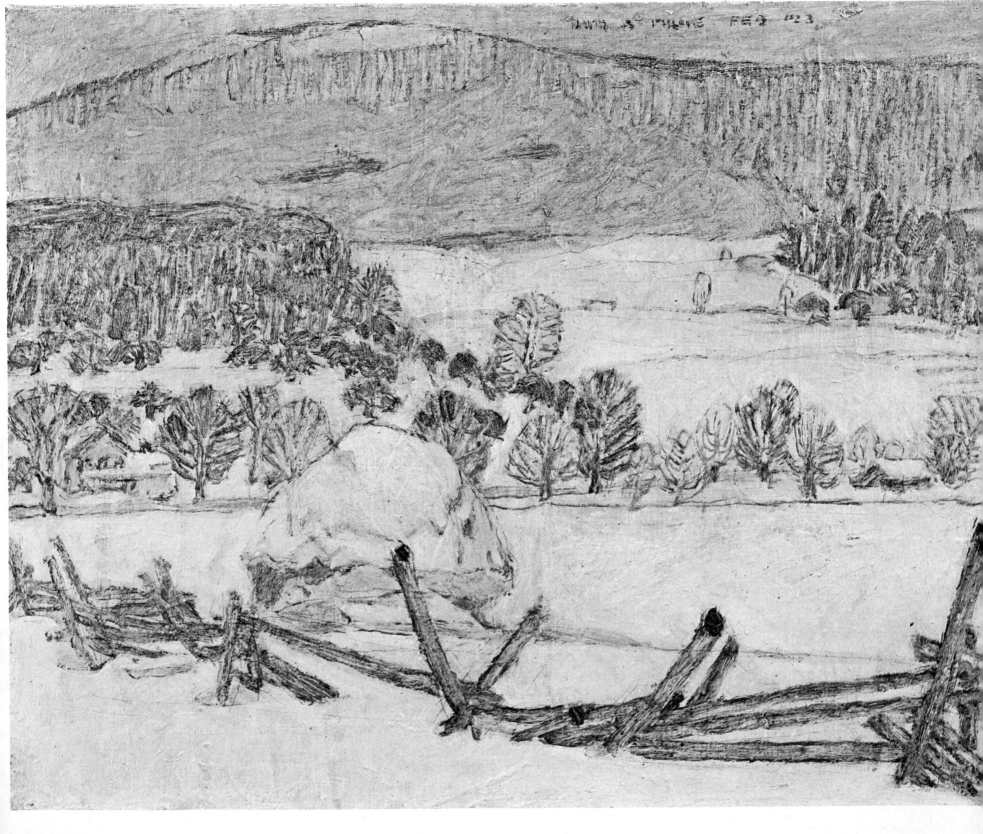

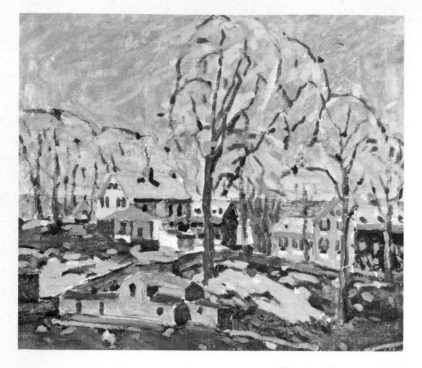

Boston Corners. 1916
17¾ x 20½

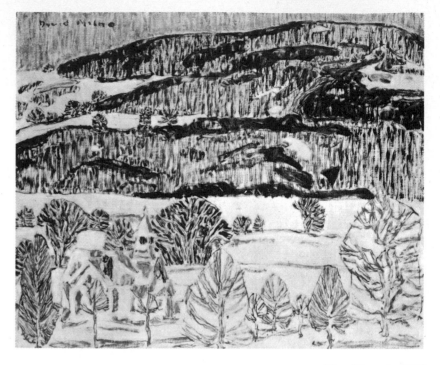

Blue Church. 1920
18³/₈ x 22⁵/₈

Patsy. 1914
20 x 23¾

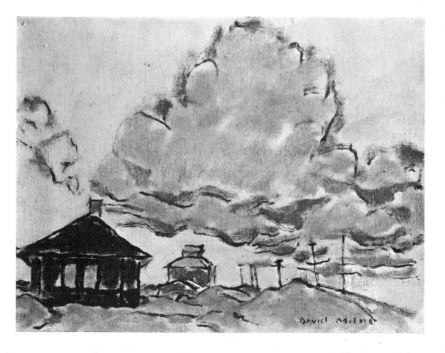

Railway Station. c. 1929
12 x 16

The Gully. 1920
20 x 24

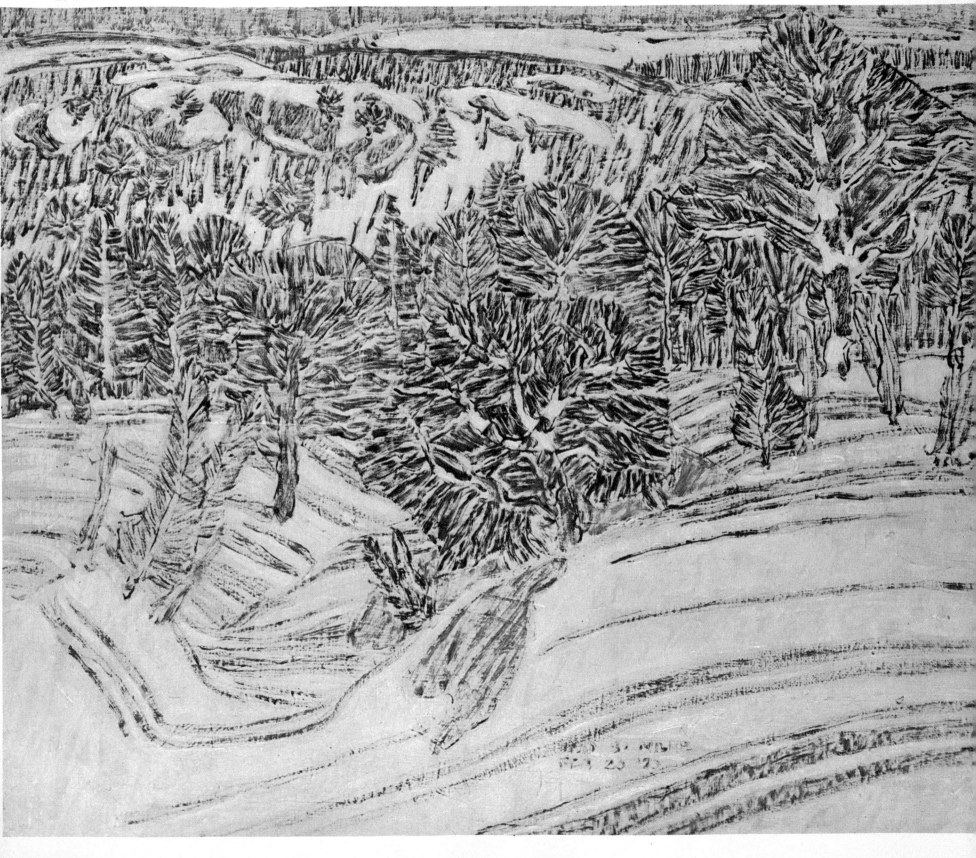

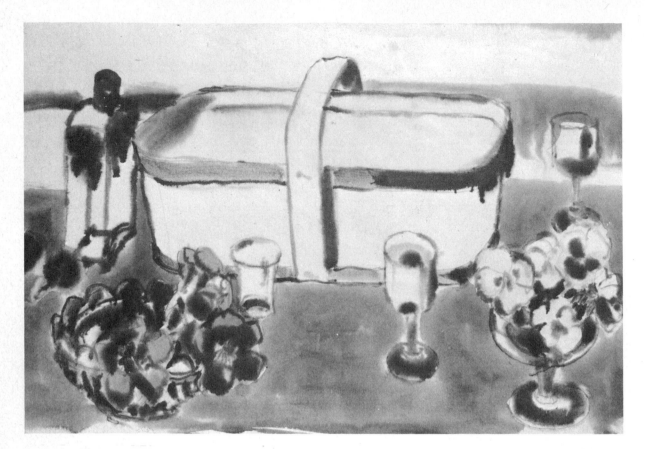

Pansies and Basket. c. 1947
14³/₄ x 21¹/₂

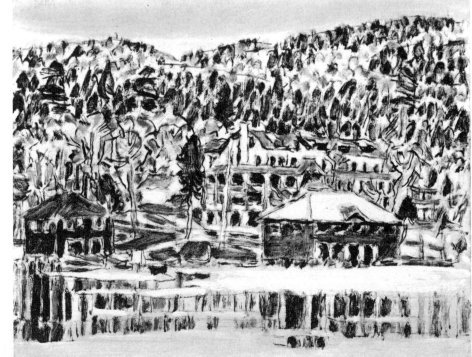

Boat Houses in Winter. 1926
16¹/₂ x 20¹/₄

Deer and Decanter. 1939
13³/₄ x 19

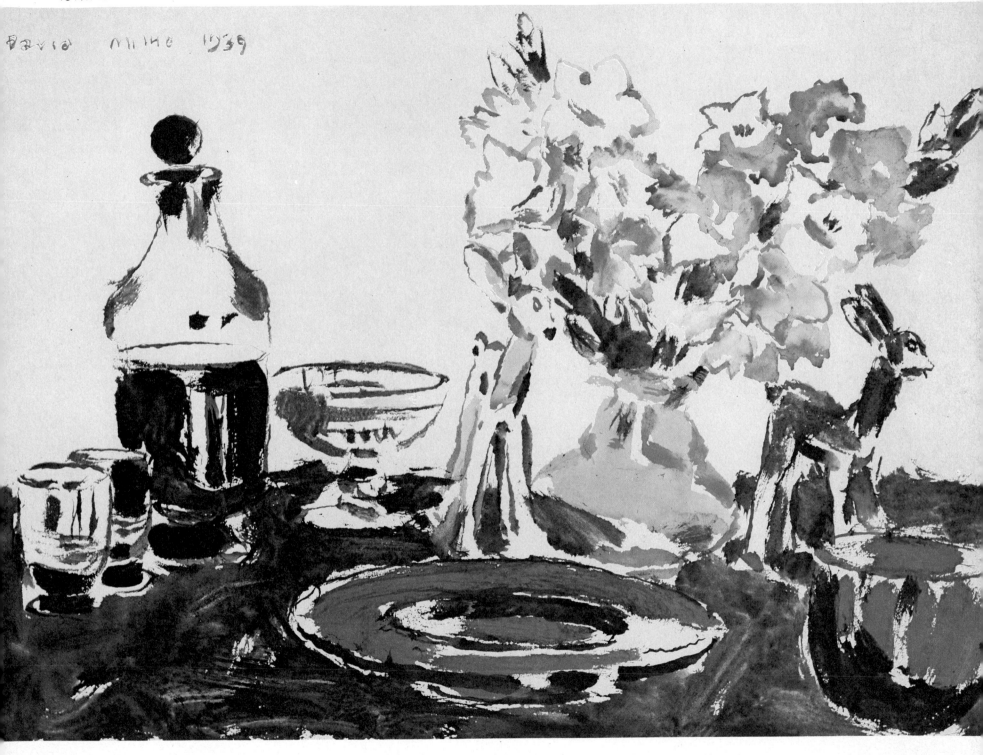

The Lilies. 1915
20 x 20

CLARENCE GAGNON 1881-1942

Clarence Gagnon was the pictorial bard of rural Quebec. The life and land of the habitant inspired him to some of the most engaging paintings ever made of the Canadian scene. His consummately drawn, high-keyed canvases are vibrant with the atmosphere and activity of French Canada.

Gagnon studied under William Brymner in Montreal and did his earliest records of Quebec at the turn of the century. After five years of study in Paris he returned to Canada in 1919 to begin his pictorial salutes to the colourful settlements of the St. Lawrence and the Laurentians. Although he spent most of his later years in France and Norway, his affections and art remained steeped in the life of his native land.

It was while living in Europe that Gagnon created what must be considered his most ambitious and remarkable creative achievement—the illustrations for the Quebec masterpiece *Maria Chapdelaine* by Louis Hémon. In the fifty-four paintings done to ornament this volume published in Paris in 1934, Gagnon equalled the eloquence of Hémon's symbolic tribute to French Canada with miniature masterpieces of his own.

Nowhere in Canadian annals has illustration reached to such heights as art. And no other Canadian artist possessed the combination of special talents to equal Gagnon's graphic eloquence. The illustrations for *Maria Chapdelaine* combine all of the factual specifics demanded of literary illustration along with tonal poetry and power of design as paintings in their own right. Sometimes as small as 3 x 3 inches and never averaging more than 10 x 9 inches, these amazing little paintings take a special place in the art of their time. They are, in turn, stark, tragic, gay, brave and tender. They move the emotions as much as they command admiration as art. Their subject matter is as timeless as their expression. From first communion to last rites, here are the vanishing traditions of rural Quebec in their totality.

For the first time, the Maria Chapdelaine illustrations can now be seen and enjoyed at will by the public.

During his lifetime, they were the most treasured possessions of the late Colonel R.S. McLaughlin, who reserved a special room for their display. It was always his wish that the paintings should never be separated. By giving them to the McMichael Canadian Collection, he was assured that they would remain together in perpetuity.

Clarence Gagnon first visited his favourite St. Lawrence painting site, Baie Saint Paul at the turn of the century, in 1900. There, he discovered his favourite themes of pastel-hued village streets, wayside shrines and parish churches. The quiet, rustic life of that early period finds its reflection in Gagnon's brush through the *habitant* figures at work, baking bread at open ovens, riding ox-pulled sleds or weaving on the doorsteps of their cottages. For the rest of his life, whether living in Quebec or Europe, Gagnon sustained his interest in the rural life of the lower St. Lawrence and Laurentians. Just before his death, he devoted his days toward a project to build a French-Canadian village museum to perpetuate the image of early habitant life.

Gagnon's great gifts as a painter have frequently overshadowed his abilities as a graphic artist. His series of etchings achieved during the first decade of this century are probably the finest ever done in this country. He also realized many distinguished figure drawings in the media of pencil and pastel.

Gagnon always carried his native Quebec within him wherever he travelled. Some of his best Canadian landscapes were painted in his Paris studio from sketches made at home. When he visited Norway or Switzerland, it was usually to sketch the snow which formed so much a part of his studies of scenes from his native land.

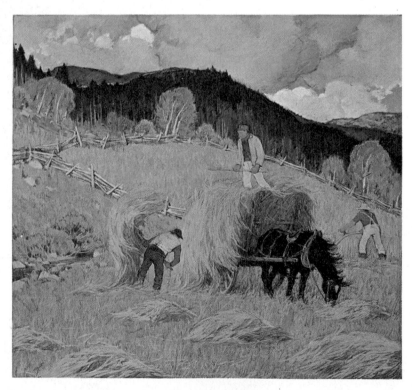
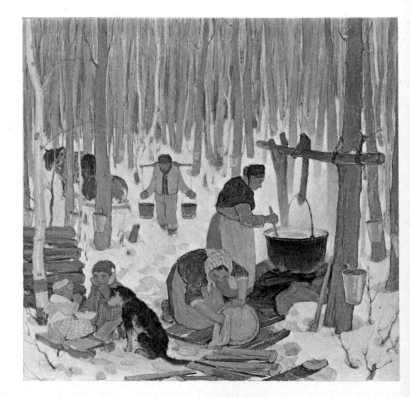

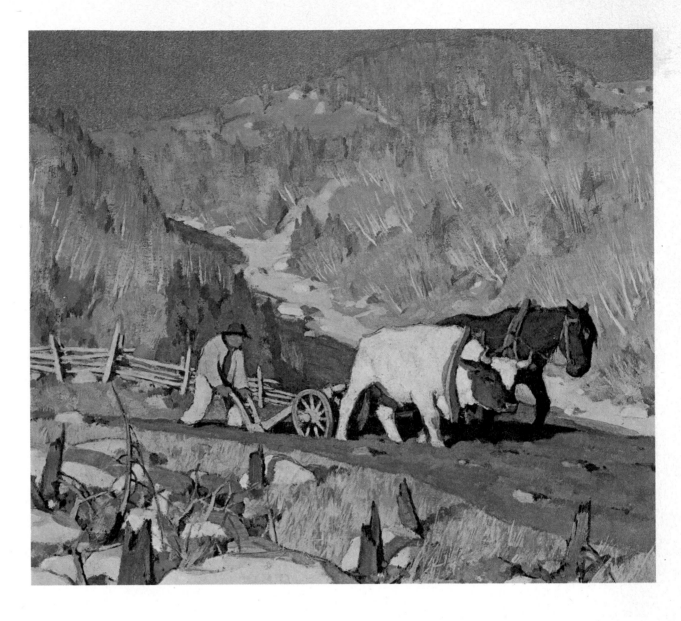

MARIA CHAPDELAINE

Maria Chapdelaine by the French author and journalist, Louis Hémon, is the classic novel of French Canadian habitant life. First published in 1914, the year after Hémon's death, it is unquestionably the most illustrated of all books about Canada. More than a dozen artists have decorated various editions including such distinguished Canadians as Suzor-Côté and Thoreau MacDonald.

The most famous edition of Maria Chapdelaine is that illustrated by Clarence Gagnon and published in 1933 by the Paris publishing house of Mornay. This volume is now one of the most sought-after of all books relating to Canada. It was first issued in a numbered deluxe edition of 2,000 copies, of which the McMichael Canadian Collection displays number 1545.

The 54 original illustrations for Maria Chapdelaine were presented by the late R. S. McLaughlin to the McMichael Canadian Collection and now form one of its most treasured exhibits.

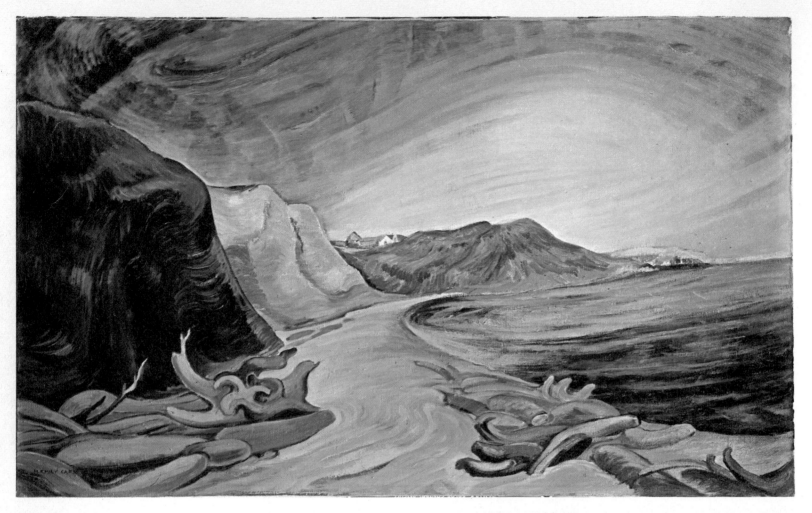

Shoreline. 1936
27 x 44

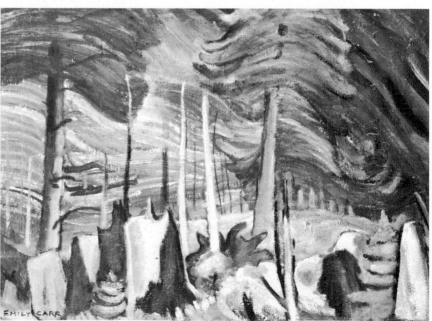

Swaying. 1936
14 x 18

EMILY CARR 1871-1945

Few artists have wedded nature and the human spirit so passionately as Emily Carr. A headlong, single-minded mingling of art with her love for her native British Columbia produced the finest expressionist painting Canada has known.

Emily Carr's long career was plagued by difficulties, financial and otherwise. Her creative demands upon herself, a lack of public appreciation and the pressures of poverty pursued her throughout her lifetime. She was forced to run a boarding house and make souvenir pottery to survive. For years, she was without the sustenance to paint. Despite this, with the encouragement of a few friends such as Lawren Harris, she persisted to create many masterpieces which include some of the most loved canvases in the history of Canadian art.

Emily Carr's first important works were closely related to the life and lore of the West Coast Indians. She spent much time among them, and from their totems, graveyards and churches composed some of her most dramatic paintings. Her canvases of the early 1912 series record such Indian villages as Skidigate, Tanov, Gitwangak and Alert Bay. In them, survive the houses, poles and people of an era then vanishing, as the career of Emily Carr was to cease for a period shortly afterwards. When she began painting again in the 1920's, Emily Carr was to approach the Indian material in a different mood and style.

By now, she was more concerned in capturing the spirit of the Indian structures than in recording them log by log. She simplified the totem poles and house poles, with their surrounding landscape, into abstracted designs which echoed the rich, carved rhythms of the Indian art itself.

By the 1930's, Emily Carr's attention turned almost completely to the B.C. coastal shorelines and forests. Her design-sense learned from the Indians and Cezanne found a looser expression. Her skies, earth and foliage became joined into a single swirling whole, reflecting her subjective feeling about her themes rather than their material facts.

Emily Carr's career as an artist spanned almost a half a century. Her earliest works are reticent watercolours done following studies in San Francisco and London. Her true power of expression first emerges in a series of brilliantly coloured canvases in the *fauve* manner painted in Brittany, France from 1910 to 1912. Upon her return to Canada in 1912, Emily Carr adapted the rich fauve style to portrayals of West Coast Indian villages and landscapes. Two examples of her work in this manner in the McMichael Canadian Collection are *Brittany, France* 1911 and *House And Garden*, probably painted in 1912.

By the early 1930's, Emily Carr had already achieved such familiar masterpieces as *Indian Church*, exhibited in 1933 by the Canadian Group of Painters. Her compelling and mystical wood interiors were also attracting the attention of a few discriminating collectors. The National Gallery of Canada had already purchased her west coast studies as early as 1928 and continued to do so through the 1930's and after. In the McMichael Collection the magnificent landscapes of the 1930's are represented by such superb, rhythmic compositions as *Reforestation* 1936, *Shoreline* 1936, *Old Tree At Dark* 1936 and *Edge Of The Forest* 1938.

Although she lived mostly alone, Emily Carr created a pictorial universe for others. From a caravan, in which she travelled up and down the British Columbia coast, she created an ageless art of the spirit to be shared by future Canadians for countless generations.

Emily Carr was a gifted writer and much of her life story and philosophy is to be found in such remarkable autobiographical books as Klee Wyck, Growing Pains, House Of All Sorts and Hundreds And Thousands.

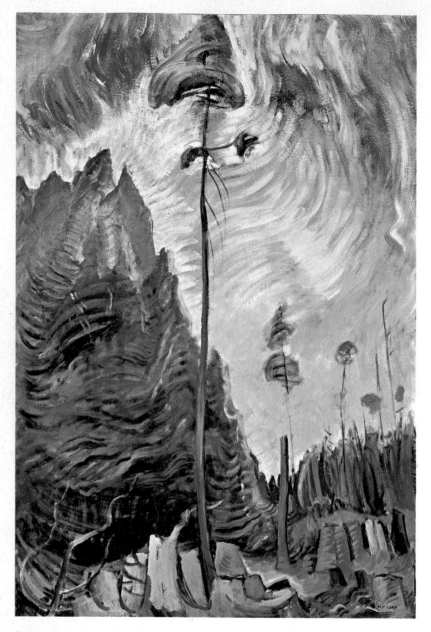

Edge of the Forest. 1938
33 x 22

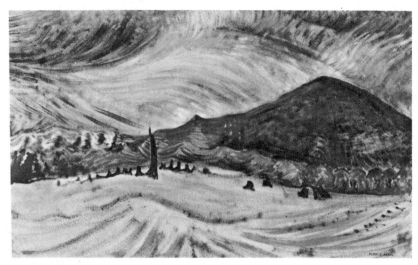

Sand Dunes and Mountains. 1940
21½ x 35¼

Brittany, France. 1911
17¾ x 20½

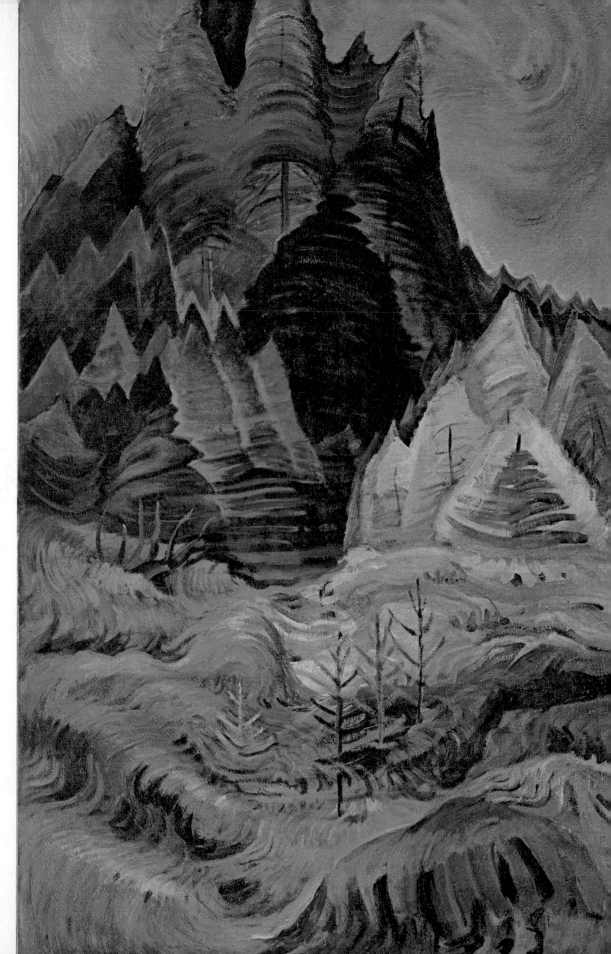

Reforestation. 1936
44 x 27

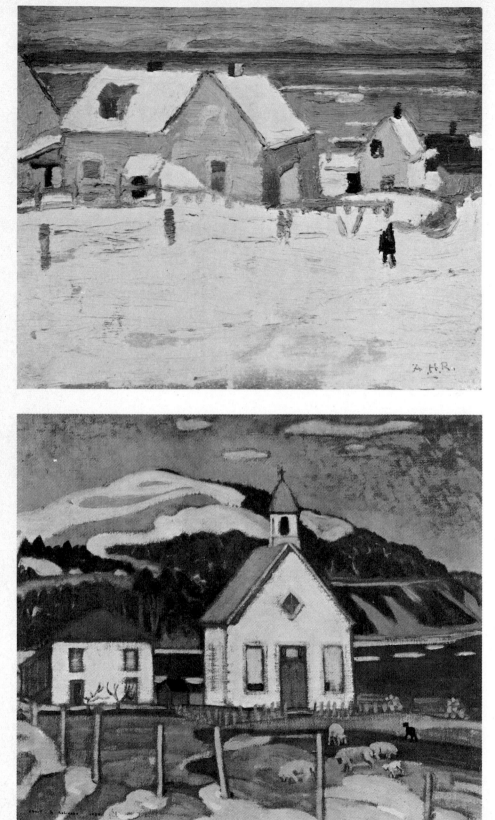

On the St. Lawrence. 1914
$8^{1}/_{2}$ x $10^{1}/_{2}$

ALBERT ROBINSON

1881-1956

The career of Albert H. Robinson was beset and shortened by illness. Rheumatism crippled him during the last decades of his life and his painting career was limited to a span of little more than twenty years. In that time, he produced some of the most subtle colour compositions ever painted of the Canadian landscape. The very earliest of these were of subjects in Europe, where he painted with his close friend A. Y. Jackson in Brittany in 1911. The delicate hues he favoured then were transferred permanently to the Quebec scene in the group of sketches and canvases he painted during the 1920's. These views of such areas as the Laurentians, Baie Saint-Paul, Saint-Fidele and Murray Bay are among the best loved and most sought-after views of French Canada.

Loosely rendered, in an almost patch-work technique of square edged, lozenge-shaped strokes, they represent a gentle and poetic response to the Canadian landscape. Robinson was primarily a painter of winter, but there appears no bitterness, starkness or challenge in his snow-clad hills and villages. His was a pastel vision. It is as though his pink, grey and blue dipped brush removed the severity from the land and left behind only the silver sunlight and the sound of sleigh bells. Like the happy French master, Raoul Dufy, Robinson turned almost everything he painted into a land a little gayer than the reality we see. Robinson's gentle tonal art is represented in the McMichael Canadian Collection by three canvases, including *St. Joseph* with its sapphire-like patches of water and several sketches of the villages he was so fond of recording.

Gaspe Church. 1929
$22^{1}/_{2}$ x $26^{1}/_{2}$

St. Joseph. 1922
26 x 32¹/₂

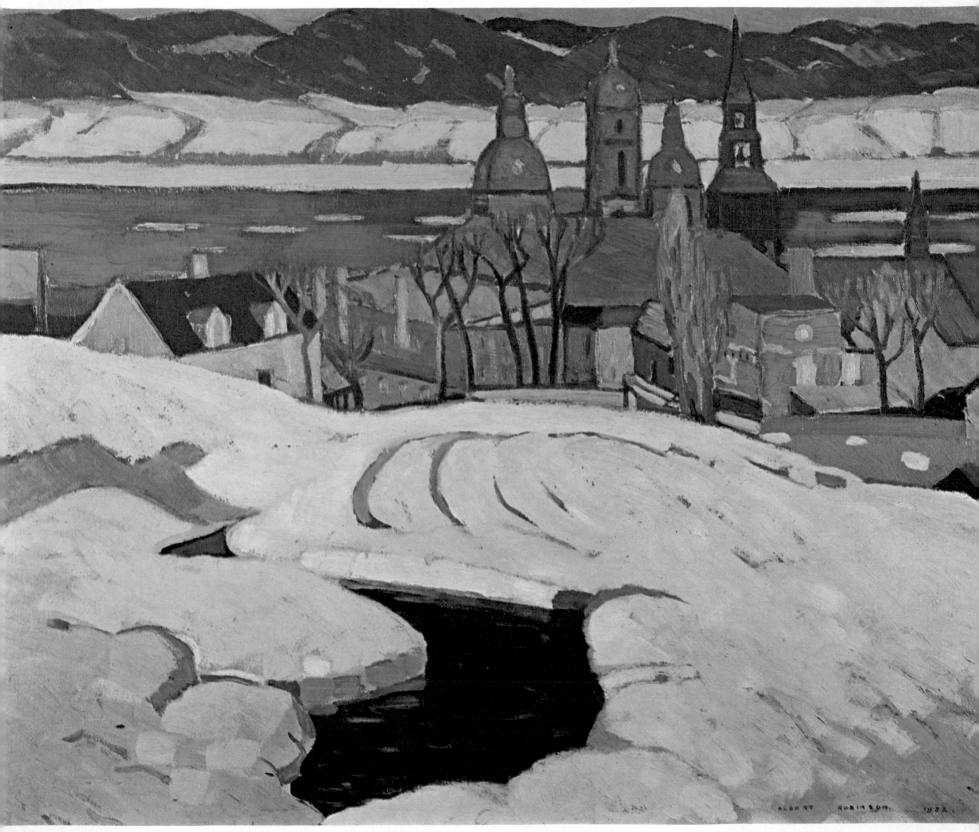

Notre Dame. c. 1898
7½ x 9½

J.W. MORRICE 1865-1924

J.W. Morrice was one of the gypsies of Canadian art. Born in Montreal, his wanderlust career took him among other places to Paris, Venice, Brittany, Spain, North Africa, Tunis, England, Cuba and Trinidad. Originally intended for a career at law, he first began to paint in the Toronto area while studying at the University of Toronto. Immediately upon finishing his legal studies, he headed for Paris to study art. For most of his life after that Paris remained his creative headquarters.

Morrice was a close friend of Canadian fellow-painters Maurice Cullen and William Brymner. Together, the trio had an immeasurable impact upon the country's art. Brymner taught A.Y. Jackson, Edwin Holgate, Clarence Gagnon, Helen McNicoll and many other important national painters. Both Morrice and Cullen were major influences upon such significant figures as A.Y. Jackson, Goodridge Roberts, Jacques de Tonnancour, John Lyman and Robert Pilot. Jackson often described Morrice and Cullen as the two who formed "the backbone" of his career.

Although he was an expatriate for most of his life, Morrice is one of the most popular and sought-after Canadian painters and is regarded by many, especially in Quebec, as our greatest painter. Certainly, Morrice has received the widest international recognition of any of our past artists. He was a close friend of the great French masters Henri Matisse and Albert Marquet, and the important British painter Matthew Smith,

and shared painting trips with all of them. Morrice's last late canvases, painted in the West Indies under the colour influence of Matisse are certainly among the best ever realized by a Canadian-born artist. Today, European critics agree that Morrice played a very real, if relatively minor role in the history of French art during the post-impressionist period.

Probably the most personal aspect of Morrice's art was his abbreviated drawing style. This loose, economic manner was already established as early as 1909 when he painted the famous *The Ferry, Quebec* and continues through to the last glowing Trinidad canvases.

Some of Morrice's most telling creations are the small pochades or quick sketches in oil he made in panels while sitting in city cafes or at the seashore. The seventeen examples of this type in the McMichael Canadian Collection reveal the artist's changing styles over a period of more than twenty years.

These range from an early grey, heavily painted panel *Notre Dame* to a luminous, simplified, sunlit view of *Tunis*, painted toward the end of his career. Although most of these works measure a mere four and three-quarters by six inches, each of them is a complete composition. The intimacy and warmth of these spontaneous notations puts them into a place of their own in Canadian art. The technique used to create these small oils was a combination of rubbed-in glazes and brushwork accents. Morrice carried a little sketchbox in his coat pocket and would stop to quickly record any on-the-spot scenes which appealed to him, whether they were in a country field or along a busy boulevard.

Although Morrice was restless in his travels, his painting arose from an inner creative constant. He turned natural forms to his own creative ends, regardless of whether he was in France, Quebec, North Africa, Cuba or Trinidad. His style of painting is unmistakable, regardless of theme.

Despite the influence upon him of several great artist-friends, Morrice remained his own creative man. There is a contagious charm about his art in general which is little short of pictorial magic. Morrice was a compulsive painter who recorded life from a deep love of the world around him.

Tunis. c. 1920-21
9 x 12½

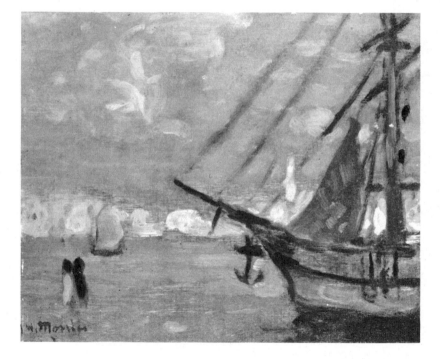

Sailboat. c. 1911
4 x 6

Algiers. c. 1919
10 x 9¼

Cuba. c. 1915
10 x 12½

Along the Bank. 1908-10
4¾ x 6

Harbour. c. 1898
4¾ x 6

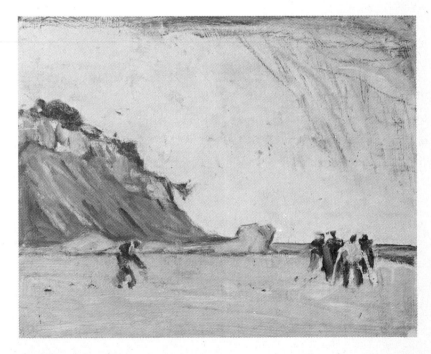

Clam Digging, France. c. 1914
4¾ x 6

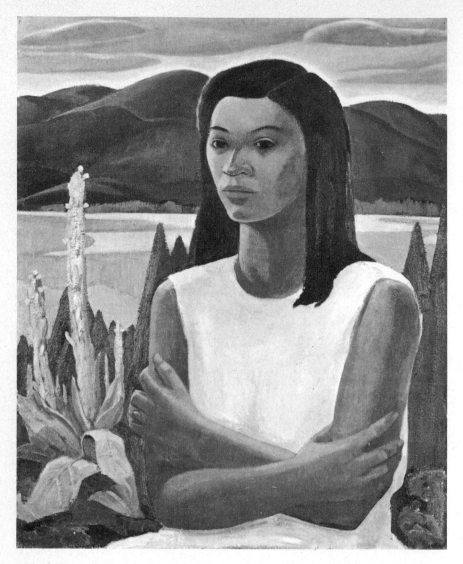

Indian Girl. 1932
30 x 24

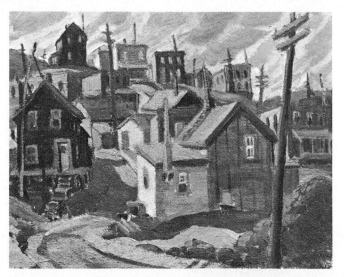

Cobalt. 1928
10³⁄₈ x 13 ³⁄₈

YVONNE HOUSSER 1898-

Although Yvonne Housser was not a member of the Group of Seven she was closely associated with the movement and was a founding member of the Canadian Group of Painters which succeeded the original Group in 1933. In canvases painted in the late twenties and early thirties, she concentrated on portraying Northern Ontario mining towns. These studies vividly capture the special character of those isolated settlements, whose frame houses scattered on a sea of rock were among the most telling symbols of a desperate era in Canadian economic history.

The career of Yvonne Housser represents the restless, questing spirit of many artists born at the turn of this century. From a near-impressionist European style of the early twenties, she moved through a Group-oriented landscape period, a finely realized series of Indian portraits and Mexican scenes to the almost pure abstractions of the 1960's. Despite these changes from style to style, her evolution was a logical and organic one, and at no time do we find a change in direction for the mere sake of fashion.

Yvonne Housser taught at the Ontario College of Art for some thirty years and, like the creative teacher she was, continued her own studies under such international masters as Hans Hofmann at Cape Cod and Emil Bistram in Mexico. Her substantial body of paintings done over many decades represents only a part of her restless dedication to the creative life of Canada as artist, teacher and counsellor to many of her colleagues.

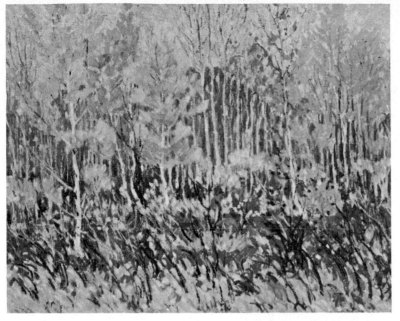

Autumn Forest. mid 1930's
24 x 30

Slumber. mid 1930's
32 x 40

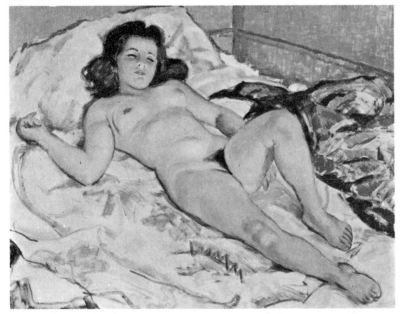

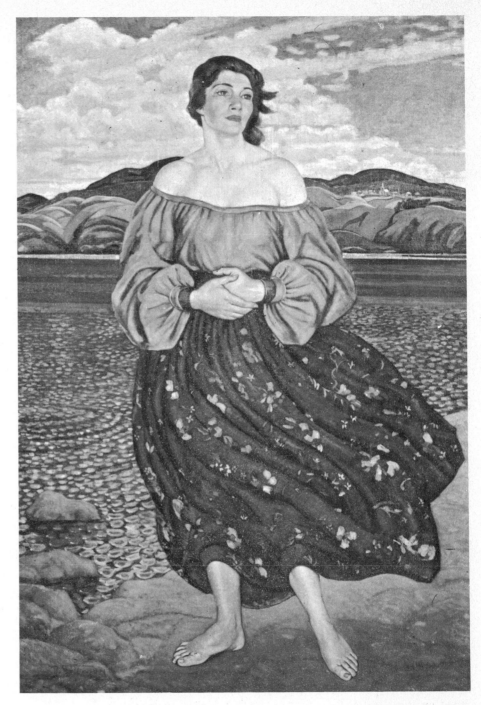

Benedicta. c. 1932
72 x 48

RANDOLPH HEWTON—1888-1960

Randolph Hewton was one of the best trained of all Canadian painters. Beginning as a student under Montreal's famed William Brymner in 1903, he later studied and painted in Paris from 1908-1913. In Paris, Hewton shared his studio for a time with A. Y. Jackson, and the two painted together in rural France. Their joint exhibition of these European works held at the Art Association of Montreal in 1913 first brought Hewton and Jackson to public attention. Hewton later exhibited with the Group of Seven as an invited contributor. His art career was cut short when he decided to enter the business world in the early 1920's. Although he continued to paint some fine canvases—particularly of figure and portrait subjects—one can only guess what Hewton might have achieved if he had continued to concentrate upon his art.

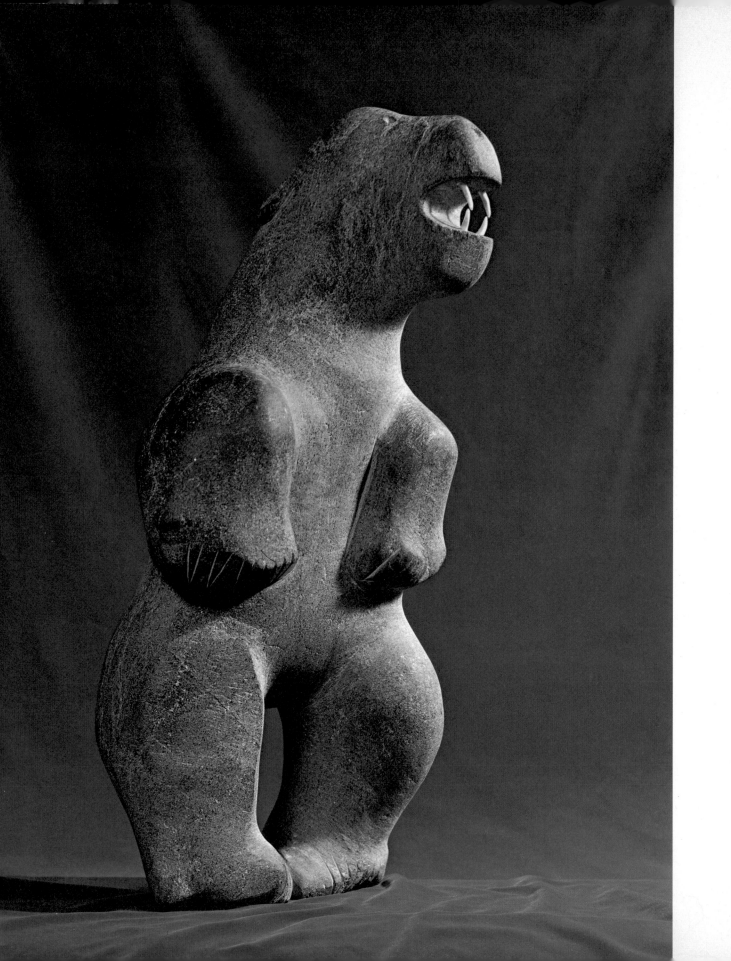

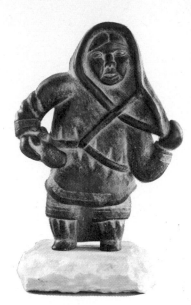

Artist Unknown
Dark grey stone
10.75 x 7.875 in.

Pauta
Cape Dorset
Grey stone
24 x 11 in.

THE CANADIAN ESKIMO

Unlike the lush, forested, formed Pacific environment which gave birth to West Coast Indian art, Eskimo culture grew out of the flat, inhospitable tundra of the Arctic plains and the endless horizons of its seas. The hardy prehistoric people who several thousand years ago migrated across the Bering Strait and made their way eastward to Hudson Bay and beyond, brought with them rudimentary creative skills which eventually led to the familiar art of the contemporary Eskimo.

Those earliest migrants are now referred to as the Denbigh People who were followed by the Dorset culture which came into being sometime around 800 B.C. and lasted about a thousand years. The Dorset Eskimos evolved a considerable civilization from the unpromising Arctic and its influence reached as far east as Newfoundland and Greenland. They used bone, stone and Caribou antlers to carve and engrave some of the most powerful miniature images of any early culture, in the form of human figures, animal and spirit forms. Around 900 A.D., the rich Dorset culture was succeeded by a wave of Eskimos from the West known as the Thule People who established a firm base for the Eskimo way of life as it existed until the recent influx of the white man and his mechanized way of life. The Thule utilized the same igloos, fur boots and clothing, kayaks and forms of entertainment which have always been associated with the Eskimo civilization.

The modern Eskimos who succeeded the Dorset and Thule cultures, have seen a telescoping of progress which, for better or worse, has taken them from a near-stoneage way of life to the atomic age in a few decades. Today, the kayak is being replaced by power boats, the dog team and sled by snowmobiles, the bow and arrow by high powered rifles and the ageless drum dances by record players. What remains of ancient traditions and legends, is to be found in the sculptures and prints of the Eskimo artists and even there, they are rapidly disappearing.

Eskimo art first became familiar to the outside world a mere quarter of a century ago when, for the first time, it found an appreciative audience outside of the Arctic. Although some Eskimo carvings and engravings in ivory had made their way into European and American museums in the last century, they were mostly looked upon as ethnological records, rather than as works of art. Only since a concentrated effort was made in the 1950's to encourage Eskimo artisans to create regularly has there emerged a group of fulltime or almost fulltime carvers and print-makers. Today, millions of Canadians and people abroad are familiar with the symbols of a vanishing way of life through their work. The legends and animals of the Arctic have been made familiar to millions of people through Eskimo portrayals of demons, spirits, musk-ox, caribou, seal, walrus, narwhale, snow geese and other creatures.

Within a few short years, places known only to a few Arctic travellers and officials have become bywords to collectors. Baker Lake, Cape Dorset, Repulse Bay, Lake Harbour, Felly Bay, Port Harrison, Pangnirtung, Belcher Islands, Povungnituk, and Rankin Inlet have become noted for their carvings in local styles and materials. Their sealskin and stone prints are eagerly sought after souvenirs of a vanishing art. As sophistication comes to the lives of the Eskimo artists and the marketing of their wares, individual names emerge. The works of such individual sculptors and printmakers as Kenojuak, Pauta, Parr, Pitseolak, Lucy, Kiakshuk, Kiawak, Simonee, Davidealuk, Akeeah and Tiktala have become famous as the creations of highly talented individuals. Such people have established the Eskimo people as artists in the minds of an international audience. What will follow this remarkable surge of creation as mechanization moves in, proves as deep a mystery as the prehistoric beginnings of Eskimo art itself.

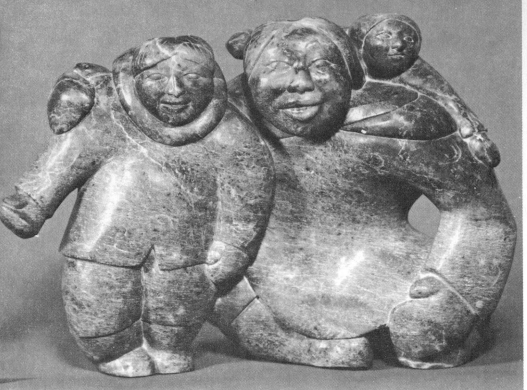

Kiawak
Cape Dorset
Green stone
13 x 19.25 in.

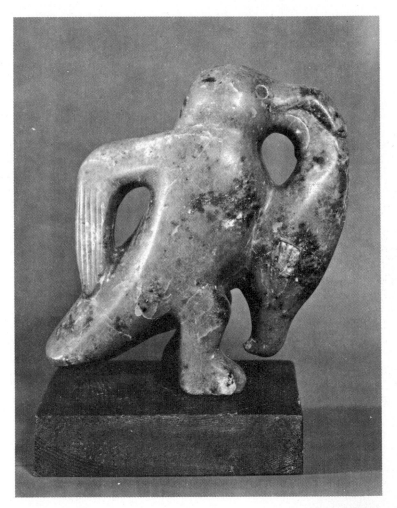

E. Guvulieh
Cape Dorset
Green stone
9.5 x 8.25 in.

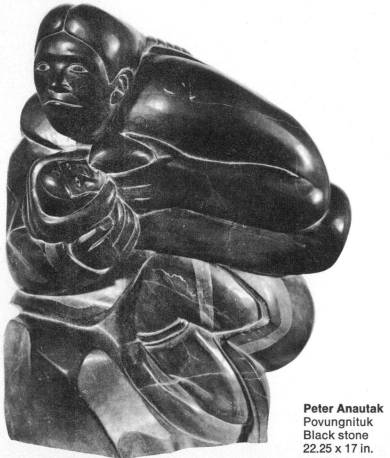

Peter Anautak
Povungnituk
Black stone
22.25 x 17 in.

WEST COAST INDIAN

The Canadian art form best known to the rest of the world is that of our West Coast Indians. For almost a century, it has been rated internationally as one of the richest and most powerful of all tribal arts. As early as the late eighteenth century, Haida and Kwakiutl artifacts were finding their way into European collections.

Canadian collectors and museums were late appreciating this native art, by which time many West Coast masterpieces had found a place of honour in foreign lands. Today, most Canadians are finally becoming aware of the magnificence of their Indian inheritance, whose forms echo with undiminished power down the years. The names of the great tribes of carvers are at last becoming a part of our national cultural pride. The Tsimshian, Haida, Tlingit, Salish, Kwakiutl and Nootka are now equated with great sculpture, where to most people, they once only represented hunting, fishing and warfare.

The traditional forms of West Coast Indian art appear centuries before the first totem pole was ever executed. Superb examples in stone, bone and antler have emerged from prehistory and by 500 A.D. many familiar animal shapes that appear in late Indian art were fully realized. The totem poles popularly associated with Indian art date from the nineteenth century, when the introduction of the metal tools of the whiteman allowed huge tree trunks to be readily carved. Wood was the most available material along the deeply forested Pacific Coast and it was natural that the greatest West Coast art should be created from it. Wood allowed for the maximum contrast of breadth and detail. It permitted both the large, sweepy volumes of giant poles and house posts, and the delicate detail of masks, rattles, boxes and headdresses.

West Coast Indian art was both religious and social. The giant totem poles were heraldic crests in which each chief boasted of his strengths and privileges. These were made visual by the use of such symbols as the beaver, bear, frog and killer whale. The red, brown, ochre, green and white paint with which they were finally decorated was ground from such natural materials as iron ore and yellow earth, frequently mixed with an oil made from salmon roe.

Of the many thousands of magnificent poles commissioned by the chiefs for their villages most have now decayed, victims of combined neglect, time and weather. Few have survived in such a remarkable state of preservation as the one from Blunden Harbour in the McMichael Canadian Collection.

Some of the finest sculptures by the West Coast artists were in the form of masks, mostly used in the famous "Potlatch" ceremony, a party thrown to establish prestige for individual chiefs or clans. Most of the masks were designed and carved by a special group of privileged caftsmen, and they were first unveiled in ritual dances around the Potlatch bonfires. These masks are dramatic masterpieces in their originality of concept and skill of rendering. Copper, abalone shell and cedar root were often added as ornamentation to the wooden faces which symbolized the wind, the moon, such animals as the bear, frog or lynx and legendary sea monsters or thunderbirds.

A favourite material used by the Haida carvers of the Queen Charlotte Islands was argillite, a clay rock often referred to as slate. Argillite came into use during the nineteenth century for the making of miniature totem poles, boxes and statuettes.

The McMichael Canadian Collection includes a number of outstanding early examples of Haida argillite carvings by such masters of the medium as Charles Edensaw, Tom Price, Isaac Chapman and William Dixon.

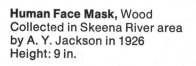

Human Face Mask, Wood
Collected in Skeena River area
by A. Y. Jackson in 1926
Height: 9 in.

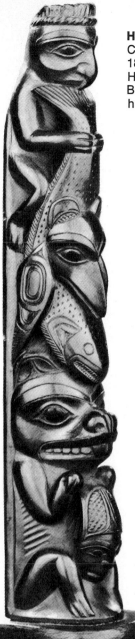

Haida, Argillite totem
Charles Edensaw
1839-1924
Height: 6.5 in.
Bottom to top figures are: beaver,
halibut, raven and human.

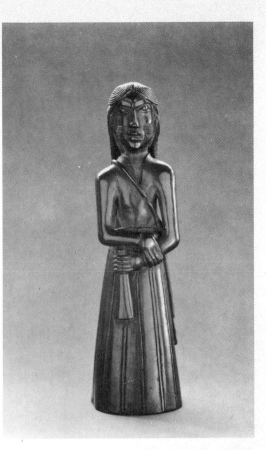

Haida, Argillite Figure
Carver Unknown
19th century
Height: 8.5 in.

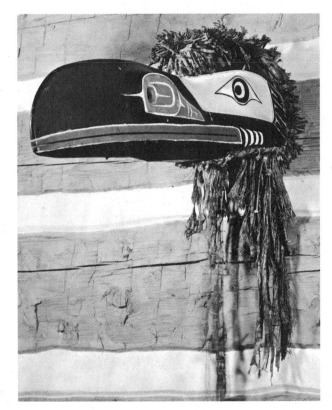

Kwakiutl, Raven Hamatsa Mask
attributed to Willie Seaweed
1873-1967
Wood and cedar bark
Length: 43.25 in.

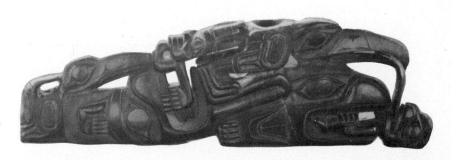

Haida, Argillite Pipe
Carver Unknown
Length: 8.5 in.

All paintings, unless otherwise noted are oil on canvas or panel. All measurements are in inches.

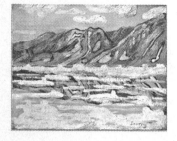
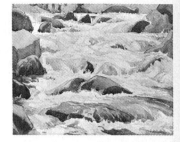
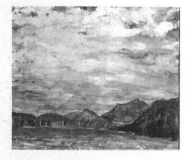
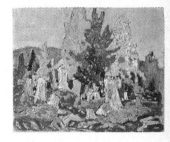
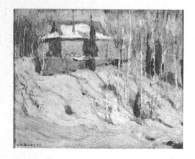
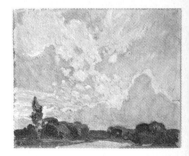

SIR FREDERICK BANTING. 1891-1941
Ellesmere. 1927
8½ x 10½
Arctic Coast. 1927
8½ x 10½

J. W. BEATTY. 1869-1941
The Red Roof. 1917
8½ x 10½

Winter Hills. c. 1925
8½ x 10½

FRANK CARMICHAEL. 1890-1945
Rocks and Stream. 1909
pencil
11 x 8¼

Go Home Bay. 1916
8½ x 10½

Hilltop Cedars. 1920
10 x 12

Autumn Tapestry. 1920
10 x 12

October Gold. 1922
47 x 38¾

Autumn Woods. c. 1922
9¾ x 12

Bolton Hills. c. 1922
9¾ x 12

Dead Spruce. 1923
9¾ x 12

Tumbling Water. 1924
watercolour
8½ x 10½

Scarlet Hilltop. c. 1924
9¾ x 12

Clouds and Sunburst. 1925
10 x 12

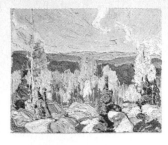

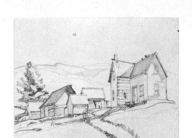
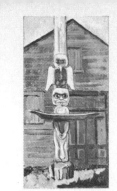

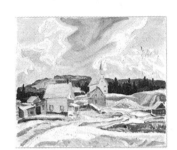

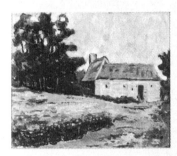

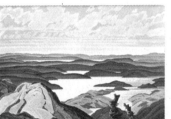

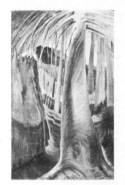

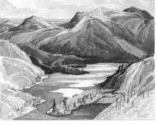
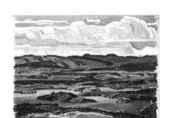
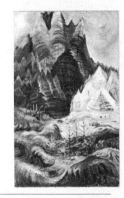

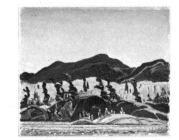

FRANK CARMICHAEL (cont.)
Autumn, Orillia. 1926
9¾ x 12

Elms. 1928
pencil
8 x 10⅜

Spring Garland. c. 1928
10 x 12

A Northern Silver Mine. 1930
40 x 48

Old Store. 1930
watercolour
3½ x 4¾

Farm House. 1930
pencil
8 x 10⅜

Northern Town. c. 1931
10 x 12

Northern Tundra. 1931
30 x 36

Grace Lake. 1933
11 x 13

LaCloche Lake. 1934
pencil
8 x 10⅜

LaCloche Mountain Tops. 1934
pencil
8 x 10⅜

Cranberry Lake. 1934
pencil
8 x 10⅜

LaCloche Panorama. 1939
10 x 12

LaCloche Silhouette. 1939
10 x 12

Alman's Trail. 1939
10 x 12

Twisted Pine. 1939
10 x 12

Waterfall. 1943
tempera
28½ x 38½

EMILY CARR. 1871-1945
Brittany, France. 1911
17¾ x 24

Kispiox. 1912
24½ x 12

Garden, Victoria. c. 1912
15 x 18

Old Tree At Dark. c. 1936
44 x 27

Reforestation. 1936
44 x 27

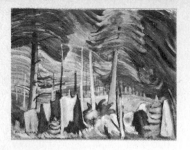
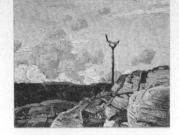

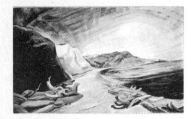
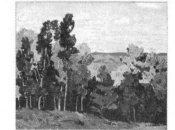

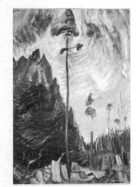

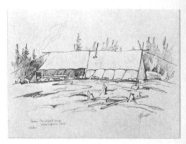

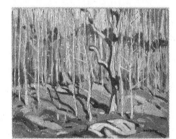

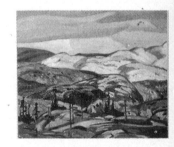

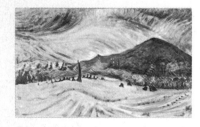
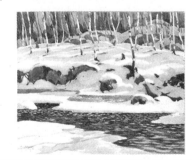

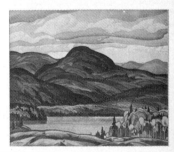

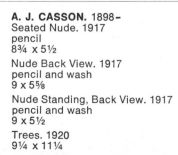

EMILY CARR (cont.)
Swaying. 1936
14 x 18

Shoreline. 1936
27 x 44

Edge of the Forest. 1938
oil on paper
33 x 22

Sand Dunes and Mountains. 1940
oil on paper
21½ x 35¼

A. J. CASSON. 1898–
Seated Nude. 1917
pencil
8¾ x 5½

Nude Back View. 1917
pencil and wash
9 x 5⅝

Nude Standing, Back View. 1917
pencil and wash
9 x 5½

Trees. 1920
9¼ x 11¼

Rock and Sky. 1921
9⅜ x 11¼

Haliburton Woods. 1924
10 x 12

Summer Landscape. 1924
10 x 12

Poplars. 1925
10 x 12

Winter on the Don. 1926
watercolour
17 x 20

Rocks and Clouds. 1926
linoleum block print
8 x 8

Ice House, Port Caldwell. 1928
pencil
7½ x 9¾

Nashville House. 1928
pencil
8 x 10¼

Hillsburg. 1928
pencil
7¾ x 10½

Country Store. 1928
pencil
8 x 10¼

Galt Road. 1928
pencil
7¾ x 10½

Casson-Carmichael Camp. 1928
pencil
8 x 10¾

Sombreland, Lake Superior. 1928
9 x 11

Pike Lake. 1929
watercolour
16½ x 20

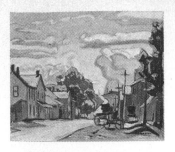
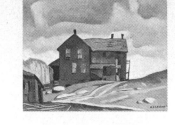

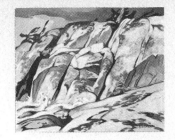

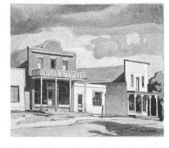
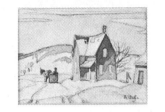
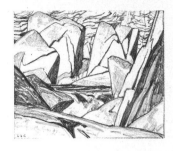

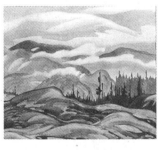
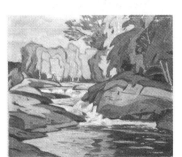
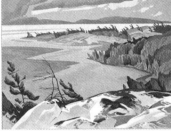

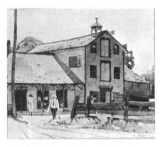
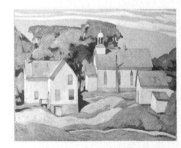

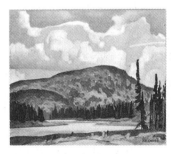
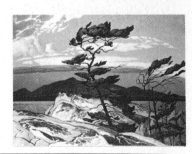

A. J. CASSON. (cont.)
Norval. 1929
10 x 12
Kleinburg. 1929
9½ x 11¼
Algoma. 1929
watercolour
17 x 20
Pinegrove Village. 1929
watercolour
9⅜ x 10¾
Farmhouse, Salem. 1929
pencil
8 x 10½

Old Man in Rocker. c. 1930
10 x 12
Spring Lasky. 1932
watercolour
14 x 16
Old House, Parry Sound. 1932
9⅝ x 11⅜
Church and Graveyard. 1933
8½ x 10½

Millworker's Boarding House. 1935
9½ x 11¼
Old House. 1935
watercolour
1¾ x 2½
Rapids and Rocks. 1935
9¼ x 11¼
Lake Baptiste. 1935
pencil
7⅞ x 10½
Flaming Autumn. 1936
10 x 12

Algonquin Park. 1940
pencil
6½ x 7½
Maple. 1941
pencil
7¾ x 10½
Fisherman's Point. 1943
tempera
29¼ x 39¼
Lake of Two Rivers. 1944
9½ x 11¼

Picnic Island. 1948
9½ x 11¼
Rocks and Waterfall. 1952
pencil
5 x 6
Britt. 1955
pencil
7⅛ x 7½
Houses, Bancroft. 1955
11⅞ x 14⅞
White Pine. 1957
30 x 40

147

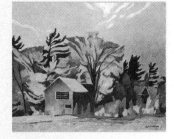

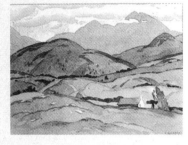

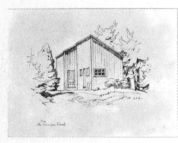

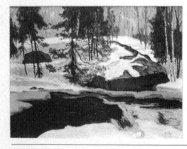

A. J. CASSON. (cont.)
Ontario Scenes. 1958/60
pencil
15½ x 12

Tom Thomson's Shack. 1962
12¼ x 15

Mountains, Scotland. 1963
watercolour
8¾ x 11⅞

The Tom Thomson Shack. 1970
pencil
8 x 10¾

MAURICE CULLEN. 1866-1934
Brook in Winter. c. 1927
24 x 32

LIONEL LEMOINE FITZGERALD.
1890-1956
Trees in the Field. 1918
23⅞ x 22

Prairie Fence. 1921
6½ x 8½

Prairie. 1921
6½ x 8½

The Harvester. 1921
27 x 24½

Trees and Wildflowers. 1922
pastel
18¼ x 26

The Cupola. 1924
10½ x 10½

The Embrace. c. 1925
10½ x 12⅞

The Woods. 1929
pencil
9½ x 12

Williamson's House. 1933
60½ x 44

Old Buildings and Shack. 1934
pencil
14⅝ x 12¼

Geraniums and Trees. 1935
pencil
12¼ x 8¼

Storm on Prairies. 1935
pencil 8¾ x 11¼

Tree Trunk. 1939
pencil
11¼ x 15

Cliffs. 1944
pastel
24 x 18

The Little Plant. 1947
24 x 18¼

Apple Basket. 1948
pen
11⅞ x 17⅞

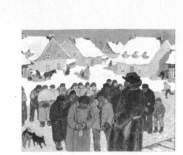
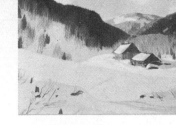

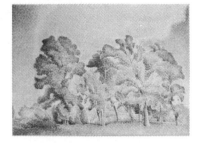
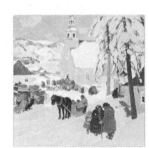

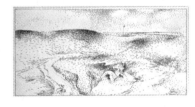
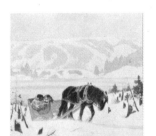

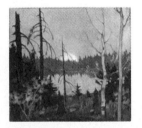
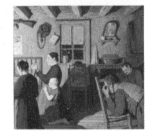
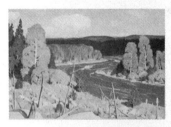

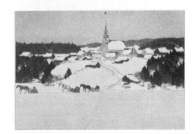

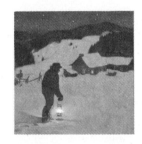
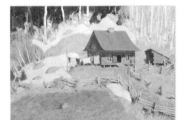
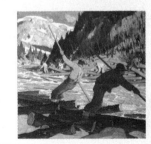

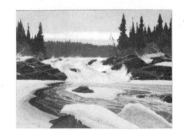

LIONEL LEMOINE FITZGERALD.
(cont.)

Trees. 1948
pen
11 x 7¾

Oak Bluff. 1950
watercolour
10¾ x 15

Prairie Landscape. 1955
pen
9 x 18

CLARENCE A. GAGNON. 1881-1942

Gagnon spent five years (1928-1933) lovingly portraying Quebec pioneer life in fifty-four superbly executed originals to illustrate Louis Hémon's Canadian classic "Maria Chapdelaine".

Mixed Media on paper

C.G. 1	3 x 3⅛	C.G. 7	6⅜ x 8¾	C.G. 14	7⅝ x 8⅛	
C.G. 2	6⅛ x 9	C.G. 8	7⅞ x 8⅞	C.G. 15	6⅛ x 9	
C.G. 3	6¾ x 8½	C.G. 9	8¾ x 9¼	C.G. 16	7⅞ x 8½	
C.G. 4	8¼ x 8⅜	C.G. 10	7⅜ x 7⅜	C.G. 17	8½ x 8¼	
C.G. 5	7⅛ x 7½	C.G. 11	7 x 9½	C.G. 18	8¼ x 8⅛	
C.G. 6	7¼ x 7	C.G. 12	7 x 8½	C.G. 19	6¼ x 9	
		C.G. 13	8 x 7¼	C.G. 20	8⅜ x 8⅛	

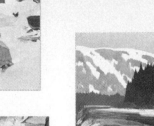
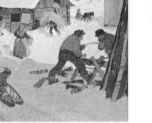
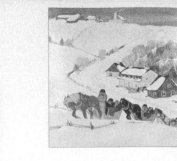
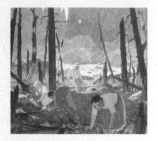
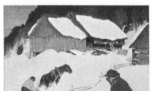
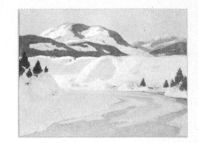
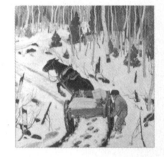
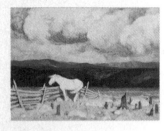
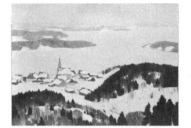

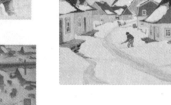

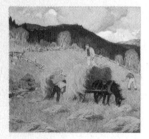

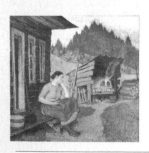

CLARENCE A. GAGNON (cont.)

C.G. 21	8⅜ x 9	C.G. 26	6½ x 9¼	C.G. 30	7⅝ x 7½
C.G. 22	7 x 7¾	C.G. 27	8⅜ x 7½	C.G. 31	7½ x 8¾
C.G. 23	6⅛ x 8½	C.G. 28	6¼ x 8¾	C.G. 32	6⅞ x 9¾
C.G. 24	7½ x 8	C.G. 29	7 x 7⅞	C.G. 33	6⅛ x 8
C.G. 25	7½ x 8			C.G. 34	7⅛ x 8½

C.G. 35	6¼ x 9	C.G. 39	7⅞ x 7⅝	
C.G. 36	7 x 8½	C.G. 40	6⅞ x 9⅜	
C.G. 37	7⅜ x 8½	C.G. 41	8 x 7⅝	
C.G. 38	6¼ x 9	C.G. 42	8¼ x 8	

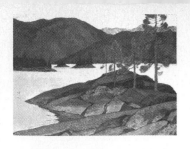

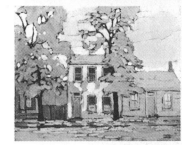

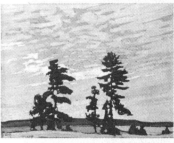

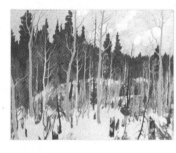

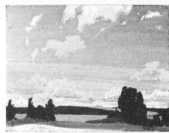

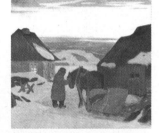

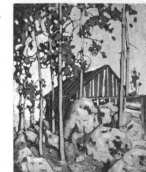

CLARENCE A. GAGNON (cont.)
C.G. 43 6¼ x 8½
C.G. 44 7⅞ x 7½
C.G. 45 8 x 10⅜
C.G. 46 7 x 7¾
C.G. 47 7¾ x 8¾

C.G. 48 7¾ x 8¼
C.G. 49 7¾ x 8
C.G. 50 6¾ x 10¼
C.G. 51 8¾ x 8¾

C.G. 52 8¼ x 8¼
C.G. 53 7¾ x 8¼
C.G. 54 8⅜ x 8¾

LAWREN HARRIS. 1885-1970
Rocky Brook. 1910
5⅝ x 8¾
Old Mill. c. 1911
10 x 8

Little House. 1911
7⅜ x 5⅛
Laurentians. 1912
5½ x 8⅝
Georgian Bay. c. 1912
5½ x 8⅝
Old Toronto Houses. 1912
pencil
9 x 7

Algonquin Park Sunburst. 1912
8 x 9¼
Early Houses. 1913
10 x 12
Lake Simcoe. 1916
10½ x 13¾
Kempenfelt Bay. 1916
10⅝ x 13⅞
Algonquin Park. 1917
14 x 10¹¹⁄₁₆

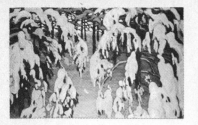

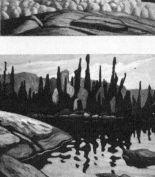

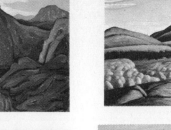

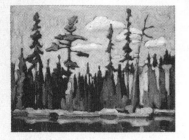

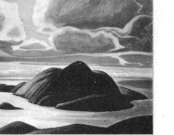

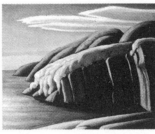

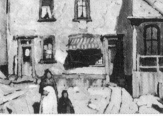

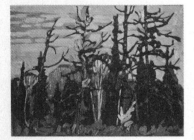

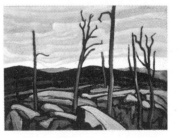

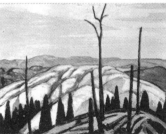

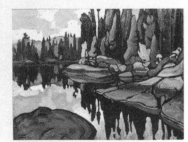

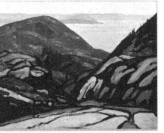

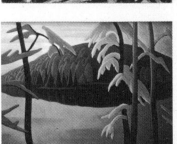

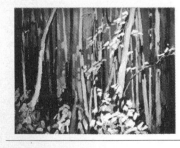

LAWREN HARRIS (cont.)
Snow. c. 1917
27 x 42

The Pool. 1918
10¾ x 14

Algoma Sketch. 1918
10¾ x 13¾

Algoma Reflections. 1919
10⅜ x 13½

Algoma Woodland. 1919
10½ x 13⅝

Beaver Dam. 1919
10½ x 13½

Algoma Panorama. c. 1919
10½ x 13⅞

Still Water, Algoma. 1919
10½ x 13½

Montreal River. 1920
10½ x 13¾

Red Maples. 1920
13⅛ x 10½

Portrait of Louise Julia Holden.
1921
29½ x 26

Early Houses with People. 1921
pencil
8 x 10

Early Houses with Gatepost. 1921
pencil
8 x 10

Newfoundland Coast. 1921
10½ x 13⅝

Pic Island, Lake Superior. 1921
12 x 15

Lake Superior Cliffs. 1921
11¾ x 14½

Country North of Lake Superior.
1921
10¼ x 13⅝

North East Lake Superior. 1921
10½ x 13⅝

Northern Lake, Autumn. 1921
12 x 15

Shimmering Water, Algonquin
Park. 1922
32 x 40

In the Ward. 1922
10½ x 13⅜

Lake Superior Country. 1922
10⅝ x 13⅞

Northern Lake. c. 1923
32 x 40

152

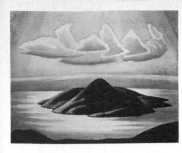
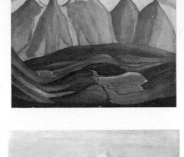
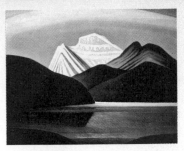

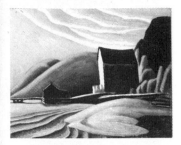
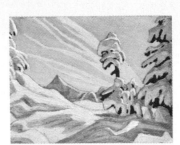

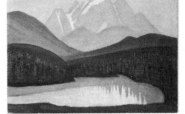
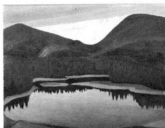
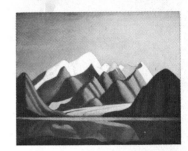

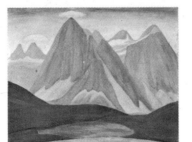
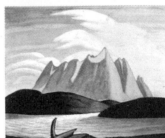

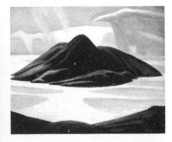
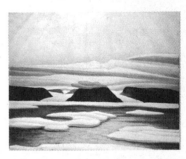

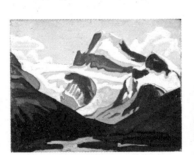
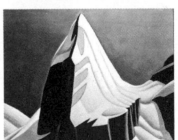
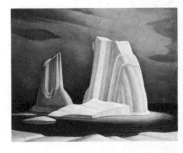

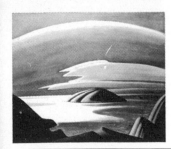

LAWREN HARRIS (cont.)
Pic Island. 1923
11½ x 14¼

The Ice House. 1923
12 x 15

Algoma Canyon. 1923
11¾ x 14⅝

Pic Island. 1923
12 x 15

Lake Superior Island. 1923
28 x 35

Shore Rocks. 1924
11½ x 14¼

Pic Island. 1924
48 x 60

Mount Temple. 1924
12 x 15

Emerald Lake. 1924
11⅞ x 15

Sentinel Pass, Above Moraine
Lake. 1924
11⅝ x 14⅝

Emerald Lake. 1924
12 x 15

Mountain Sketch. 1924
12 x 15

South End of Maligne Lake. 1925
10¼ x 13⅝

Snow, Rocky Mountains. 1925
10½ x 13⅞

Northern Lake. 1926
12 x 15

Lake and Mountains. 1927
11½ x 14½

Rocky Mountain Sketch,
Mt. Lefroy. c. 1928
12 x 15

Mountains and Lake. 1929
35¾ x 44½

Eclipse Sound and Bylot Island.
1930
12 x 15

Ellesmere Island. 1930
12 x 15

Icebergs, Davis Strait. 1930
48 x 60

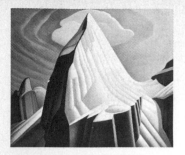
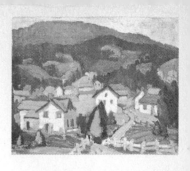
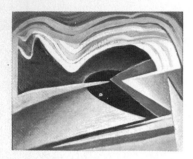
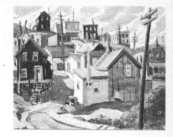
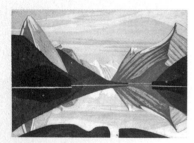
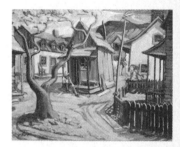
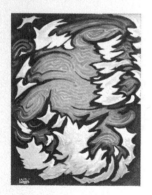
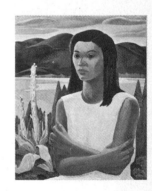

LAWREN HARRIS (cont.)
Mt. Lefroy. 1930
52¼ x 60⅜

Abstract Sketch. c. 1937
12 x 15

Maligne Lake. 1940
tempera
30 x 40

Autumn Rhythm. c. 1955
37 x 25

RANDOLPH HEWTON. 1888-1960
Apres-Midi Camaret. 1913
28 x 23

Benedicta. c. 1932
72 x 48

Rocky Slopes. Mid 1930's
20 x 24

Spring in the Valley. Mid 1930's
20 x 24

Autumn Forest. Mid 1930's
24 x 30

Slumber. Mid 1930's
32 x 40

EDWIN HOLGATE. 1892-
Nude. 1922
11½ 10

The Cellist. 1923
51 x 38½

Mother and Daughter. 1926
24 x 24

Melting Snow. 1948
8½ x 10½

The Pool. 1965
8½ x 10½

YVONNE McKAGUE HOUSSER.
1898-
Adriatic Docks. c. 1922
8½ x 10½

Houses in Valley. 1926
8½ x 10½

Cobalt. 1928
10⅜ x 13⅜

Quebec Village. 1928
24 x 30

Indian Girl. 1932
30 x 24

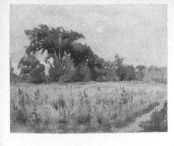
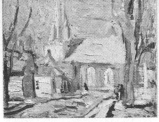
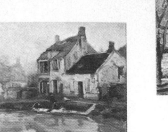
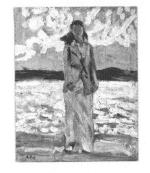

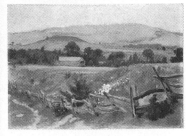

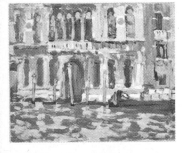

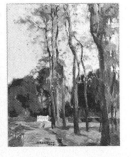
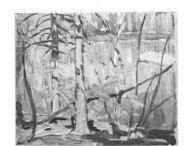

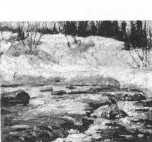

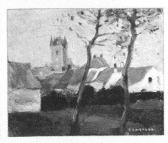

A. Y. JACKSON. 1882-
Elms and Wildflowers. 1902
watercolour
10¾ x 13¼

Covered Bridge. 1906
12 x 17

Venice. 1908
8½ x 10½

Country Road, Bruges. 1908
7½ x 9½

Bruges, Belgium. 1908
7½ x 9½

Canal du Loing. 1909
20½ x 24

The Parlour. 1910
14 x 16

Sand Dunes Etaples, France. 1912
21½ x 25½

Dahlias. 1913
13 x 16

St. Pie Church, Quebec. c. 1913
8½ x 10½

Figure Against the Sky. 1913
10½ x 8½

Algonquin Park River. 1914
8½ x 10½

Algonquin Park Blue River with
Rocks. 1914
8½ x 10½

Riverbank and Green Trees. 1914
8½ x 10½

The Red Maple. 1914
8½ x 10½

Mount Robson. 1914
8½ x 10½

Rapids, Algonquin Park. 1914
8½ x 10½

Lorette Ridge. 1917
8½ x 10½

Cathedral at Ypres. 1917
8½ x 10½

Twisted Trees. 1919
8¼ x 10½

Beaver Pond in Autumn. 1919
8½ x 10½

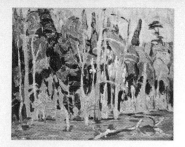
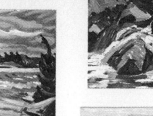
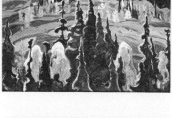
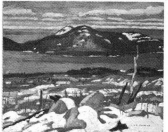
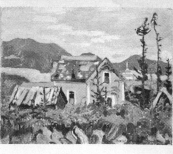
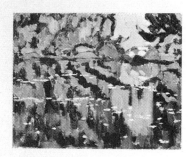
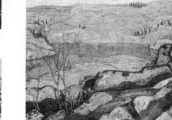
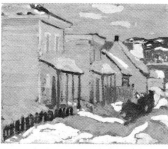
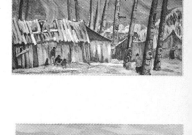

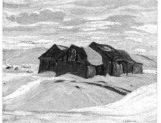
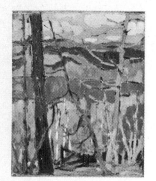
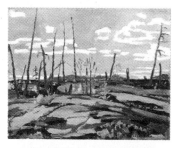
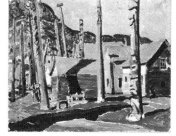

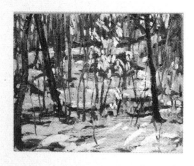
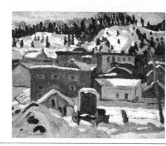
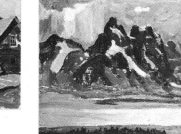

A. Y. JACKSON (cont.)
Beaver Lake, Algoma. 1919
8½ x 10½

Agawa River. 1919
8½ x 10½

Algoma Canyon. 1919
10½ x 8½

Early Spring. 1920
8½ x 10½

Storm, Georgian Bay. c. 1920
8½ x 10½

Go Home Bay. 1920
8½ x 10½

Pere Raquette. 1921
tempera
31 x 25

First Snow, Algoma. 1920-21
42 x 50

Waterfall, Algoma, 1921
8½ x 10½

Lake in the Hills. 1922
24½ x 32

Quebec Houses and Sleigh. 1923
8½ x 10½

October. Lake Superior. 1923
8½ x 10½

Murray Bay. c. 1923
8½ x 10½

Above Lake Superior. 1924
46 x 58

Pic Island, Lake Superior. 1925
8½ x 10½

Barns. 1926
8½ x 10½

Totem Poles Indian Village. 1926
8½ x 10½

Indian Home. 1926
8½ x 10½

Skeena Crossing. 1926
21 x 26

Indian Houses, Skeena River. 1926
16⅛ x 20⅛

Mountains near Skeena. 1926
8½ x 10½

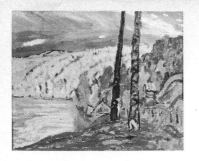
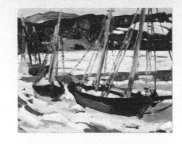
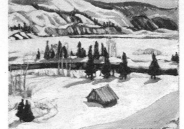
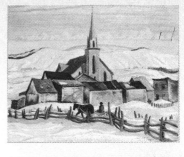

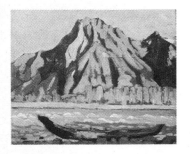
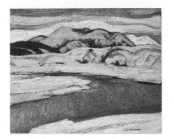
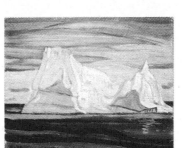
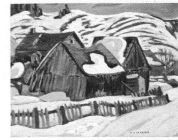

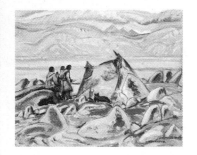
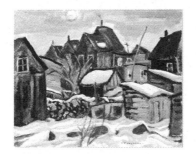
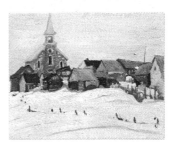
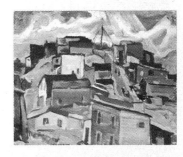

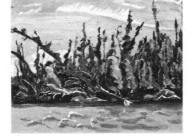
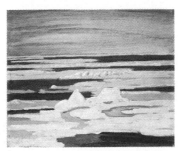
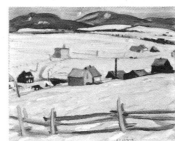
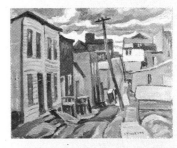

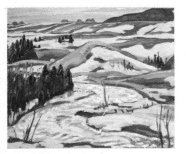
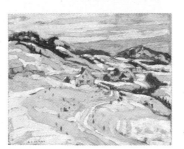
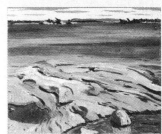

A. Y. JACKSON (cont.)
Totems, Skeena River. 1926
8½ x 10½

Mt. Rocher Eboule near
Hazelton, B.C. 1927
8¼ x 10½

Eskimos and Tent. 1927
8½ x 10½

Bic. 1927
8½ x 10½

Arctic Summer. 1927
pen
6¾ x 6½

Labrador. 1927
pen
7 x 6⅜

Eskimo Summer Camp. 1927
20 x 25

Yellowknife Forest. 1928
8½ x 10½

Fishing Boats. c. 1928
8½ x 10½

River, Baie St. Paul. 1928
8½ x 10½

Grey Day, Hull, Quebec. 1930
8½ x 10½

Ice, Davis Strait, 1930
8½ x 10½

River Near Murray Bay. 1930
8½ x 10½

River St. Urbain. 1930
8½ x 10½

Iceberg at Godhaven. 1930
8½ x 10½

Quebec Village. c. 1930
8½ x 10½

St. Tite des Caps. c. 1930
8½ x 10½

Church at St. Urbain. 1931
21 x 26

Morning Les Eboulements. 1932
8½ x 10½

Cobalt. 1932
8½ x 10½

Mining Town. 1932
8½ x 10½

Blue Water, Georgian Bay. c. 1932
8½ x 10½

157

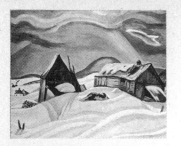
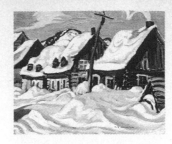
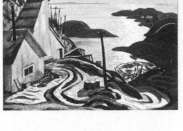
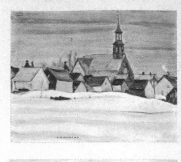
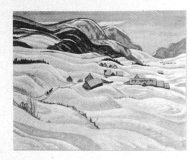
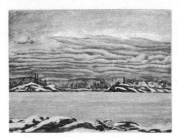
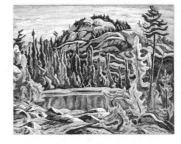
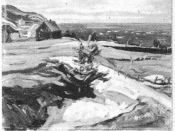
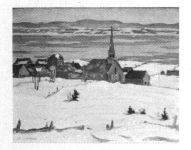
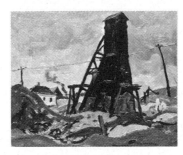
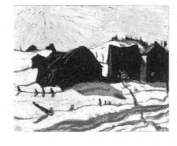
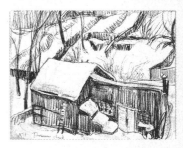
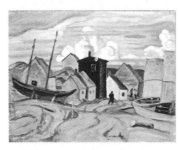
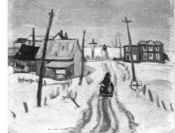
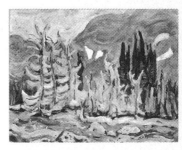
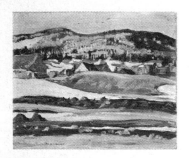
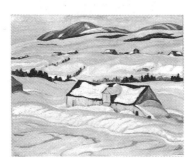
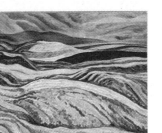
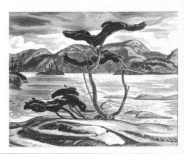

A. Y. JACKSON (cont.)
Grey Day, Laurentians. 1933
21 x 26

Valley of the Gouffre River. 1933
25½ x 32

Quebec Village in Winter. 1933
8½ x 10½

Near Murray Bay. 1933
8½ x 10½

Nellie Lake. 1933
31½ x 29½

Les Eboulements. 1933
8½ x 10½

St. Lawrence at St. Fabien. 1933
8½ x 10½

Winter Morning, St. Tite des Caps.
1934.
21 x 26½

Houses, St. Urbain. c. 1934
8½ x 10½

Algoma November. 1934
10¾ x 13¾

Cobalt Mine Shaft. 1935
8½ x 10½

Village, Cape Breton. 1936
10½ x 13½

Alberta Foothills. 1937
25 x 32

Radium Mine. 1938
32 x 40

Sunlit Tapestry. 1939
28 x 36

Quebec Farm. c. 1940
8½ x 10½

St. Pierre. 1942
8½ x 10½

St. Pierre, Montagne. 1942
8½ x 10½

Gaspe Near Pierre. 1942
10½ x 13½

Tom Thomson's Shack. c. 1942
Pencil
8½ x 10½

Langlais Larch Sunshine
Ski Lodge. 1944
10½ x 13½

Bent Pine. 1948
32 x 40

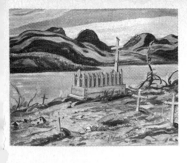
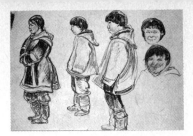
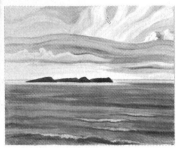
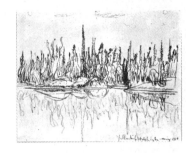

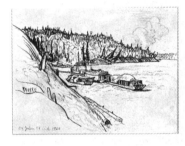
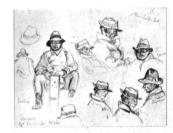
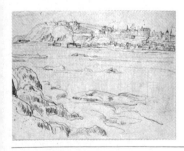

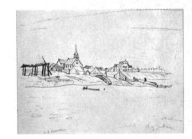

A. Y. JACKSON (cont.)
Dog Ribb, Indian Chief's Grave.
1949
21⅛ x 26⅛

Superstition Island, Great Bear
Lake. 1950
21 x 26

DRAWINGS — Pencil
Halifax, the Narrows Bedford
Basin. 1919 6½ x 8¼

Windy Day, Georgian Bay. 1920's
7⅛ x 10⅞

Quebec, seen from South Shore.
1922 7⅛ x 9⅜

Ramparts in the Tonquin. 1924
8⅛ x 10½

Slate Isles, Lake Superior. 1925
9⅛ x 10⅜

Canoe-Georgian Bay. 1925
4³⁄₁₆ x 7⁷⁄₁₆

Pines, Georgian Bay. 1925
8⁷⁄₁₆ x 11⁷⁄₁₆

Mt. Getsegyakla, Upper Skeena
River, B.C. 1926
7¾ x 9½

Potlatch Houses, Kispiox, Upper
Skeena River, B.C. 1926
7¾ x 9½

Hahao of Kitwanga. 1926
8¾ x 5½

Mt. Rocher, Eboule, Hazelton,
B.C. 1927
9 x 10½

South of Coast of Bylot Island.
1927
7¼ x 10⅝

St. Simon. 1927
8½ x 11⅜

Studies of Beothic and Eskimos.
1927
10½ x 7⅜

Crap Game (Tutin,
Dr. Livingstone). 1927
7½ x 9¾

Studies of Eskimos. 1927
7¼ x 10⁷⁄₁₆

Yellowknife, Walsh Lake,
Evening. 1928
9⅛ x 10⅜

Fort Smith. 1928
7⅞ x 10½

Crossing, Great Slave Lake. 1928
8⅛ x 10½

Fort Resolution. 1928
7¾ x 10½

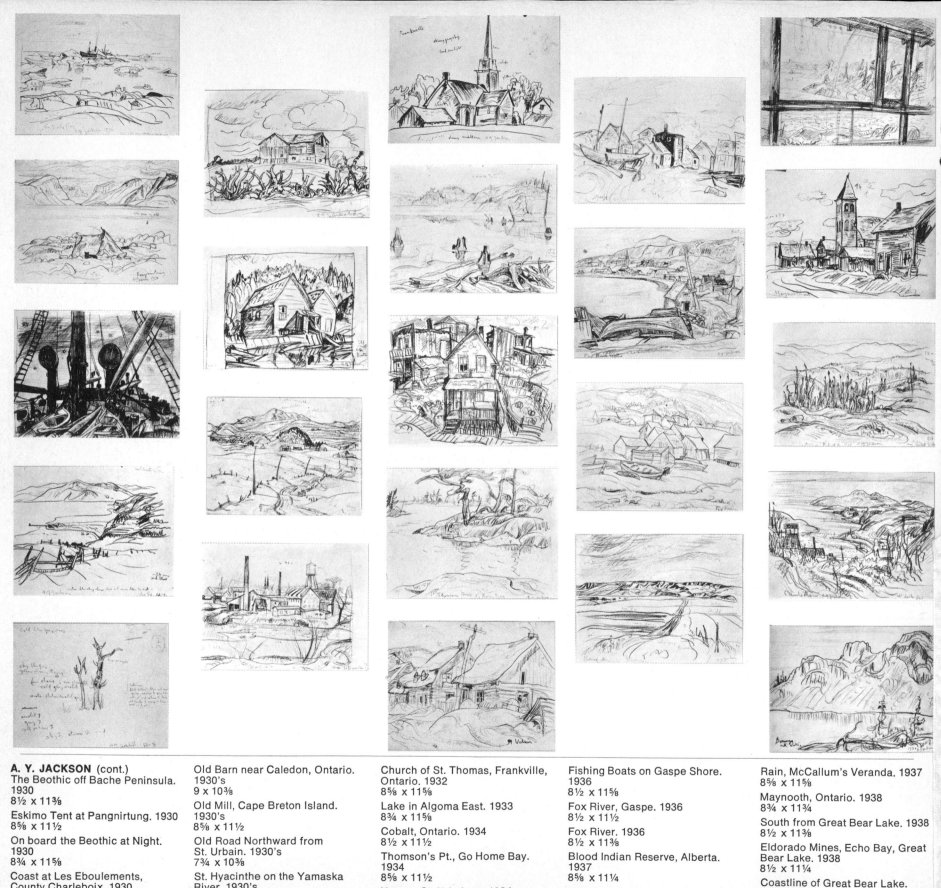

A. Y. JACKSON (cont.)

The Beothic off Bache Peninsula.
1930
8½ x 11⅜

Eskimo Tent at Pangnirtung. 1930
8⅝ x 11½

On board the Beothic at Night.
1930
8¾ x 11⅝

Coast at Les Eboulements,
County Charleboix. 1930
8¼ x 10⅜

Dead Tree Study. mid 1930's
6½ x 8¼

Old Barn near Caledon, Ontario.
1930's
9 x 10⅜

Old Mill, Cape Breton Island.
1930's
8⅝ x 11½

Old Road Northward from
St. Urbain. 1930's
7¾ x 10⅜

St. Hyacinthe on the Yamaska
River. 1930's
8⅝ x 11½

Church of St. Thomas, Frankville,
Ontario. 1932
8⅝ x 11⅝

Lake in Algoma East. 1933
8¾ x 11⅝

Cobalt, Ontario. 1934
8½ x 11½

Thomson's Pt., Go Home Bay.
1934
8⅝ x 11½

Houses St. Urbain. c. 1934
pencil
8 x 10¾

Fishing Boats on Gaspe Shore.
1936
8½ x 11⅝

Fox River, Gaspe. 1936
8½ x 11½

Fox River. 1936
8½ x 11⅜

Blood Indian Reserve, Alberta.
1937
8⅝ x 11¼

Rain, McCallum's Veranda. 1937
8⅝ x 11⅝

Maynooth, Ontario. 1938
8¾ x 11¾

South from Great Bear Lake. 1938
8½ x 11⅜

Eldorado Mines, Echo Bay, Great
Bear Lake. 1938
8½ x 11¼

Coastline of Great Bear Lake.
1938
8¾ x 11⅜

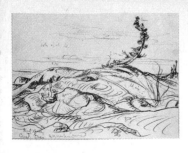

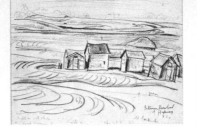

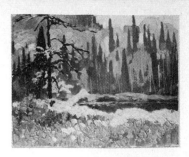

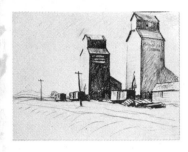

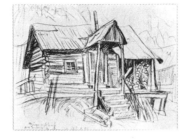

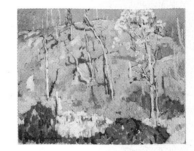

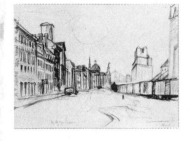

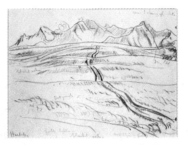

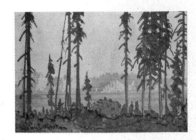

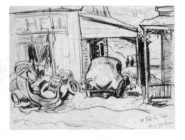

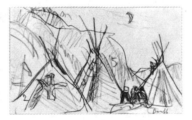

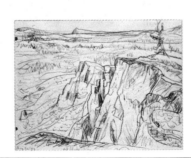

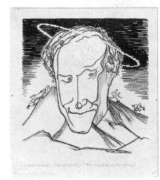

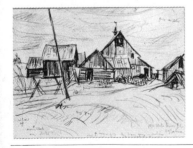

A. Y. JACKSON (cont.)
Bent Spruce, Great Bear Lake. 1938
8½ x 11¼

Grain Elevators, Western Canada. 1940
8½ x 11⅜

Commissionaire Street, Montreal. 1940
8½ x 11½

Street Scene at St. Tite des Caps, Que. 1940's
8¼ x 11½

150 Mile House, B.C. 1940's
8⅜ x 11⅜

St. Pierre, County Montmagny, Que. 1942
8½ x 11⅝

Canmore, Alberta. 1943
8⅝ x 11½

Old River Boats, Whitehorse, Yukon. 1943
8½ x 11½

Indian Village, Kamloops, B.C. 1943
8¾ x 11½

Farm Between Rosebud & Hwy. 518. 1944
8½ x 11⅜

Miner's Shack, Barkerville. 1945
8¾ x 11½

Looking West from Harland's Ranch. 1946
8½ x 11¼

Indian Tents, Banff. 1946
4¹¹⁄₁₆ x 7⁹⁄₁₆

Hunter Bay, Great Bear Lake. 1951
8⅝ x 11¼

Yellowknife, N.W.T. 1951
8½ x 11⅜

Houses above St. John's, Nfld. 1952
8⅝ x 11⅝

Harbour of St. John's, Nfld. 1952
8½ x 11½

FRANK H. JOHNSTON. 1888-1949
Drowned Land, Algoma. 1918
tempera
18 x 21

Moose Pond. 1918
10 x 13

Patterned Hillside. 1918
10 x 13

Dawn Silhouette. c. 1922
tempera
4½ x 6¾

J. E. H. MacDonald. 1928
pen and ink
12 x 10¼

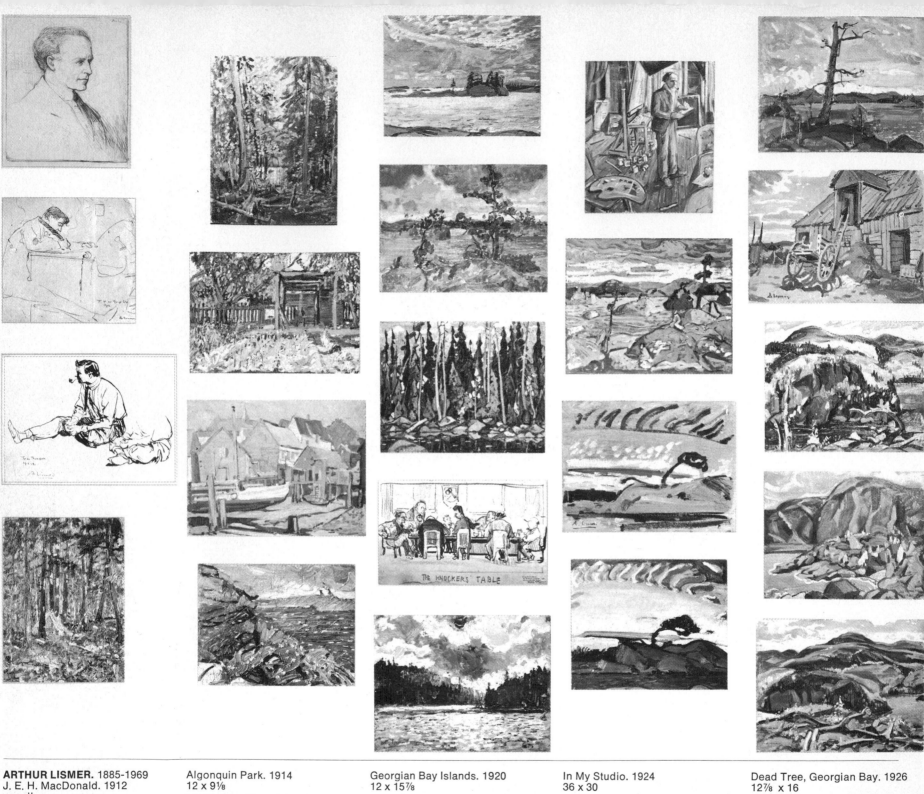

ARTHUR LISMER. 1885-1969
J. E. H. MacDonald. 1912
pencil
7⅛ x 5¾

Tom Thomson at Grip. 1912
pencil
7¾ x 8⅜

Tom Thomson. 1912
brush and ink
9 x 12

Tom Thomson's Camp. 1914
12 x 9

Algonquin Park. 1914
12 x 9⅛

My Garden, Thornhill. 1916
14⅜ x 20½

Maritime Village. 1919
12 x 14½

Rain in the North Country. 1920
8¾ x 12⅛

Georgian Bay Islands. 1920
12 x 15⅞

Gusty Day, Georgian Bay. 1920
9 x 11⅞

Forest, Algoma. 1922
28 x 36

Knocker's Table. 1922
pencil
18¼ x 30

Sunset, Algoma. 1922
9 x 12

In My Studio. 1924
36 x 30

Summer Day. 1924
16⅛ x 20

Preliminary Sketch, Evening
Silhouette. 1926
9 x 11¹⁵⁄₁₆

Evening Silhouette. 1926
12¾ x 16

Dead Tree, Georgian Bay. 1926
12⅞ x 16

Old Barn, Quebec. 1926
11¼ x 15½

Lake Superior. 1927
12⅝ x 15⅞

Lake Superior Shoreline. 1927
12⅝ x 16

October on the North Shore. 1927
12¼ x 15½

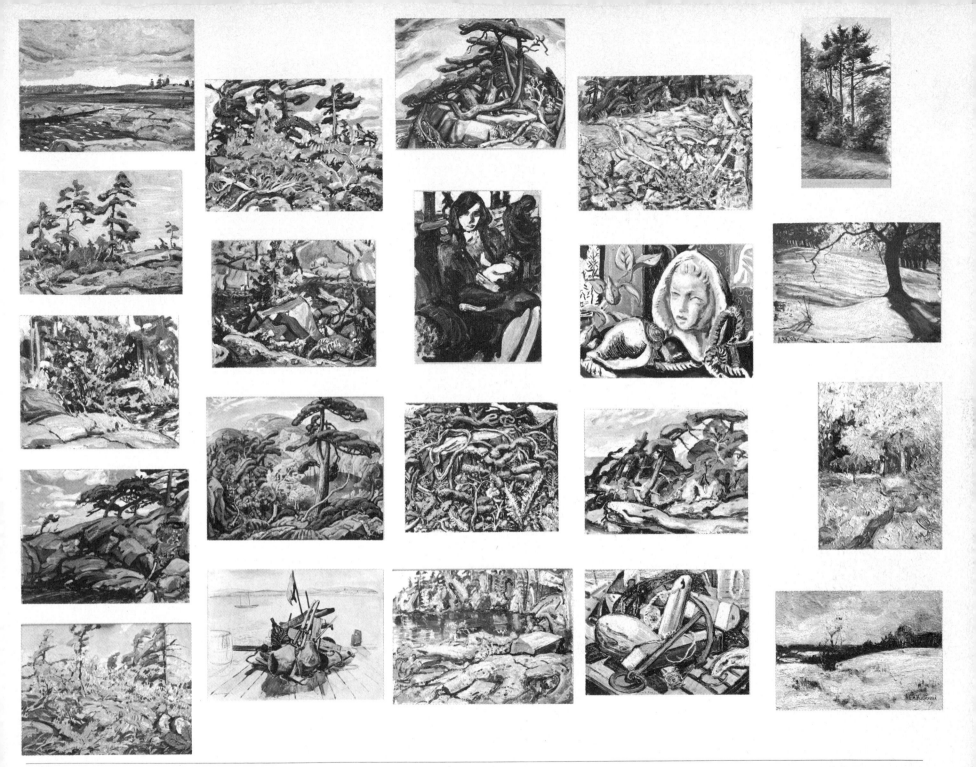

ARTHUR LISMER (cont.)
Stormy Sky, Georgian Bay. 1928
11¾ x 15⅝

Pines Against the Sky. 1929
11¾ x 16

Red Sapling. 1929
13 x 16

Moon River, Georgian Bay. 1931
12¼ x 15½

Pine and Rocks. 1933
12 x 15½

McGregor Bay. 1933
11 x 15½

Green Pool. 1935
12 x 16

Bright Land. 1938
32 x 40

Maritime Wharf. 1938-40
watercolour
16⅝ x 22½

Pine Wrack. 1939
watercolour
21½ x 30

Mother and Child. 1946
12¼ x 9¼

Canadian Jungle. c. 1946
17½ x 22

Near Amanda, Georgian Bay. 1947
11½ x 14¾

Georgian Bay. 1947
11½ x 15½

Still Life with Greek Head. 1949
12 x 16

Pine and Rock, Georgian Bay.
1950
12 x 15⅞

Red Anchor. 1954
11⅞ x 15⅞

J. E. H. MACDONALD. 1873-1932
Nova Scotia. 1898
watercolour
9⅜ x 4⅞

In High Park. 1908
3½ x 5

Oaks, October Morning. 1909
5 x 6⅞

Snow, High Park. 1909
5 x 7

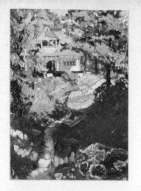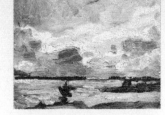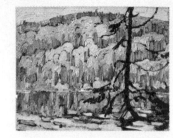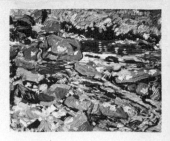

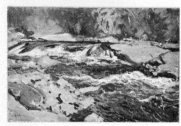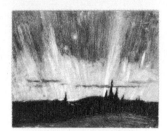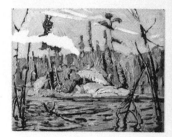

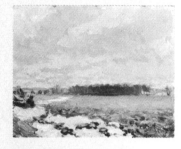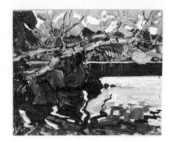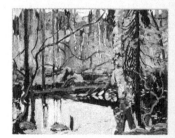

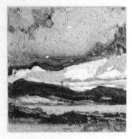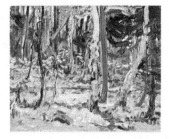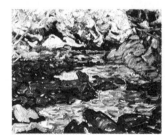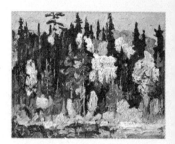

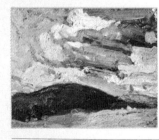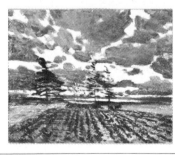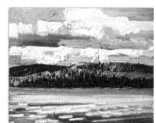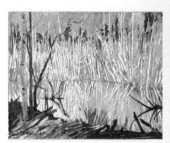

J. E. H. MACDONALD (cont.)
Chipmunk Point. 1911
7 x 5

Thomson's Rapids Magnetawan
River. 1912
6 x 9 3/16

Oakwood. 1913
8 x 10

Laurentian Storm. 1913
4½ x 4½

Elements, Laurentians. 1913
8 x 10

Snow, Algonquin Park. 1914
8 x 10

Gatineau River. 1914-15
8 x 10

Sunflower Garden. 1916
8 x 10

Near Minden. 1916
8½ x 10½

Wild Ducks. 1916
8 x 10

Northern Lights. 1916
8 x 10

Sunflower Study, Tangled Garden
Sketch. 1916
10 x 8

Canoe Lake. 1917
8 x 10

In November. 1917
21 x 26

Autumn Algoma. 1918
8½ x 10½

The Lake, Grey Day. 1918
8½ x 10½

Algoma Woodland, 1918
8½ x 10½

Rocky Stream, Algoma. 1918
8½ x 10½

Leaves in the Brook. 1918
panel
8½ x 10½

Moose Lake, Algoma. 1919
8½ x 10½

Algoma Bush, September. 1919
8½ x 10½

Silver Swamp, Algoma. 1919
8½ x 10½

Beaver Dam and Birches. 1919
8⅞ x 10⅞

164

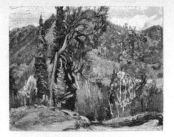 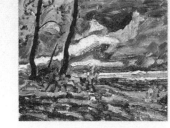 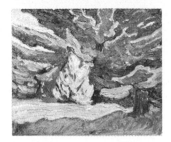 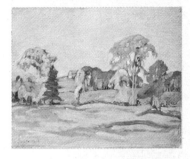

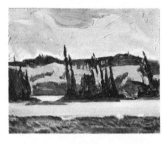 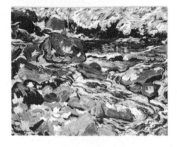 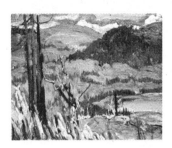 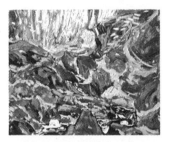 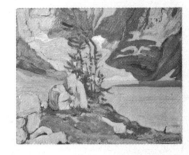

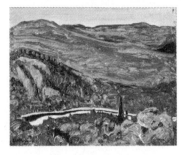 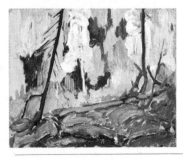 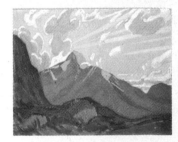 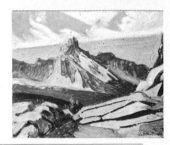

J. E. H. MACDONALD (cont.)
Lake in the Valley. 1919
8½ x 10½

Leaves in the Brook. 1919
canvas
21 x 26

Stormy Weather, Algoma. 1919
8½ x 10½

Agawa. 1920
8½ x 10½

Algoma Trees. 1920
8½ x 10½

Algoma Waterfall. 1920
30 x 35

Agawa River, Algoma. 1920
8½ x 10½

Algoma Forest. 1920
8½ x 10½

Algoma Hills. 1920
8½ x 10½

Sungleams, Algoma Hilltop. 1920
8½ x 10½

Tree Patterns. 1920
8½ x 10½

Agawa Canyon. 1920
8½ x 10½

Woodland Brook. 1920
8½ x 10½

Young Maples, Algoma. 1920
8½ x 10½

Forest Wilderness. 1921
48 x 60

Horses, Hardy's Barn, Oakwood.
1921
8½ x 10½

Nova Scotia Barn. 1922
4¼ x 5

Nova Scotian Shore. 1922
8½ x 10½

Buckwheat Field. 1923
8½ x 10½

Pastures, Gull River. 1923
8½ x 10½

Lake McArthur, Lake O'Hara
Camp. 1924
8½ x 10½

Valley from McArthur Lake, Rocky
Mountains. 1925
7 x 9

Cathedral Mountain. 1925
8½ x 10½

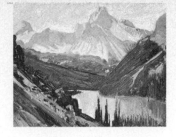

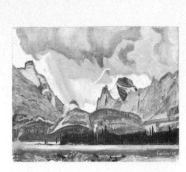

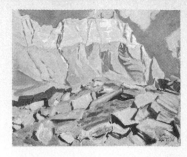

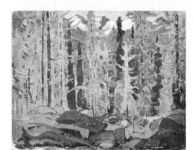

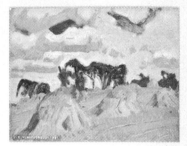

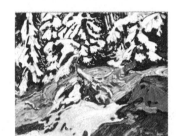

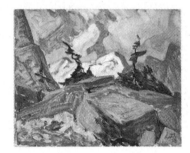

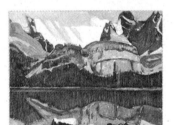

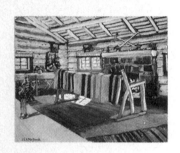

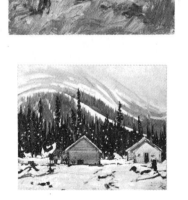

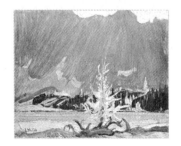

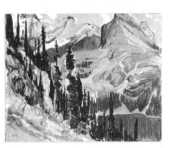

J. E. H. MACDONALD (cont.)
Autumn Sunset. 1925
pen and ink
8½ x 10½

Northern Pine. 1925
pen
7¾ x 5¾

Lodge Interior, Lake O'Hara. 1925
8½ x 10½

Prairie Sunrise. 1926
8½ x 10½

Wiwaxy Peaks, Lake O'Hara. 1926
8½ x 10½

Snow, Lake O'Hara. 1926
8½ x 10½

Artist's Home and Orchard. 1927
8½ x 10½

Snow, Lake O'Hara Camp. 1927
8½ x 10½

Cathedral Peak, Lake O'Hara. 1927
8½ x 10½

Little Turtle Lake. 1927
5¼ x 8½

Mountain Stream. 1928
8½ x 10½

Lake O'Hara, Rainy Weather. 1928
8½ x 10½

Lake O'Hara. 1928
8½ x 10½

Storm Clouds, Mountains. 1929
8½ x 10½

Tamarack, Lake O'Hara. 1929
8½ x 10½

Above Lake O'Hara. 1929
8½ x 10½

Mountains and Larch. 1929
8½ x 10½

Lichen Covered Shale Slabs. 1930
8½ x 10½

Wheatfield, Thornhill. 1931
8½ x 10½

Aurora, Georgian Bay. 1931
8½ x 10½

Goat Range, Rocky Mountains.
1932
21 x 26

THOREAU MACDONALD. 1901-
Old House. c. 1924
mixed media
5½ x 7

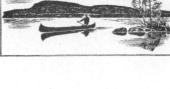

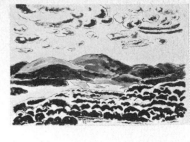

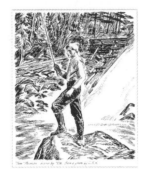

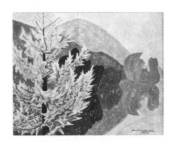

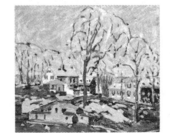

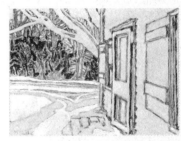

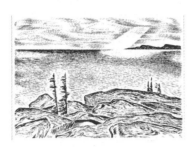

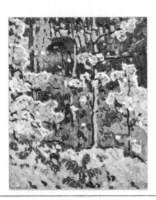

THOREAU MACDONALD (cont.)
Book Jacket. 1926
pen and ink
7 x 6

Marsh Hawk. 1939
20 x 30

Great Horned Owl. c. 1940
23 x 24

St. John's, York Mills. 1940
pen and ink
6 x 7

Squared Logs Near Purpleville.
1950
pen and ink
5½ x 6⅞

Great Slave Lake. c. 1950
pen and ink
9 x 12½

Tom Thomson. 1965
pen and ink
8⅜ x 6¾

Man and Horse. 1965
pen and ink
3⅝ x 3¾

Man and Canoe. 1969
pen and ink
4 x 8½

Loon. 1969
ink drawing on paper
6 x 9

Canoe. 1969
ink drawing on paper
6 x 9

ISABEL McLAUGHLIN. 1903-
Mountains and Yellow Tree. 1964
19 x 15½

DAVID B. MILNE. 1882-1953
West Saugerties. 1914
20¼ x 17

Relaxation. 1914
watercolour
14¾ x 18

Patsy. 1914
20 x 23¾

The Lilies. 1915
20 x 20

Boston Corners. 1916
17¾ x 20½

Blue Hills. 1917
watercolour
15 x 21

The Gully. 1920
20 x 24

Blue Church. 1920
18⅜ x 22⅝

Clarke's House. 1923
12 x 16

Clarke's House. 1923
12 x 16

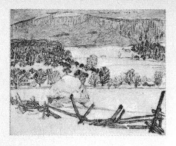
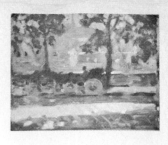
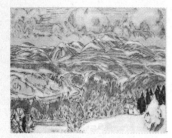

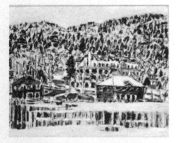

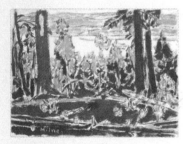
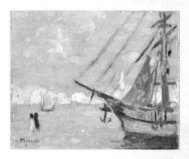
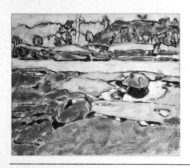

DAVID B. MILNE (cont.)
Haystack. 1923
15¾ x 19¾

Mountains and Clouds. 1925
15¾ x 19¾

Boat Houses in Winter. 1926
16½ x 20¼

Painting Place: Brown & Black
c. 1926
11¾ x 11¾

The Stream. c. 1928
16 x 22

Railway Station. c. 1929
12 x 16

Canoe and Campfire. 1936
13½ x 9¾

Nasturtiums and Carton. 1937
18¼ x 26¼

Deer and Decanter. 1939
13¾ x 19

Forest Floor. c. 1943
13¾ x 20½

Pansies and Basket. c. 1947
14¾ x 21½

J. W. MORRICE. 1865-1924
Notre Dame. c. 1898
7½ x 9½

Harbour. c. 1898
4¾ x 6

Sunset. c. 1898
4¾ x 6

Reflections. 1908-10
4¾ x 6

In the Park. 1908-10
4¾ x 6

Winter in France. 1908-10
4¾ x 6

Along the Bank. 1908-10
4¾ x 6

Paris. 1908-10
4¾ x 6

The Promenade. 1908-10
4¾ x 6

Roadside Scene. c. 1911
4¾ x 6

Sailboat. c. 1911
4 x 6

Clam Digging, France. c. 1914
4¾ x 6

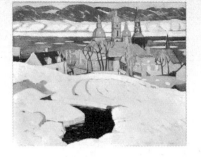
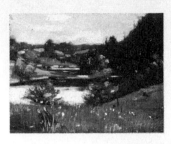

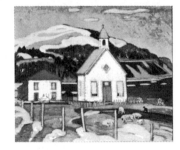
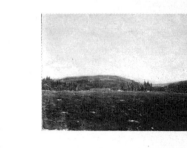

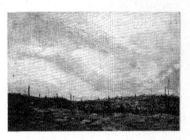

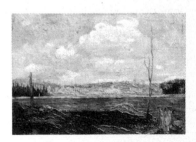

J. W. MORRICE (cont.)
Cuba. 1915
10 x 12½

Village Square. c. 1918
4¾ x 6

The Jetty. c. 1918
4¾ x 6

Algiers. c. 1919
10 x 9¼

Tunis. 1920-21
9 x 12½

ALBERT H. ROBINSON. 1881-1956
Nude. 1906
pencil
12 x 9¼

On the St. Lawrence. 1914
8½ x 10½

Scene in Laurentians. 1914
8½ x 10½

Quebec Houses and Yards. c. 1920
8½ x 10½

St. Joseph. 1922
26 x 32½

Gaspe Church. 1929
22½ x 26½

TOM THOMSON. 1877-1917
Nearing the End. c. 1905
13¾ x 22⅜

Young Fisherman. c. 1905
pen and ink
12 x 18

Lady in Her Garden. 1906
17½ x 9½

Head of a Woman. 1907
watercolour
12⅝ x 8¾

Sailboat. c. 1908
4½ x 5½

Burn's Blessing. 1909
watercolour
13¾ x 9½

Fairy Lake. 1910
6⅞ x 9

A Northern Lake. c. 1912
6⅞ x 9⅞

Red Forest. 1913
6⅞ x 9¾

Springtime, Algonquin Park. 1913
6⅞ x 9¾

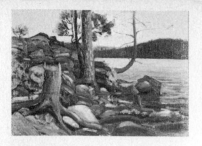

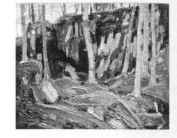

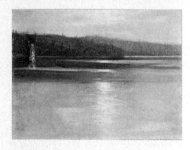
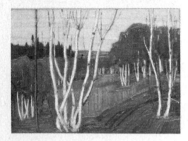
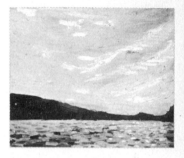

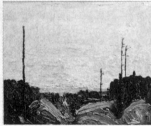

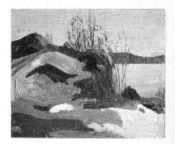

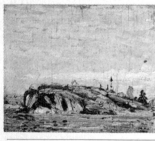

TOM THOMSON (cont.)
Pine Stump and Rocks. 1913
6¾ x 9¾

Sunset Over Hills. 1913
7 x 9

Silver Birches. 1914
15½ x 22

Burned Over Land. 1914
8½ x 10½

Georgian Bay Islands #1
1914
8½ x 10½

Georgian Bay Islands With Pine #2
1914
8½ x 10½

Pine Island. 1914
8½ x 10½

New Life After Fire. 1914
8½ x 10½

Spring. 1914
8¾ x 10½

Afternoon Algonquin Park. 1915
25 x 32

Islands, Canoe Lake. 1915
8½ x 10½

The Log Flume. 1915
8½ x 10½

Log Jam. 1915
5 x 6¾

Evening Clouds. 1915
8½ x 10½

Autumn Algonquin. 1915
8½ x 10½

Autumn Clouds. 1915
8½ x 10½

Spring Flood. 1915
8½ x 10½

Algonquin, October. 1915
10½ x 8½

Burned Over Swamp. 1915
8½ x 10½

Poplar Hillside. 1915
8½ x 10½

Smoke Lake. 1915
8½ x 10½

Moonlight, Canoe Lake. 1915
8½ x 10½

Deer. 1915
pencil
4¾ x 7½

170

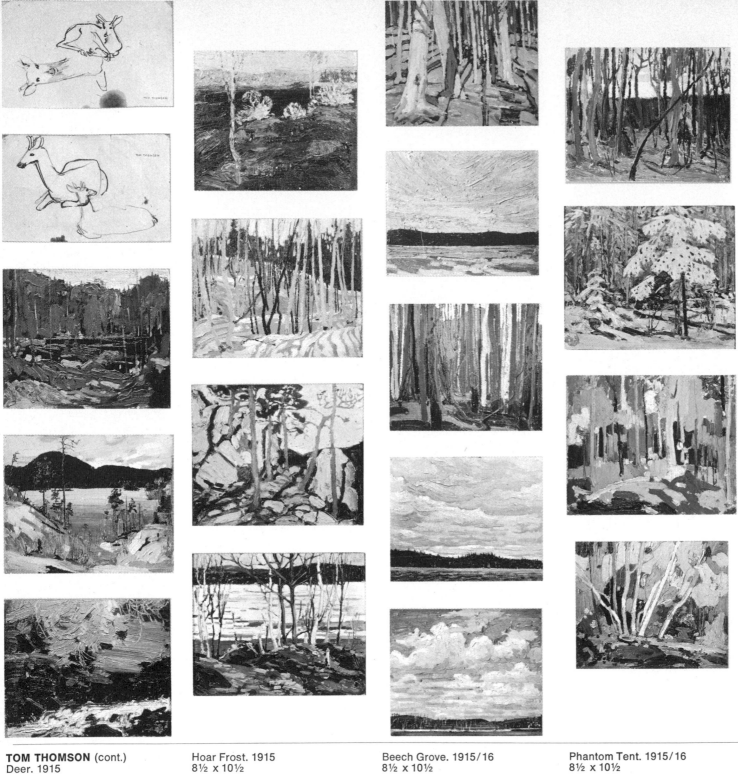

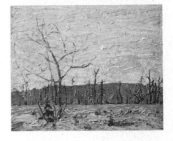
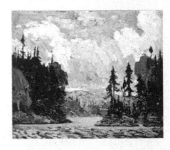
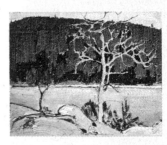
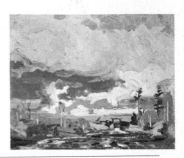

TOM THOMSON (cont.)
Deer. 1915
pencil
4¾ x 7½

Deer. 1915
pencil
4¾ x 7½

Backwater. 1915
8½ x 10½

Aura Lee Lake. 1915
8½ x 10½

Rushing Stream. 1915
8½ x 10½

Hoar Frost. 1915
8½ x 10½

Snow Shadows. 1915
8½ x 10½

Pine Cleft Rocks. 1915
8½ x 10½

Spring Breakup. 1915
8½ x 10½

Beech Grove. 1915/16
8½ x 10½

Sunset. 1915/16
8½ x 10½

Wood Interior. 1915/16
8½ x 10½

Lake, Hills and Sky. 1915/16
8½ x 10½

Summer Day. 1915/16
8½ x 10½

Phantom Tent. 1915/16
8½ x 10½

Snow in the Woods. 1916
8½ x 10½

Autumn Colour. 1916
8½ x 10½

Autumn Birches. 1916
8½ x 10½

Rocks and Deep Water. 1916
8½ x 10½

Sombre Day. 1916
8½ x 10½

Black Spruce in Autumn. 1916
8½ x 10½

Purple Hill. 1916
8½ x 10½

Tea Lake Dam. 1916
8½ x 10½

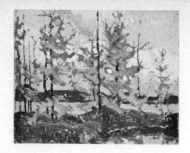
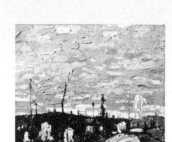

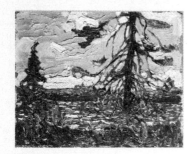
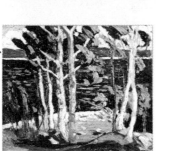
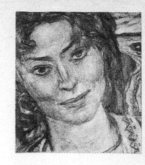

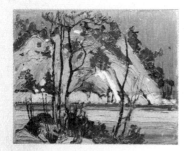

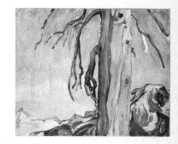

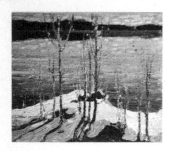
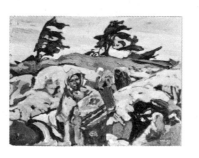
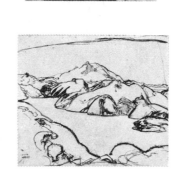
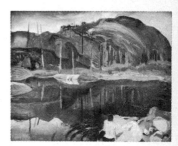

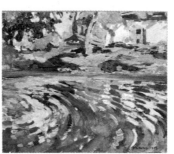

TOM THOMSON (cont.)
Tamaracks. 1916
8½ x 10½

Ragged Pine. 1916
8½ x 10½

Algonquin Waterfall. c. 1916
8½ x 10½

Moonlight and Birches. 1916/17
8½ x 10½

Sunrise. 1916-17
8½ x 10½

Windy Day. 1916/17
8½ x 10½

Wildflowers. 1917
8½ x 10½

F. H. VARLEY. 1881-1969
Indians Crossing Georgian Bay
1920
11½ x 15¼

Nude. c. 1920
24 x 16

Stormy Weather, Georgian Bay.
1920
8½ x 10½

Little Girl. 1923
11½ x 15

Meadowvale. 1923
8 x 10

John in the Studio. 1924
pen and ink
10½ x 8½

Mountain Portage. 1925
20 x 24

Girl in Red. 1926
21 x 20⅜

Mountains. 1927
pen and ink
12 x 14

Indian Girl. 1927
mixed media
8⅞ x 7⅞

Sketchers. 1927
pencil
12 x 14¾

Dead Tree, Garibaldi Park. c. 1928
12 x 15

Blue Pool. 1930
11 x 13

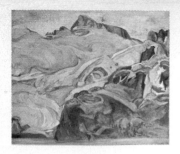
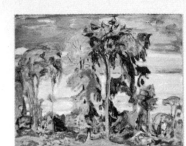
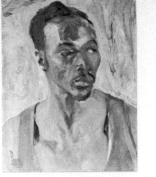
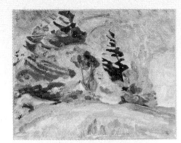

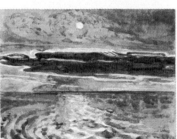

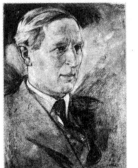
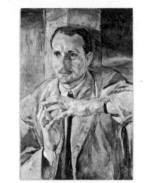
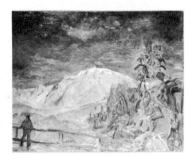
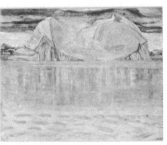
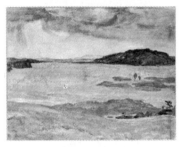
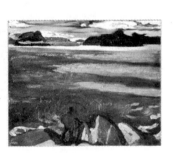

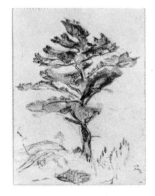
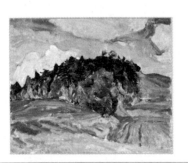

F. H. VARLEY (cont.)
Sphinx Glacier, Mt. Garibaldi.
c. 1930
47⅛ x 55⅛

The Lions. c. 1931
12 x 14⅞

Moonlight at Lynn. 1933
23½ x 29¾

West Coast inlet. c. 1933
12 x 14⅞

Trees Against the Sky. 1934
12⅛ x 15

Arctic Waste. 1938
watercolour
8¾ x 12

Iceberg. 1938
12 x 15

Eskimo Woman. 1938
mixed media
9 x 3½

Negro Head. 1940
15¾ x 11⅝

Portrait of Doctor Mason. c. 1940
mixed media
14 x 10

Portrait of Old Man. c. 1942
charcoal
16½ x 12⅞

Hilltop Doon. 1948
11¾ x 15

Fall Landscape. 1948
12 x 15

Portrait of a Man. 1950
27 x 18

Little Lake, Bras D'Or. 1953
9½ x 12

Pine Tree. c. 1959
mixed media
12 x 8⅞

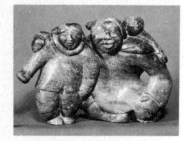
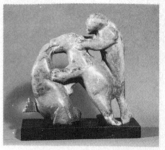
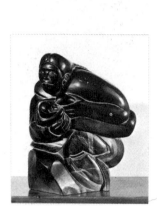
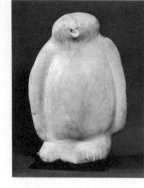
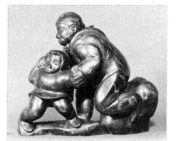
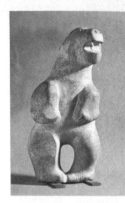
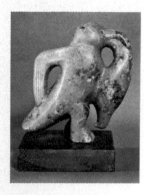
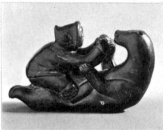
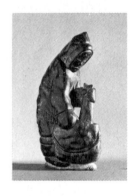
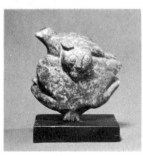
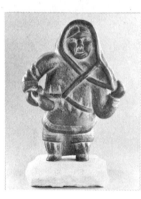
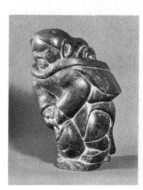

Kiawak
Cape Dorset
Green stone. 13 x 19.25 in.

E. Guvulieh
Cape Dorset
Green stone. 9.5 x 8.25 in.

Peter Anautak
Povungnituk
Black stone. 22.25 x 17 in.

Artist Unknown
Grey stone. 21.125 x 5.5 in.

Numani
Cape Dorset
White stone. 20.75 x 12.5 in.

Artist Unknown
Black stone. 11 x 18.5 in.

Duiesha
Cape Dorset
Green stone. 10.25 x 10.25 in.

Artist Unknown
Black stone. 16.75 x 18.75 in.

Artist Unknown
Dark grey stone. 10.75 x 7.875 in.

Mungita
Cape Dorset
Green stone. 14 x 14 in.

Pauta
Cape Dorset
Grey stone. 24 x 11 in.

Artist Unknown
Grey stone. 15.5 x 7.5 in.

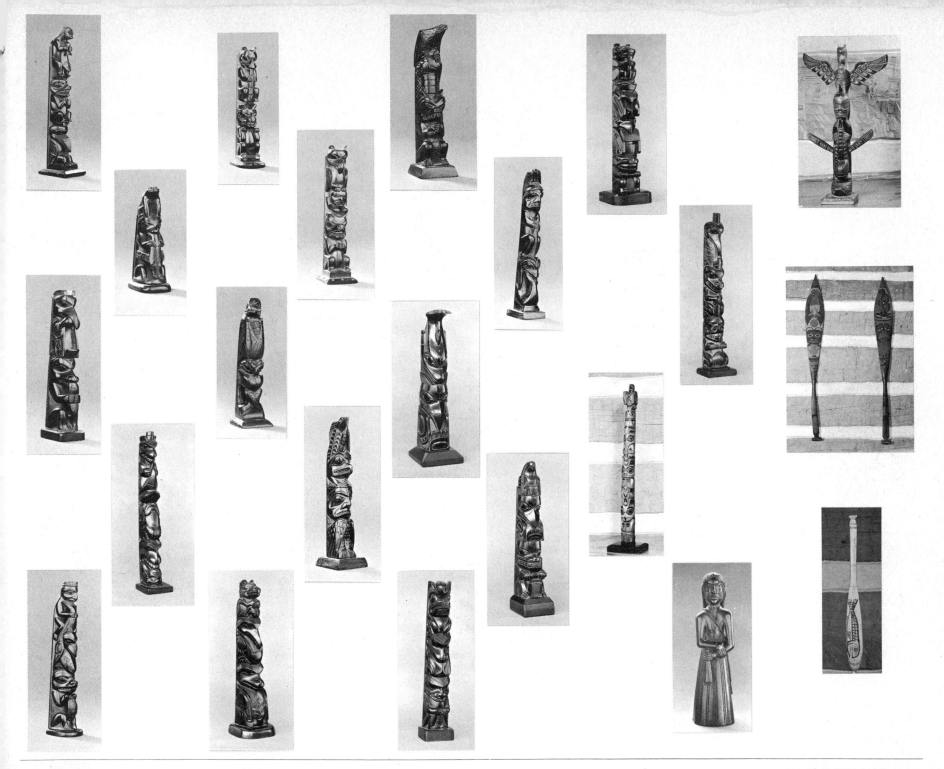

Isaac Chapman
1880?-1908? Height: 6.25 in.
 Charles Edensaw
 1839-1924. Height 4.375 in.
Isaac Chapman
1880?-1908? Height: 6.25 in.
 Carver unknown
 Height: 10.625 in.
Charles Edensaw
1839-1924. Height: 6.5 in.

Isaac Chapman
1880?-1908? Height: 5.125 in.
 Isaac Chapman
 1880?-1908? Height: 5.75 in.
'Captain' Andrew Brown
Height: 5.375 in.
 'Captain' Andrew Brown
 Height: 6.5 in.
Carver unknown
Height: 10.5 in.

'Captain' Andrew Brown
Height: 6.375 in.
 'Captain' Andrew Brown
 Height: 6.375 in.
Patrick Dixon
Height: 8.25 in.
 Patrick Dixon
 Height: 10.375 in.
Carver unknown
Height: 13.75 in.

Ed Calder
Height: 21.5 in.
 Carver unknown
 Height: 16.675 in.
Wooden Totem
Carver unknown
Height 38.75 in.
 Carver unknown
 Height: 8.5 in.

Kwakiutl, Wooden Totem
Charlie James
1876-1948. Height: 20 in.
Wooden Ceremonial Paddles
Length: 64.5 in.

Kwakiutl, Wooden Paddle
Charlie James
1876-1948. Length 15.25 in.

Unless otherwise noted, the above items are
carvings in argillite by Haida Indians.

175

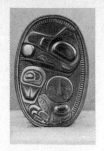
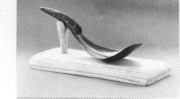
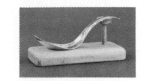
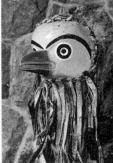
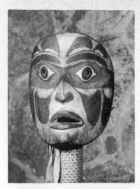
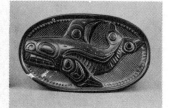
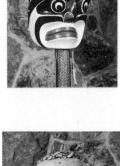
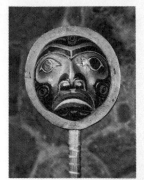
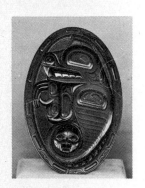
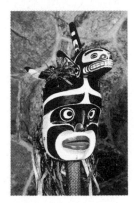
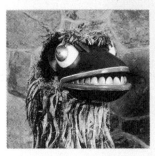
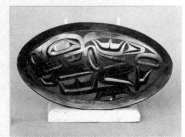
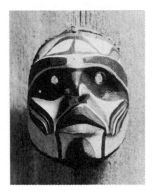
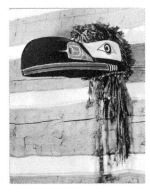
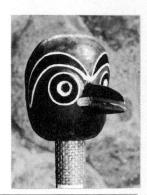
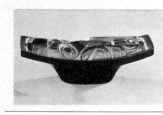
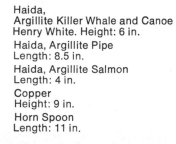

Haida, Argillite Dish
Patrick Dixon. Length: 5 in.

Haida, Argillite Dish
Greg Lightbown. Length: 4 in.

Haida, Argillite Platter
Patrick Dixon. Length: 9.5 in.

Haida, Argillite Platter
Tom Price
c. 1850-1929. Length: 10.875 in.

Haida, Argillite Dish
Patrick Dixon. Length: 3.875 in.

Haida,
Argillite Killer Whale and Canoe
Henry White. Height: 6 in.

Haida, Argillite Pipe
Length: 8.5 in.

Haida, Argillite Salmon
Length: 4 in.

Copper
Height: 9 in.

Horn Spoon
Length: 11 in.

Horn Spoon
Length: 6.5 in.

Haida, Silver Spoon
Robert Davidson. Length: 3.5 in.

Kwakiutl, Mask, Wood
Mungo Martin
1880-1962. Height: 20 in.

Bella Coola,
Human Face Mask, Wood
Height: 9.375 in.

Kwakiutl, Mask, Wood
Mungo Martin
1880-1962. Height: 15 in.

Kwakiutl, Kingfisher Mask, Wood
attributed to Mungo Martin
1880-1962. Height: 9 in.

Kwakiutl,
Raven Hamatsa Mask, Wood
attributed to Willie Seaweed
1873-1967. Length: 43.25 in.

Human Face Mask, Wood
Height: 9 in.

Rattle, Wood
Height: 14 in.

Kwakiutl,
Frog Mask, Wood and Copper
attributed to Mungo Martin
1880-1962. Length: 17.5 in.

Kwakiutl, Wren Mask, Wood
attributed to Mungo Martin
1880-1962. Height: 7 in.